Celine Dion

A New Day Dawns

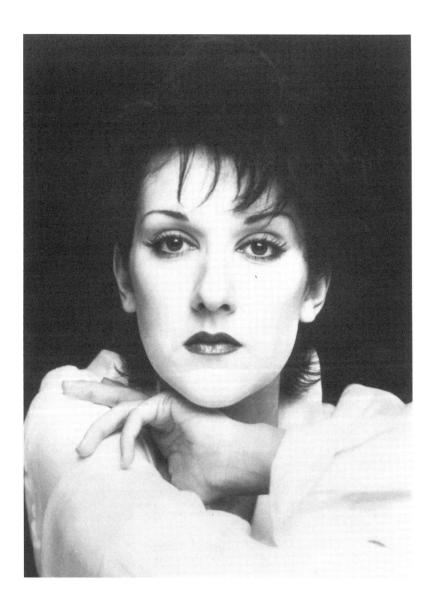

Celine Dion

A New Day Dawns

Barry Grills and Jim Brown

F 0 XM U S I C
B 0 0 K S

Copyright © Barry Grills and Jim Brown, 2004. All rights reserved.

The publisher acknowledges the support of the Government of Canada, Department of Canadian Heritage, Book Publishing Industry Development Program.

ISBN 1-894997-05-0

Design by Gordon Robertson. Typeset by Susan Hannah.

Printed and bound in Canada.

Published by Fox Music Books, PO Box 1061, Kingston, Ontario K7L 4Y5 Canada.

Contents

7	My Family
2 I	The Real Life
35	It Was Just a Dream
51	Widening the Orbit
67	New Words, New Worlds to Conquer
81	Disneyland
107	The Colour of Their Love
123	Divadom
139	Global Diva
159	D'eux
169	The Power of the Dream
195	Let's Talk about Love
211	A New Day Has Come
231	Ribliography

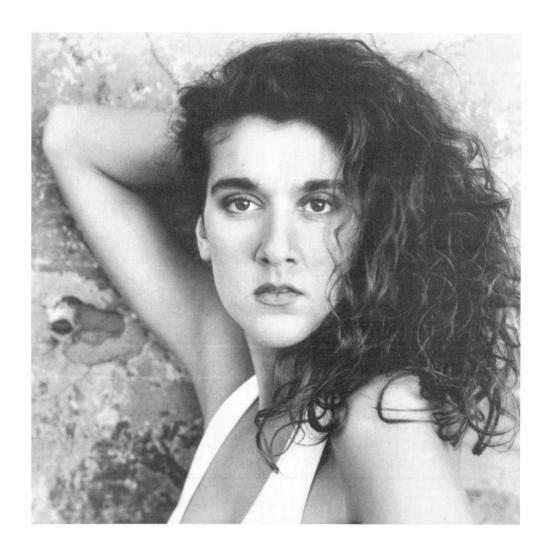

My **F**amily

I don't know myself very well because my life went faster than the time I had to live it. — Celine Dion

Tonight's the night. The grand opening of Celine Dion's show "A New Day in the Colosseum at Caesar's Palace" has arrived! The most elaborate Las Vegas show ever mounted. Everybody who is somebody in Las Vegas, the entertainment capital of the world, has been invited to attend. Elvis may even be in the building. Siegfried and Roy have left their white tigers behind at the Mirage and are seen along with Oprah Winfrey, Barry Manilow, Ricky Lake, Alan Thicke, and Dick Clark among the audience of 4,000 elegantly coiffed women and tuxedo-clad men entering the new \$95 million-dollar showroom built specifically for Celine a post-modern edifice that resembles the Roman original but boasts the world's largest high definition LED screen, a concave Diamond Vision Mitsubishi product that towers 40 feet above the entire 40-yard wide stage. As patrons are seated in the plush theater seats, they see gold-bordered mirror images of themselves projected on the screen. The spectacle has begun. The audience

has entered the universe of illusion created by show producer Franco Dragone from Circle du Soleil and become part of the set. No one in the audience would be seated more than 120 feet from the stage.

The house lights dim and the 'new' Celine Dion, sporting a short blonde haircut and a sleek black pantsuit, sneaks onto the stage through a seamless door in the Diamond Vision screen, magically appearing before her audience as the band launches into the opening strains of Nature Boy. Spotlights follow her, back-lighting defining her silhouette in a pool of liquid light on the stage floor that appears to merge seamlessly with the screen behind her, providing ultimate depth. The sound, oozing from 150 speakers and two banks of sub-woofers, bathes the audience. After changing into a red chiffon and beaded pantsuit, Celine and the band move on to The Power of Love. The tempo picks up as a fogged central staircase rises from the floor with Vegas showgirls dancing on the steps in feathery costumes, paying a tribute to classic Broadway and Vegas style shows. But Franco Dragone, his set designer, Michel Crete, and costume designer, Dominique Lemieux, along with Celine's own sound and lighting directors, Denis Savage and Yves Aucoin, have just begun to weave their spell into a Cirque spectacular where more than pianist Mego's grand piano will soar through the air. Trees sprout from the stage. Exotic background projections recreate Times Square. A tumultuous thunderstorm flashes across the screen and booms from the speakers.

Celine herself dances surprisingly well when she joins the bare-to-the-waist male dancers and literally takes to the air Peter-Pan style with the rest of the cast during *The First Time Ever I Saw Your Face*. Everybody appears moved by the choreography designed for *Seduces Me* as the chanteuse sits in a chair while the male dancers entwine themselves around her, a seduction scene so dripping with sexuality that it leads Celine to quip, "Hey, want to try that chair?"

As the 100-minute mark approaches, Celine brings it all home with her hit single I Drove All Night, her Titanic movie theme My Heart Will Go On, and Louis Armstrong's eternally endearing What A Wonderful World. As the audience showers her with a standing ovation, she thanks them simply and humbly: "This is what show business is about, you the audience. When I was a little girl my manager always told me, 'Celine don't be scared, when you get in front of the audience pretend they are your family and you are singing for them in the living room of your home.' Tonight, you are my family."

On September 11, 2001, the world we share was changed forever. During the troubled days that followed the terrorist attack, re-run images of jet airliners crashing into the towers of the World Trade Center and the Pentagon fed public anxiety. No one wanted to board a 747. But when Celine Dion received a call from the organizers of America: A Tribute To Heroes, the multi-network tv special, broadcast on September 20 from studios in New York, Los Angeles, and London, she set aside her fears and agreed to fly to New York City. The healing had to start somewhere.

Celine had been scheduled to film a clip in a recording studio in Montreal to be shown on the tribute show, then — as plans changed hourly - she was asked to come to New York. "It was hard for me," she confessed later. "They wanted me to sing in New York. I didn't want to leave my son. I was still breast-feeding at the time. My husband and I were crying. Going to New York, I thought I was never going to come back. But I'm glad I went. It was a responsibility. I had no choice. Nobody had a dressing room. Everybody was backstage together. It was a very emotional experience."

America: A Tribute To Heroes was a rallying point for the free

world. Bruce Springsteen began the night on an inspirational note, calling for everybody to "rise up!" He prefaced his performance of *My City Of Ruins* by saying, "This is a prayer for our fallen brothers and sisters." Tom Hanks quoted from cell phone messages, relayed back and forth between the passengers on the 'fourth plane' and their loved ones on the ground, before the passengers responded to the terrorists' brutality with a counterattack of their own, crashing that 747 into a field in Pennsylvania, far short of the hijackers' target. "In their heroic, undying spirit," Hanks said, "we all feel the need to do something."

Tom Cruise, Robin Williams, Julia Roberts, and George Clooney were among other celebrities who rallied the television audience. James Woods, Whoopi Goldberg, Andy Garcia, Meg Ryan, Reba McEntire, and Sylvester Stallone were on hand to staff the pledge-drive phone lines. Tom Petty stared defiantly into the camera lens as he and his band launched into *I Won't Back Down*, which on this night became an anthem of solidarity. Paul Simon showed his solidarity with New York fire fighters when he donned one of their caps and sang *Bridge Over Troubled Waters*. Neil Young's delivery of John Lennon's *Imagine*, backed by a string section, was another stirring performance. From the heartland, Willie Nelson sang *America The Beautiful*.

But perhaps the most moving tribute came from Celine Dion, whose performance of the patriotic anthem *God Bless America* moved everybody, especially Americans. "She may be Canadian," Mark Armstrong commented in an article posted at *Eonline.com*, "but her lungs were 'All-American'!"

Celine Dion would wait until the New Year to release her own inspirational song, A New Day Has Come. And although she would not hype it to the press as anything other than her newest single, Billboard Senior Features Editor Chuck Taylor was quick to spot the song's healing potential. "A New Day Has Come, the title track from her eighth English-language album," he observed, "comes off like a gentle exhale against the world's ills, as

we all look ahead to a changed but hopeful nation. For Dion, the tailored lyric also represents the birth of her son a year ago: 'The world thought I had it all / but I was waiting for a miracle to come.'"

Celine Dion has been bridging cultures and offering comfort with her music since she first took to the stage at age 10. Her remarkable four-to-five octave voice — theatrical, acrobatic, rich, evocative, powerful — can interpret the quiet cul-de-sac of a sensuous ballad, take a left downtown where pulsating, primal rock hangs out, then, just as easily, negotiate the rich human slums where blues has traditionally cried itself out of the womb. And she can do it in two languages, in French and in English, blending the two distinct cultures these languages reflect, yet respecting their unique character. A child star in Quebec and a hit in France before she was 20 years old, Celine became a full-fledged Canadian superstar when she released UNISON, her first English language album in 1990, launching a career that has led her to the top of the American charts and lodged her in the heart of her fans. Celine has taken her music even further afield onto the world stage, selling 140 million albums worldwide, more than any other pop artist in history, and touring the globe extensively from dateline to dateline, pole to pole. Celine Dion is the reigning pop diva, a performer who is asked to appear before the world whenever its citizens gather in the millions to celebrate or commiserate.

There has always been something special about Celine Dion that inhabits her music, lifts the spirit, and brings us all together. In 1984, an adolescent Celine, only 16 years old, performed on command for Pope John Paul II before 65,000 people at Olympic Stadium in Montreal, Canada's first covered sports complex. Later in her career, Celine would meet John Paul II in Rome for an official 'Papal Audience'. The daughter of small town rural parents, she is

the youngest of 14 children in her family, all raised as Roman Catholics. Occasionally rebellious, Quebec is still a loyal North American stronghold for the Vatican. The papal visit was full of pomp and majesty, rich with history. When Celine performed for the Pope, she was able to sing only in French, but through the medium of satellite television she reached beyond her provincial limits. Her agile voice was already more than merely a musical instrument — it was the voice of her culture.

Throughout her rapid rise to international superstandom, Celine Dion would never forget her Quebecois brethren, even though she was forced to learn a new language in order to conquer the rest of the world. In 1987, Celine won the Eurovision Song Contest before an estimated tv audience of 600 million, which prompted sales of more than 200,000 copies of Ne partez pas sans moi in Europe. That same year, at the Junos, she delivered her first significant English-language performance, and first met fellow Canadian David Foster, who would take her music to the American stage. "The Junos were a turning point in my life," she recalls. "I met so many people and got lots of calls and offers of work, and I met David Foster, who wanted to produce me." The deal with Foster was facilitated when CBC producer Carol Reynolds, a personal friend of Foster, provided the L.A. producer with a copy of Dion's new French-language album INCOGNITO, and a done deal when Foster dropped in for a casual viewing of Celine performing in a tent in rural Quebec. When Celine moved into a condo on the beach in Malibu, near Foster's home, she found herself being introduced to his circle of friends who dropped by Chartmaker Studios to hear her sing. Prince would pen With This Tear for her.

The voice of Quebecois culture and the pride of multicultural Canada, Celine Dion soon made herself at home in America. Her first significant industry awards, however, would be won in Canada. At the Juno Awards in 1991, Celine Dion won her first of many Canadian Female Vocalist of the Year awards. Her English

language debut, UNISON, produced by David Foster in Los Angeles, Christopher Neal in London, and Andy Goldmark in New York, was named Album of the Year.

In March 1993, Celine Dion hosted the 22nd annual Juno Awards at the O'Keefe Centre in Toronto. The reigning Canadian Female Vocalist, having won the award again in '92, Celine was a popular choice to be host, even though she was still mastering the English language. At this event, Leonard Cohen won two awards, k.d. lang three. The Tragically Hip were once again named Entertainers of the Year. A special tribute was reserved for Anne Murray. En route to her induction into the Canadian Music Hall of Fame, she was lauded by Gordon Lightfoot, Burt Reynolds, Kenny Rogers, Glen Campbell, Gene MacLellan, Alan Thicke, k.d. lang, Rita MacNeil — even Jerry Seinfeld. Despite the glow of so many luminaries, the night was still Celine Dion's. She won four Junos for her work in two languages — Best Selling Francophone Album for DION CHANTE PLAMANDON, Single of the Year (with Peabo Bryson) for Beauty and the Beast, Best Dance Recording for Love Can Move Mountains, and Female Vocalist of the Year. That night, Celine Dion became the pride of Canada, celebrated by anglophone and francophone, 'side by each'. She has built a musical bridge between these two irascible Canadian cultures, cultures politicians have been unable to reconcile since a British army led by General Wolfe defeated a French army led by General Montcalm on the Plains of Abraham in 1759.

Acceptance did not come immediately in the United States, even though Celine Dion fared well on the talk show circuit, holding her own with the enigmatic David Letterman, and winning him over by telling him that she was there on his 'Late Night' show to practice her English-language skills. Celine Dion's first major industry award in the United States would be won at the Grammy Awards in Los Angeles in 1993 when she and duet partner Peabo Bryson were acknowledged for their recording

of *Beauty and the Beast*. That same year she scored her first number one hit on the *Billboard* charts. In the summer of 1996, Celine performed *The Power of the Dream* at the opening ceremonies for the Olympic Games in Atlanta, an anthem written by David Foster, Linda Thompson, and Babyface. Her voice captured the culturally harmonious spirit of the games; her attitude seemed to conquer all. We felt the power of the Olympic dream. By 1997, she had ascended to the lofty position of the world's best-selling pop diva.

In February 1997, at the Grammy Awards in New York City, Celine Dion accepted awards for Album of the Year and Best Pop Album for FALLING INTO YOU. She began her acceptance speech with an address to her loyal francophone viewers in Quebec, spoken in her native Quebecois language, never forgetting where she came from even though she had moved so far away. "The few French phrases that Ms. Dion reserved for her Quebecois fans during her acceptance speech at the Grammy Awards," Konrad Yakabuski noted in *The Globe and Mail*, "uttered in a *joual* inaccessible to almost everyone but her six million French-speaking compatriots, validated their unique and enduring culture. In front of the United States and the world, Ms. Dion proved to Quebeckers that they exist."

One month later, at the Academy Awards in Los Angeles, Celine Dion performed Diane Warren's *Because You Loved Me*, her David Foster-produced cut from the *Up Close And Personal* sound-track. When Celine came to the aid of an ailing Natalie Cole, and sang *I Finally Found Someone*, Barbra Streisand's song nominated from her film *The Mirror Has Two Faces*, she made a little Oscar night history, becoming the first artist to perform twice on the show. Celine Dion, generous in spirit, was always ready to help out in times of need. Scheduled to sing a duet with Barbra Streisand at the Grammy and the Academy Awards shows in 1998, Celine went on alone when Barbra could not appear, singing *My Heart Goes On*. Her vocal interpretation of this song, written by James Horner and

Will Jennings for the soundtrack of the movie *Titanic*, had won a Golden Globe award and two Grammys, for Record of the Year and Best Female Pop Performance. An Oscar soon followed for Best Original Song. In addition, she accepted two American Music Awards, five *Billboard* awards, two Golden Disc awards, two Edisons, a Blockbuster award, a Popcorn award, an Amigo award, and industry acknowledgements in Japan and Canada — where she was named 'Favorite Canadian Artist' by MuchMusic.

Nearly everybody on the planet has heard Celine sing My Heart Will Go On. Some 28 million of them eventually purchased her album LET'S TALK ABOUT LOVE, 27 million bought the Titanic soundtrack album. On the heels of this astounding success — this unsurpassed international achievement — Celine told VH1, "I'm here because I want to be with people, I want to enter people's lives." No one could have imagined the number of lives her music now touched. No one could have imagined that her dream to become an international superstar would come true on such a grand scale.

Celine Dion has never been afraid to dream. As she told the Vancouver *Province* in 1990, "my big dream was to be known everywhere in the world. But it's just a dream. I'm known in Quebec, I'm known in France a little bit, but to sing in English means starting my career all over again. It doesn't matter that I've been known in Quebec for nine years." Miraculously, her dreams have come true, in part because of true talent, in part because of hard work, in part because of her good will, in part because of circumstance.

Since her first few performances as a child, Celine Dion has desperately wanted to become an international superstar. When her talent revealed itself at a very young age, she was encouraged to stand on tables in her parents' café and sing, performances that soon began to draw crowds. With the help of her mother, Celine

made her first steps toward stardom by taking the tape of an original song, co-written with her mother and one of her brothers, to René Angélil, former manager of Quebec diva Ginette Reno and future husband of Celine Dion. René recognized her talent immediately. He mortgaged his house to finance her first record. Together, Celine and René carefully structured a career for her as a child star in her native Quebec. Then, feeling that the Quebecois who had embraced her abilities as a child might not accept her as an adult performer, they contrived to move out of the entertainment spotlight for approximately a year to make a skilful transition from child to woman star. To achieve the international recognition they desired, there was one more cornerstone to lay—the international language of music is English. Celine Dion, risking a backlash in her native province, soon mastered and recorded in a second language.

Veteran music critic Martin Melhuish has watched Celine Dion from the early days, noting her uncanny ability to overcome obstacles in order to keep her career moving from stage to stage. "Speaking English was a big wall to climb," he says. "Here you are sitting there talking another language, realizing that if you're going to have any chance at even a minor career outside of Quebec, you're going to have to converse in English or do something in English. I think there's something quite courageous about that, and I say that because I lived in Quebec for a while and never did quite master the language like she's mastered English. When I saw her host the Juno Awards in 1993, I got goose bumps from the whole thing because I realized that that was so short a period, relatively, from the time she made the changeover to speaking English. You'd see her on Johnny Carson. That takes a lot of guts, to go on those shows to start with. But to have to deal in a language that's not your own . . . "

Few entertainers emerge from a unique culture, go on to assimilate a larger and somewhat antagonistic one, and then continue to gain the international stage. Some would attribute this achievement to talent alone — to Celine's sensuously versatile voice capable of

expressing extreme passion with breathtaking modulation. Others attribute her success to the clever management of the Svengali-like René Angélil. Still others point to her fierce drive and ambition. Celine Dion's ambition to succeed has never waned. She has continued to demonstrate a willingness to work a good deal harder than most people, whether they are in the entertainment business or not. "I didn't grow up the normal way," she told Brendan Kelly at the Financial Post, "there is a price. At ten, I was already on stage practising my songs. Every day, I take care of my voice. There's no air conditioning, even if it's summer and I'm sweating. If people are smoking, I have to ask them to stop. I can't go out because if you go to a discotheque, everybody's screaming and you have to talk louder, and you have no voice for the next morning. So this is discipline. But, with time, you do it naturally. For me, the only thing on my mind is my voice and my career. This is my life. So it's not an effort for me. It comes naturally now because I've been doing it for 12 years and it's going to be like this for the rest of my life. There's one way to do showbiz — if you want to do it perfectly, you have to be disciplined and you have to be ready to work really hard."

Polly Anthony, president of 550/Sony, who once described Dion's work ethic as "almost inhuman," has said, "there's talent and then there's talent. Celine has a talent that supersedes any trend, any movement. This is a talent for decades. Her ambition, her drive, and the sacrifices she makes on a daily basis for her career, her voice, for her fans — that's what really pushes her over the top. She's not a fragile little girl. She's a very confident, intelligent, funny woman who knows what she wants and how to get it. And yet she remains so very nice."

"Oddly," Jeff Gordanier noted in *Entertainment Weekly*, "the woman at the heart of this juggernaut acts less like a powerhouse diva than a '90s version of Mary Poppins. She doesn't smoke or drink; she doesn't throw hissy fits when she has to wait for a table; she greets her fans with a saintly supply of enthusiasm."

Celine has stated, "I'm not trying to be a nice girl, but it's me. I'm not afraid to be nice." Jim Steinman, producer of *River Deep*, *Mountain High* on Celine's FALLING INTO YOU album, observes, "she's aggressive in the most *sweet* way."

Talent and ambition, bitter or sweet, are probably common to all successful performers, but another characteristic has transported Celine Dion to the zenith of the pop galaxy. No matter how famous she becomes, how many accolades she receives, Celine Dion continues to exude an aura of being natural. Only the most cynical music critics have remained convinced that her warm personality is a contrived artifice, and even they grudgingly admit that there is something very honest about Celine Dion. There is no denying that Celine Dion is an original. There is no one in the world quite like her. Components of her originality emerge from her Quebec cultural heritage and include the personal way she bonds with representatives of the music industry. Celine Dion is well respected by recording executives and concert producers, dearly loved by her band and many of her peers.

And unlike many of her fellow divas, Celine demonstrates an abiding willingness to please, rising to each professional occasion while, at the same time, keeping to the busy schedule superstars of her magnitude are compelled to maintain. This character trait led her to 'lend a hand' at the Academy Awards in 1997 by standing in for Natalie Cole. Billboard Canada editor Larry LeBlanc, a personal friend of Celine Dion, notes the extraordinary confidence it took to perform that last-minute additional song, especially before a global audience. "She didn't have to do that," he suggests. "Some people wouldn't put themselves on the line like that. She was criticized in some quarters for doing so, but think about the coup. You know what prepared her for that? The hothouse of Quebec television, where you're doing four shows a week sometimes. A lot of artists would not want to have a) overexposed themselves, b) and — this is really important — set themselves up for failure. I can see them — Celine and her husband-manager René Angélil — saying we can help out here. They're that kind of people."

Our pop divas — gifted with extraordinary musical ability and driven by an all-powerful desire to succeed — seem to transcend not only the limits of the individual citizen but also the world of politics and cultural nationalism, residing in a realm outside of the petty concerns that dog our everyday lives. Perhaps some pop divas like Celine Dion overcome with their music all the energy-sapping preoccupations that less focused people utilize in their otherwise insecure lives. But Celine Dion still doesn't think of herself as a diva at all, just your average small-town girl who returns time and time again to her family home, singing at family get-togethers and offering homespun solace to her concert audiences as if she had never become rich and famous at all. Many stars have begun the long and winding road toward superstardom in similar humble circumstances; few have retained Celine Dion's humility. Despite the aura of glamor that seems to envelope her at times, Celine is at the core a common girl.

Superstars like Celine Dion do not simply happen. Their rise to international fame is the result of an array of factors that coalesce to transform their achievements, at least in retrospect, into apparent inevitability. There is, of course, the matter of raw talent, drive, ambition, and character. The calling, if you will. As well, stars are influenced by other individuals, relatives and friends who encourage them, help them manage their way past the obstacles impeding their progress along the paths leading to their goals. These are the personal factors in an artist's success. There are other pieces of the puzzle to be discovered and placed correctly before it is possible to complete the picture. Culture, political times, social trends and tastes, the presence and pressure

of peers, the historical tradition of "stardom" itself, must all be placed beside the personal history. Celine Dion's positioning of herself, in the midst of motherhood in her prime years, as an artist set upon developing a new, more theatrical approach to her performances adds a dimension that may see her leave the designation "diva" on the cutting room floor, along with other attempts to define and confine her.

With all of this in mind, Celine Dion: A New Day Dawns is more than simply a biography of a Quebec singer who drove in the fast-lane of pop culture and has settled down in Las Vegas to play a little golf with her husband and raise her son. The book sets out not only to appreciate Celine Dion's art but also to understand the pop culture phenomenon of 'divadom' itself. The intention is to sacrifice the minute details of Celine's life, trivial or superficial material more suitable to gossip, in favor of a broader cultural approach. The mission is to examine the "times" that have shaped her music and the power her music has to shape our lives.

The Real Life of Celine **D**ion

I'll always be a Quebecker-Canadian. I'm from Quebec and every time I go to a country I say that. It's my roots, my origins and it's the most important thing to me. — Celine Dion

For me, singing was the real life, not two plus two equals four.

— Celine Dion

The year that Celine Dion was born the world was embroiled in the turbulent decade sometimes celebrated but other times abhorred as the "Sixties". The war in Viet Nam was escalating and the successful flight of Apollo 8 took astronauts Borman, Lovell, and Anders on a journey culminating in ten orbitings of the moon, a then remarkable step towards the first landing by earthlings on the lifeless, but enchanted sphere at which we gaze nearly a quarter million miles away. Nineteen sixty-eight was a year of death too. Even outside of Viet Nam, there was the horror of children starving in Biafra and the dismay we felt over two major assassinations, those of Robert Kennedy and Martin Luther King. Students were protesting all authority, often violently clashing with police, in

North America, France, and England, to name but a few locations of campus unrest. Black Power became a highly visible movement as victorious American athletes raised their fists in the Black Power salute while they stood on the winners' podium at the Olympic games in Mexico City. In the Vatican there was controversy over whether or not Catholics should be allowed to make use of oral contraceptives. Richard Nixon finally moved into the White House, beginning an era of political corruption and a compromising forgiveness of ethical decay which continues to this day.

In the world of popular culture, Yves St. Laurent unveiled his see-through fashions that year, while Jacqueline Kennedy married Aristotle Onassis. Elsewhere, O.J. Simpson was being touted as the best college football running back ever and was expected to be picked first in the NFL draft, headed for a place on the roster of the Buffalo Bills, while Peggy Fleming was a gold medalist that year. Dustin Hoffman became a Broadway star in the wake of his successful tutoring by Mrs. Robinson. The world of music entertained us with the folk sounds of Joan Baez and the hard-rock blues of Janis Joplin, while Barbra Streisand began her long reign as the first modern pop diva, both a singer and an actor.

In the decidedly provincial world of Canadian music, 1968 was the year the Canadian Radio-Television Commission (CRTC) was created under new broadcast legislation. Joni Mitchell received a Grammy for Best Folk Performance after recording her album CLOUDS and releasing the classic single Both Sides Now. The rock musical Hair opened in New York, featuring the musical score and direction of Montreal composer Galt MacDermot, while Buffalo Springfield, the Canadian-American combination featuring Neil Young and Stephen Stills, played their final concert in California. Rising higher in 1968 were Canadian musicians like David Clayton Thomas, who was recruited into Blood, Sweat & Tears. Notable for achievement and success were The Band and Steppenwolf. The Guess Who went to New York to begin recording their album WHEATFIELD SOUL, while Ian and Sylvia

traveled there as well, to play the Cafe Au Go Go and launch a nationwide tour.

The year that Celine Dion was born a charismatic fellow Quebecker, Pierre Trudeau, became prime minister of Canada. There was a nascent separatist or nationalist movement in Quebec, including a radical revolutionary cell, the FLQ (Front de liberacion du Quebec). The Front was preparing to flex its terrorist muscles, revealing the centuries-old division between French and English Canada that would lead to the October crisis in 1970 — the passing of the War Measures Act and a temporary suspension of a wide variety of rights and freedoms in Quebec. Quebec was already rich in all of the arts — in music, dance, literature, film, fine art — already culturally distinct from the various arts produced in the rest of Canada. Performers such as Ginette Reno and Robert Charlebois were preparing to take their place in the world, the first Quebec pop stars to achieve international acclaim. Reno would become not only a French-language but also an English-language star, the first performer from Quebec to bridge these cultures, while Charlebois was revolutionizing francophone pop music, performing his unique Quebec-style of rock theater and opera before an appreciative Parisien crowd.

At the time when Celine Dion was born, traditional Quebec music was still under the influence of the British Invasion. René Angélil, Dion's mentor, manager, and now husband, became a key performer on this pop music stage. As Canadian music historian Martin Melhuish notes, Angélil was part of a Sixties musical movement featuring what were termed Yé-Yé Groups. "It was a French version of The Beatles and the English Invasion, groups of people who did pop songs, dressed up in weird outfits," he recalls. "That really was sort of bizarre. I think it's interesting where he came from. A lot of people keep asking how come Dion married this guy, he's so much older. What was it about him? Probably he had his own charisma that came from all the stuff he'd done in the past."

Angélil had already performed with a group called Les Baronets, which had a minor hit, Le petit sous-marine jaune (Yellow Submarine), by the time Celine Dion was born. He soon left the stage to become an impresario, what English Canada, mimicking the American slant on the vocation, would call a "promoter." Impresario is a word which perhaps best defines the Quebec passion for public entertainment and the people who organize it, a passion not only far outstripping the enthusiasm displayed in the rest of Canada, but elevating the vocation of promotion to an art form in itself. One of his first clients as a manager was Ginette Reno. And Reno was the reason that Angélil was selected by Celine Dion's mother to listen to her first demo tape. Reno was also one of the Quebec performers who contributed significantly to the province's respect for child entertainers. And, finally, Reno was a vocal inspiration for Dion who, from a very young age, preferred singing Reno's songs. As Larry LeBlanc points out, "Angélil had managed Ginette Reno who was Celine's biggest idol, in fact probably the biggest influence in the French part of her life as a singer. Ginette Reno once described herself in Maclean's as one of the five great entertainers in the world. Quite frankly, she's right. She is."

Born Ginette Raynault in Montreal on 28 April 1946, Reno launched her singing career at the age of 14 when she began to appear in amateur music contests, often taking first prize. Encouraged to continue on as a performer, Reno soon began to appear in Montreal area nightclubs and eventually graduated between 1960 and 1964 to radio and television studios throughout Quebec. At the same time, she took singing lessons with Roger Larivière. Popular acclaim for Reno came quickly, on the heels of her first single, *Non Papa* and *J'aime Guy*. The follow-up success came with the song *Roger*. Demonstrating an ability to sing and perform in both French and English, it was not long before Reno was gaining an English-speaking following as well. Among a list of Canadian milestones, she performed at the Olympia in Paris, was voted by

the Quebec public as Miss Radio-Television in 1968, and, that same year, won a trophy at the MIDEM festival in Cannes. Reno won Junos in two consecutive years, 1972 and 1973, for Outstanding Performance of the Year, Female.

Her distinguished career continued with even broader global appreciation. Signing a contract with Decca in 1969, she performed twice on England's BBC-TV and was seen on stage at the Savoy Theatre. She also hosted a series of programs with England's Roger Whittaker. While chalking up Canadian and European successes — notably the 1970 English-speaking hit *Beautiful Second Hand Man* — Reno also had an impact in the United States, touring there and appearing on such talk shows as Johnny Carson, Merv Griffin, and Dinah Shore.

After forming her own record company in 1977, Melon-Miel, her album JE NE SUIS QU'UNE CHANSON sold nearly 400,000 copies in Quebec alone, and she won several Felix Awards in that province for her efforts. She also appeared as one of the co-hosts of the 1981 Juno Awards. She was named an Officer of the Order of Canada in 1982.

Reno has managed to remain popular in Quebec to the present time. After a performance in 1977, Pierre Beaulieau wrote in Montreal's *La Presse*, "what a Colossus of the stage, what a magnificent performer, what a voice, what soul, what warmth she radiates ... Ginette Reno is music pure and simple, music with no nationality, no boundaries, ageless, beyond time. Ginette Reno is the soul of music, a succession of notes that she rethinks, reworks, to which she gives new life and finally delivers to us through her own view of things, her warmth, her voice and her incredible talent."

But as Larry LeBlanc notes, Ginette Reno is one more thing. Difficult. "She's just extraordinary, but to work with her, she's very difficult. She's extremely difficult. And René had just had enough, and I think the story went he had just broken up with her, with working with her, and then Celine and her mother came into the office about two or three weeks later."

The year that Celine Dion was born, Quebec, much more so than any other "nation" or culture, embraced the child performer as a legitimate entertainer. Just three years after Dion's birth, ten-year-old René Simard would make his performance debut at Montreal's Place des Arts and become an instant hit. Simard was destined to precede Dion as a child star of 14 — he too was managed for a time by René Angélil — to a first appearance at the Olympia in Paris in 1975.

Celine Dion was born in a province which demonstrates a powerful receptiveness to popular culture in general and pop music in particular. As such, Quebec contrasts deeply with the rest of Canada. In Quebec there is a powerful star system in place and a dedicated enthusiasm for its musical and other celebrities, whether they originate in Quebec or not. In addition, the various media feed and enhance the already intense interest Quebeckers have in both their international stars and their home-grown products. "When talking about the Quebecois music scene, one should be aware of the fact that Quebeckers are one of the highest per capita purchasers of records in the world," Martin Melhuish emphasizes. "It is not uncommon to find a big hit in Quebec selling more records than in the rest of Canada combined. Much of the credit for this enthusiasm has to go to the star system that exists in Quebec because of the heavy exposure generated by newspapers, fan magazines, tv, and radio. This is another part of the scene that Dion came out of. They had a built-in star system there which we never got together in anglo Canada. The newspapers got behind her and tv and everything else. The big difference between Quebec and the rest of Canada is the media. A press conference in Quebec attracts 100 media people. In Toronto you're lucky to get a dozen."

Billboard's Larry LeBlanc agrees. He has described the Quebec pop market as the most unique pop market "in the absolute world." Noting that Dion has stated many times that the people of Quebec watched her grow up, he too refers to the heavy exposure performers

get on weekly television shows and in the various tabloids and media. "There's a star system there that is unique," he says.

Where Celine Dion was born there were two cooperating musical languages, French and English. Though sensitive to the broadening political divisions looming on the horizon, many musicians from these two linguistic communities considered nationalist politics irrelevant when it came to music and openly fraternized. Even later, when the Parti québécois came to power in Quebec, candidly straightforward about its avowed aim to separate Quebec from the rest of Canada, musicians continued to find common musical ground outside the realm of political issues.

It is arguable, in many ways, whether Dion would still have emerged as a superstar had she not come from Quebec. It is not arguable, however, that her birth in Quebec, with all its influences, possibilities, and unique cultural receptiveness, was a powerful factor in shaping her musical destiny. It was in Quebec that she was able to establish the foundations of her eventual rise to superstardom. And no one knows this better than Celine Dion.

To her, Quebec is the reason for virtually everything that has transpired in her life. "I'll always be a Quebecker-Canadian," she told *Maclean's* in 1992 when she was selected for the magazine's 1992 Honor Roll as one of the 12 most notable Canadian achievers of the year. "I'm from Quebec and every time I go to a country I say that. It's my roots, my origins and it's the most important thing to me."

This then, was the world in 1968, Canada in 1968 and, most of all, Quebec in 1968, when Celine Dion was born on March 30th in the small municipality of Charlemagne, scarcely 30 kilometers from Montreal.

Charlemagne is about as far-removed from the musical capitals of the world as one can get, an unlikely location for a superstar to be born. Small and humble, the town is an especially unlikely place for a family of musical people to begin believing that their daughter's ambition to be a star holds any potential for becoming real whatsoever.

Not far from the metropolis of Montreal, Charlemagne is actually a suburb of the City of Repentigny in the Municipal Regional Community of L'Assomption. There is little to distinguish it from any other suburb of any other small city and any other regional municipality in Quebec or the rest of Canada. Its population is just slightly less than 6,000 people but nearly 90 percent of that number are of French origin. Most men work in the trades, manufacturing, construction, and a variety of service industries, most women in clerical positions or sales and services occupations — a working-class town. Charlemagne does not attract ethnic minorities. Conservative and rather conventional, fully more than 95 percent of its residents were born in Quebec and have elected to stay there. The predominant language is, of course, French with nearly 98 percent of its residents speaking only that language. According to Census information from 1991, less than one percent of the population there was bilingual. Those who spoke exclusively English outnumbered those who were bilingual. The predominant religion, of course, is Catholic, well over 90 percent. A relatively new community, most of its homes, an equal split between rental and owned residences, were constructed in the period since 1970. The town is too new to have much history, too small to have its own distinctive soul. Charlemagne is a product of the times. In 1991 the town suffered more than 11 percent unemployment and a 22 percent incidence of low income families. It is the kind of municipality where, generally speaking, rather unextraordinary people tend to live out their unextraordinary lives, clinging to whatever status quo defines the times. This way of life is what most of us would call normal or traditional. But, being part of Quebec, the residents of Charlemagne enjoy a passionate zeal for music and pop culture.

Here Celine Dion was born, the last of fourteen children, nine daughters and five sons, raised by Adhémar and Thérèse Dion, both of whom, in the Catholic tradition, had been part of large families themselves. Adhémar Dion, for example, born 2 March 1923, was the eldest of five boys and two girls, while Thérèse Tanguay, born 20 March 1927, was the sixth child born in a family of four girls and five boys. It is Celine's mother who claims that her daughter has a strong sense of family values and she admits that she did not leave the home to go to work until her youngest daughter was attending school. This close family bond would ultimately be strengthened as Thérèse not only encouraged Celine to embark on a musical career, but served as her chaperone until she was 18, joining the precocious singer on most of her professional journeys, appointments, and obligations.

Before his death in 2003 Adhémar credited himself as a man who took on a number of projects to provide for his family, claiming he enjoyed hard work, but he always credited his wife for his daughter's determination as well as her ability to be diplomatic, a characteristic her father did not share with her. Dion's mother was the stronger force within the family and, not surprisingly, encouraged her youngest daughter's early efforts to pursue a musical career. It is now part of the lore of Quebec — with its fascination for the story of Celine Dion and her rise to international fame — to relate stories about the indomitable will of Mm. Dion.

"Almost everyone in Quebec has heard the story of how Thérèse Dion, pregnant with her seventh child in 1954, climbed daily up the ladder with a hammer to help build her rapidly growing family's home in a hamlet east of Montreal," Konrad Yakabuski recounts in *The Globe & Mail*. Yakabuski reports on the psychological study Dion's family has inspired in some quarters in Europe since she has become the world's reigning pop diva, a mission which led him to talk to author and journalist Georges-Hébert Germain, the man who is known as Dion's official biographer. "Mr. Dion didn't have the same drive as Maman Dion. He didn't have

30

the same openness to the world. It's always been the mother who has pushed the kids," Mr. Germain said. "Never once did my mother let her pregnancies get in the way of her responsibilities or the needs of her family," Dion herself has said.

"In short," adds Yakabuski, "Maman Dion has been a tough act to follow for Ms. Dion and her eight sisters. . . . Always the referee, it was *Maman* who, in 1992, intervened when her youngest daughter created a stir at home by launching an emotional plea for national unity at the World's Fair in Seville, Spain. 'When there's 14 of you around the table, you can have 14 different opinions. Not talking about politics is the best way to avoid fights.'" The continental French magazine *Psychologies* claimed, according to Yakabuski, that Dion's marriage to Angélil was like "a security blanket that bears witness to the difficulty some women experience in attaining adult female maturity, in displacing their mother from her position as the ideal woman."

But whether or not her mother was destined to be the ultimate guiding influence on Dion, either psychologically or vocationally, the entire family possessed a love and talent for music which was the real source of inspiration for her. Her father played the accordion and her mother the violin. Celine has said, "I'm not the most talented person in my family. I'm the luckiest one! They all sing, they all play instruments." It is not surprising to learn that Dion was even named after a song, the Hughes Auffray hit Dis-Moi Celine. As for the music created and performed by the Dion family, there was no effort made to keep it a secret. Often members of the family would perform at weddings, give concerts at orphanages, or appear at a host of other local events. Even today, various members of the family either continue music as a hobby, or are pursuing it professionally, some of them in connection to their superstar sister. Michel Dion, for instance, has tour duties with the Dion show, while Pauline is president of her fan club. Still others, sister Claudette, sister Linda, and brother Paul, have held positions with Nickels Restaurant, co-owned by Celine and her husband René with other principals. Claudette has been a singer, chief hostess, and cashier supervisor at the Nickels Restaurant in Repentigny. Linda has been the restaurant's manager. Paul has been its owner. Jacques' occupation is as a composer.

Clément, Pauline, Daniel, Ghislaine, and Manon Dion have occupations separate from Celine's career. Liette is a homemaker. Celine has always had a close emotional tie to Liette because of her abiding interest in Liette's daughter, Karine, who died of cystic fibrosis. While performing once at Place des Arts, Celine dedicated a song to Liette, asking her to imagine that it was her own daughter singing for her. And it also explains why, as part of Dion and Angélil's wedding, a cheque for \$85,600 was presented by the couple to the Quebec Cystic Fibrosis Association, which had members on the guest list for the wedding.

Her oldest sibling, Denise, was already 22 years old when Celine was born and, according to family lore, still refers to her as "my baby." Maintaining that the entire clan was sensitive, she has reported that her youngest sister often had difficulties while she was attending high school, not only because of her busy schedule in the music industry, but because cruel classmates would play tricks on her. Her oldest brother Clément has remarked that Celine was mischievous.

Dion herself has admitted that her family encouraged her to sing from an early age. When she was three years old, her sisters, she has said, would costume her in a little dress, add a minimal amount of makeup, then place her on the table in the kitchen. From that vantage point, she would sing to the applause of her family. This form of family acceptance was especially enthralling for the little girl who, not long afterwards, would be ridiculed at school by her peers as "the vampire" because of the prominence of her teeth. She learned to abhor school.

Celine first performed in public at her brother Michel's wedding, at five years of age, singing three songs. This was followed by

a concert at the La Cachette hotel in Joliette, where, before a large crowd, she brought the house down. There is no doubt in anyone's mind that her ambition to sing was born that early in her life.

Except for a couple of near-tragedies involving significant injury to Celine, her childhood, beyond its musical focus, was relatively normal and uneventful, especially defined as it was by close family ties. Anecdotes abound about how Celine replaced the composition on one of her brother Jacques' master tapes with her own voice, resulting in a surprised call from the recording engineers on the project. There are also stories of a somewhat conventional nature referring to her collection of dolls, 14 in all, which she carefully tucked into bed every night. Still, the family was shocked when she was struck by a car, at age five, right across the street from the family home while her father and her brother Clément looked on. She was hospitalized with a concussion but recovered completely. A number of years later, she was also injured while sliding with tubes on the snow when she struck her head on the ice. After a few hours of nausea, however, she fully recovered from the incident.

While Dion was still a young child, the enthusiastic response demonstrated by her family grew into a cluster of admirers who regularly came to her parents' piano bar and restaurant, Le Vieux Baril, just to hear her sing. "There," as E. Kaye Fulton of *Maclean's* describes it, "a precocious five-year-old stood atop a table and belted out the songs of Ginette Reno. Before long, customers called in advance to fashion their evening plans around the performance of 'that little girl.'" Le Vieux Baril was virtually defined by music. The children took turns singing and waiting on tables and "a typical family gathering, with an assortment of instruments, was a jam session of traditional and contemporary songs."

"I would run — running as fast as I can — home from school. I couldn't wait to come back to the basement to hear them rehearse every day. When I was 12, I told my mom that all I dreamed about was singing," Dion told *Maclean's*. In fact, Dion was so focused on

music, she had no time for school. Her attendance there was primarily as a physical presence only, her heart and mind were elsewhere. Part of this indifference about her education — she was known to fall asleep during class — was the result of staying up late to sing in her parents' restaurant, something that was a regular occurrence by the time she was nine, despite efforts by her mother to be strict about how late she could remain in the establishment. Her distraction at school seemed to have as much to do with her focus on music as it did on actual fatigue. Sometimes, however, her sister Claudette would drive her to school so that she could sleep a little longer, getting her there just in time for the bell. "At school," Celine told writer Lyle Slack for *Chatelaine* in 1991, "I was sleeping and dreaming all the time. I didn't learn anything. For me, singing was the *real* life, not two plus two equals four."

If, beyond the talent and ambition, there was any good fortune for Dion in becoming a member of a family committed to making music, it was perhaps the impact of being the family's youngest child. During those early formative years, she noticed and regretted each occasion when one of her older siblings reluctantly gave up music, at least as a career, to seek out more conventional employment as a means of supporting themselves. If anything, this contributed to a strengthening of her resolve not to follow suit. Her earlier declaration that she wanted to sing professionally, even that she wanted to be a star, never waned, and by the time she was 12, her mother was as convinced as she was that it was time to take the bull by the horns.

In the true style of Thérèse Dion, the decision to help her daughter achieve her ambitions was accompanied by a resolve to accomplish this goal in a professional fashion. As Martin Melhuish puts it, Dion's initial success was the result of the confluence of two separate events. "Her mother, number one — I mean you don't emerge from anywhere unless somebody, as a young kid, is there to say, 'Look, I believe in my daughter and I

think she's good and has the conviction to do something about that.' She dragged Celine from the place she was born, Charlemagne, took her up to big bad Montreal where all the big stars were and got hold of this guy, René Angélil who was managing Ginette Reno. The interesting thing about what her mother did was this, she recognized that her daughter has a great voice, Ginette Reno has a great voice so she took her to the person who's made Reno's career work, and she did that."

Even so, it still took the involvement of other members of the family to accomplish the task, a solidarity which reflected their shared enthusiasm for Celine's ambitions. The family recorded a demonstration tape in the basement of their home. On the tape, Celine performed a new song, Ce n'était qu'un rêve (It Was Just A Dream), co-written by her mother and her brother, Jacques. Celine was involved in the arrangement. Wrapped in a red ribbon, the tape was sent to René Angélil, along with a note that said, "This is a 12-year-old with a fantastic voice. Please listen to her. We want her to be like Ginette Reno." Angélil did not respond immediately. He had recently parted company with Reno and has since admitted in interviews that he was depressed for a few weeks after her departure. In addition, child singers wanting to be like Ginette Reno or René Simard were quite common at the time. "Every kid of 12 in Quebec wanted to be either Ginette or René," he has said. The tape gathered a bit of dust before he finally played it. Some further gentle but aggressive push from another member of the Dion clan, Celine's brother, Michel, led Angélil to play the tape.

Soon after, the various influences on Celine Dion's life, peculiar to her family home in Charlemagne and to the province of Quebec, finally fell into cohesive place and launched her astonishing career.

It Was Just A **D**ream

I asked her to pretend she was in front of 2,000 people. When I handed her a pen to use as a microphone, she closed her eyes and she was there. — René Angélil

You can have the biggest talent in the world, but if you don't have the team and the timing — because I believe in destiny — to be there at the right time with the right song, it just won't happen. — Celine Dion

Destiny was scheming in Celine Dion's favor when René Angélil played the tape of her first recording, then invited the young singer to his office so he could listen to her in person. To understand the almost predestined way, musically speaking at least, Celine Dion and René Angélil were suited to one another, we need only recognize their shared image of success, an image blending the aspirations of an old French and a new American culture in a distinctive Québécois amalgam. "Descended from a French culture, surrounded by an Anglo-Saxon one and living like Americans — these are the elements that sum Quebeckers up," Jean-Marc Leger has concluded in a poll of the aspirations and character of Quebeckers.

"Celine Dion is the perfect embodiment of the happy balance [of these forces] to which Quebeckers aspire." One could add the name of René Angélil to that mix as well.

Angélil is a gambler by nature. Born in 1942 to a Syrian father and Quebec mother, he showed at an early age an enthusiasm for life and a belief in his own abilities to make things happen. He learned to speak English as well as Arabic and French. Although it was expected that he would go into business — for a time he worked in a bank and also studied accounting — there was surprise in his family when he moved into the entertainment business. Still, it was the 1960s and popular music was enjoying a renaissance. The British Invasion —The Beatles, and a myriad of other groups — had invigorated rock and pop music and the songs which resulted were as popular in Angélil's Quebec as they were in the rest of the world. Towards the end of that decade, groups were being formed to perform a Quebec version of either psychedelic or English-language pop music. Angélil, aware of the popularity of such groups, and inspired by his characteristic view, "Why not?", formed what was then known as a Yé-Yé group of his own called Les Baronets, encouraged by the fact that similar groups were being seen on The Ed Sullivan Show. Yé-Yé groups, as the trend of the times had it, dressed up in relatively outrageous outfits to perform their versions of translated British Invasion melodies. He was so sure of success, he gave up school at the age of fourteen to pursue music. Performing with cohorts Pierre Labelle and Jean Beaulne, the group had some significant success in the early days.

Known as a practical joker and a teller of tall tales, Angélil also developed an early appreciation for the best things in life, and this, combined with his affection for taking risks, inspired him to apply his accounting skills to the concept of developing a winning system he might use in the world's gambling casinos. He solicited funds to try out his system in Las Vegas, ultimately learning that there is no such system, or, if there is, no one has yet discovered it.

Still, Angélil enjoys gambling to this day; he is a popular visitor in Monaco.

Another story has become part of the lore surrounding Dion and Angélil. René's brother, André, tells of an incident combining his brother's urge to be a joker with his love for risk. While driving with his brother, at the time he was gaining success with The Baronets, René came to a stop at a Montreal intersection and suggested to his brother that he could defy the red light there and not be ticketed. The idea was to gamble that a nearby policeman would pull him over, discover he was a musical celebrity, and ask for an autograph for his daughter before letting him off with a warning. As it turned out, the scenario developed exactly as René predicted.

Angélil's playful and optimistic character is in part a product of the the 1960s, the "Age of Aquarius" when anything seemed possible. This attitude would provide the antidote to the cynicism which may have resulted from the ambition to succeed (Americanstyle) he shared with Celine Dion. This, then, was at least part of the character of the man who would guide Celine Dion's career and eventually become her husband. As a lively child, he excelled in most endeavors in which he was involved and he brought to his life a powerful belief in his own abilities. He has been known to bring a positive attitude even to life's normal setbacks, keeping whatever worries he suffers to himself. He is also known as a man with a high regard for traditional family values, something else he shares with Dion. Angélil has a broad streak of generosity and kindness, as well as what are termed superior organizational skills and the ability to know in advance the results his actions will provoke. René Angélil is also not a man who gives in easily or forgets those who have helped him or Celine to succeed.

By the time the Dion family showed up on his doorstep with the young Celine, René Angélil was an impresario of some repute in Quebec, well-known and well-connected in the music business, not only for managing Ginette Reno but also for producing music for child-star René Simard, the most visible child entertainer in Quebec, a youngster who had achieved an outstanding amount of international success.

Martin Melhuish speculates that while Dion was performing the songs of Ginette Reno, she also was probably aware of the success of Simard as a child entertainer in both Ouebec and internationally. "René Simard did become an international star," he says. "He had his debut album sell over 160,000 copies in Quebec. Was he one of those people she had on her wall, that she looked up to? And did she know that he had broken out into the big time and gone into the English market? There had to be someone who gave her the hope." The career of Dion would follow the path of Simard's, for the two performers began their careers at a very young age and both deliberately transformed their images to make the transition from child to adult star. They would achieve international success in Japan and in France in much the same fashion, even winning similar awards at the International Festival of Song in Tokyo. They would sing theme songs for the Olympics, Simard at the Montreal games in 1976, Dion at the Atlanta games in 1996. And so on.

Born in Chicoutimi, Quebec, on 28 February 1961, Simard grew up as the son of a choirmaster on the Îsle d'Orléans. His initial break came when he won first prize on a CFTM Television program in Montreal called *Les Couverts de Jen Rouger*. Impresario Guy Cloutier took notice of the young phenomenon and transformed him, as a soprano, into an international star. Simard appeared at Place D'Armes in 1971 and was instantly the toast of Quebec. He also succeeded with recordings such as AVE MARIA, L'OISEAU, and EN ENFANT COMME LES AUTRES, all of which were created through Cloutier's production company. Like Dion eight years later, Simard represented Canada in Tokyo, where he captured first prize for performance and won the Frank Sinatra Trophy, an award which was presented to him by Frank Sinatra himself. Soon acclaimed in Japan and in France — he debuted at

the Olympia in Paris in 1975 — Simard made the leap to English-speaking music to develop his career in the United States and in other international markets. In this he was extremely successful.

Soon he was appearing on the American television networks with such established artists as Liza Minnelli, Andy Williams, Bing Crosby, and Bob Hope. Simard also performed with Liberace in Las Vegas and toured with him in 1977. That year was a busy one for Simard, by then 16, who returned to Quebec to perform in a large number of towns in his home province, as well as to begin hosting a CBC English-language television variety series produced in Vancouver, The René Simard Show. To maintain his popularity as his voice changed, he relied on a repertoire of sentimental ballads, disco tunes, and rock melodies designed to appeal to a broadly based audience of all ages. Among his wellknown songs of the period were Ma mere est un ange, a tune composed by his brother Régis, Le dimanche aprés-midi (1974), Maman, laisse-moi sortir ce soir (1975), Bébé bleu (1975), Fernando (1976), Bienvenue at Montréal (the theme song for the 1976 Montreal Olympics), Never Know The Reason Why (1977), and You're My Everything (1978). Always physically appealing, the 1970s saw him appear in a documentary film, En enfant comme les autres in 1972 and René Simard au Japon in 1974.

Abandoning his teenage image at the beginning of the 1980s, about the time Dion was preparing to replace him as a child star, and preceding her as a Quebec entertainer with a connection to Walt Disney, Simard took on a rock look, described in some circles as intentionally seductive. Teaming up with his sister, Nathalie, he was the host for two live television programs from Disneyworld in Florida and Disneyland in California. Among other achievements that decade, he participated in Jerry Lewis' Muscular Dystrophy Telethon from Las Vegas, hosted *RSVP* at Télé-Métropole in 1984-85, as well as another CBC-TV program, *Laser 33-45*, where he promoted music in the French language. He recorded *Tourne la page* with his sister Nathalie in 1987, a song which demonstrated

40

the child René Simard had now grown up.

After the departure of Ginette Reno from his management, René Angélil was ready to apply his faith in the future and his instinct to gamble on the career of another young singer, especially one who shared his vision of the future and his willingness to takes risks. Indeed, the decision to approach Angélil was somewhat of a gamble, as Celine explains: "We found his name on a record cover after which I waited and hoped. And then it all happened. It's been a dream ever since, a fairy tale."

The two somewhat related personalities of Angélil and Dion, equally matched in drive, ambition, and their hunger for the good life, met in his office the day after he asked to see her. At the time she was described as shy and skinny, still in possession of conspicuously long incisors.

"You wouldn't say she was a cute child," Angélil recalls. "But she had these incredible brown eyes. I asked her to pretend she was in front of 2,000 people. When I handed her a pen to use as a microphone, she closed her eyes and she was there. I had goose bumps listening to that voice, so full of feeling, and older than her years. I have believed in Celine ever since I heard that song (*It Was Just A Dream*)." The song, the one composed by her family and recorded in the basement, still often appears in Dion's concert repertoire.

Both Celine Dion and René Angélil were building their respective dreams on an appreciation for American culture which would define, almost from the outset, the direction they took in bringing her to the international stage. Both of them shared an ambition to succeed based on an American model; that is, they had an optimistic faith in a materially successful future generally and the courage to gamble in the entertainment business specifically. No innate Canadian conservatism was going to hold them back. What made the union so successful had more to do with cultural influences than with Quebec's receptiveness to child stars and the

fact Angélil was the right choice to take responsibility for Dion's career, given his experience with Ginette Reno and René Simard.

There are, of course, other personality traits Dion and Angélil share — they are both known to be mischievous and fond of practical jokes. Both dream of the fruits of the good life. Both are generous. But these shared traits, although they might create a successful working relationship and even, ultimately, a happy marriage, could not guarantee that Dion would succeed musically beyond the boundaries of Quebec or France. The driving force propelling Dion's career in an international direction was Quebec's cultural appreciation for the imposing entertainment giant, the United States, looming along the province's southern border. As Dominique Demers observed in a profile of Dion in L'Actualité in August 1989, "She has the voice of Ginette Reno, the waistline of Marjo. And she is American to the backbone: she finds Paris a little grey, and Los Angeles as beautiful as a paradise. Long before her recent revival, in her days of angelic dresses and hymns to doves, she flipped over Michael Jackson and dreamt of dethroning Whitney Houston." As Hélène de Billy put it in L'Actualité in June 1993, "Le mot de passe dans l'univers Dion-Angélil n'est pas mode ou beauté, main bien rêve. Celine Dion en particulier voit sa vie en cinémascope. Se promener en limousine a Hollywood, manger à la table de Michael Jackson ou encore chanter devant le prince Charles et la princesse Diana, voilà de quoi est tissé ce rêve a la Walt Disney. C'est un truc d'enfant qu'elle traîne avec elle depuis toujours, à côté de ses 14 poupées et de la photo de sa future robe de mariée." As Dion herself admitted in Châtelaine, "Je suis très americanisée." In other words, Dion and her husband have shared almost from the beginning a love and admiration for the spoils of musical success, as it applies to a Walt Disney image of the universe.

The appeal of this American dream to Quebeckers also explains how, over the years, Dion has become a cultural icon as she gradually approached pop diva superstardom. Because her Quebec audience could measure its own potential for success through Dion's achievements, combined with her refusal to forsake her Quebec roots to achieve international success, Dion became a measuring stick to Quebeckers of what is possible, if one has the talent and the drive to succeed. Celine Dion has reinforced the notion that the lavish American definition of success that they culturally respected was not a myth. It was real. Celine Dion was the proof of that.

This belief in the American dream becomes culturally poignant when the reactions of "old" France and "new" France are compared. Almost from the beginning, Quebec audiences save for a brief backlash when Dion switched to English, a backlash which ended when she continued to record in French — appreciated Dion's achievements. France, where Dion had so much initial success, had to be treated differently. Where American culture is concerned, it is well known that the people of France generally view this culture with a jaundiced eye. So it is not surprising to note that only recently has Dion been promoted there as an international pop diva. Rather astutely, Sony has marketed Dion's music to her audience in France as the music of a chanteuse. The switch to acknowledging her as a pop diva came only after marketing representatives at Sony determined it would not aggravate France's impatience with the Americanism implied in any pop diva persona. As Olivier Monfort, head of Sony in France, pointed out in a January 1997 article in the French-language Châtelaine by Michel Dolbec, noting that her international stardom in the English language was presented as a secondary aspect of Sony's marketing plan, "On voulu créer une dimension de proximité en faisant en sorte que Celine soit tres présente en France. . . . C'est un élément qui permet de donner du rêve en plus. Nous avons repositionné Celine pour que les Français la considerent d'abord et avant tout comme leur vedette à eaux, et pas comme une diva pour qui la France n'est qu'un pays parmi d'autres."

There is a bit of a myth, especially believed by English-speaking Canadians, that Quebec artists inevitably do well when they

are presented to audiences in France. Despite Ginette Reno's success in Quebec, Canada, and elsewhere, she never did become a superstar in France. As Larry LeBlanc points out, "France is not readily open to Quebec performers. There's been very few breakthrough Quebec artists in France, Roch Voisine being the best known. Before that, there was the odd one like Charlebois, but for the most part Quebec performers have not done well in France." It is a tribute to Dion's musical achievements, and perhaps some canny marketing, that she has been able to maintain into adulthood her outstanding success in France, first achieved as a child, in spite of this country's tendency to shun international pop divas.

With the cultural match nearly as perfect as the personality match, both Dion and Angélil, from the very beginning, were poised to gamble it all on Celine's potential as an international star. Both knew exactly how they wanted their lives to transpire and both had the ambition and faith to pursue the opportunities Dion's magnificent voice presented. The fact they did so in such a complementary fashion — exploiting Angélil's experience and Dion's unmistakable talent — indicates both of them apparently believed from the outset that they could ultimately achieve their personal and culturally-inspired goals. And Celine, if not René, believed that all this was predestined, tempered with a willingness to work hard. "You can have the biggest talent in the world," Dion has commented, "but if you don't have the team and the timing — because I believe in destiny — to be there at the right time with the right song, it just won't happen."

After Angélil heard the 12-year-old perform in his office, events began to happen quickly. The impresario made it quite plain he was willing to invest his all to provide a successful career for the prodigious performer. What was interesting as well was that Dion had not had one speck of vocal training up to that point. Angélil determined this was a situation to be rectified right away. At his insistence, she was soon taking voice lessons from vocal coach Cécile Jalbert. While Dion was encouraged to study music

vocally, Angélil dropped his law studies at that point to work on the development of her career. And he mortgaged his house to finance the recording of her first two albums himself, under his own label, TBS. As a result two albums were released at the same time, LA VOIX DU BON DIEU and CELINE DION CHANTE NOËL.

"Now again it's a remarkable story in two parts," explains Martin Melhuish. "Not only for Celine at this point, but also for René who has been dealing primarily in the French market, in France and in Europe and Quebec. Suddenly he has to start looking globally or start thinking globally, as Celine gets bigger and bigger in Quebec. So obviously there was somebody there who had a plan. I always have a great deal of respect for managers who take an act and put their lives on the line with that act. It either works or it fails. It works or you both fail." Melhuish cites Angélil's decision to mortgage his house to raise funds for Dion's career as an almost ultimate act of commitment to the artist. "This was total belief on his part. This was something, is something, when people hear about it, not a lot of them can relate to. Usually people mortgage for something specific, but when you mortgage your house for something that's in the entertainment business, you're taking the ultimate chance. Because of the failure rate. So, again, it's just another indication of the type of belief that went into the whole thing. And, as it turns out, the love that went into it. Their partnership, their relationship, just became very natural. And moved on through the years. Of course, they got married."

Nor was mortgaging his house the only provocative way Angélil demonstrated his complete support for the young vocalist. He also made use of his connections to convince others in the music business of Celine's promising future. He contacted songwriter Eddy Marnay in France to do the lyrics for la voix du bon dieu, just one of the steps he took to ensure that Dion's debut had every opportunity for success. Angélil began to promote live appearances for Dion as well.

It was at just such an event that Billboard's Larry LeBlanc first

encountered her. "I saw her when she was 13," he recalls. "It was 1981, I think. She did one of the galas. And galas are something like — it's political — and you maneuver and you sing for people and you're on stage with nine or ten other acts. I just remember her as a novelty because she was so young." He also remembers that she was very poised, quite dressed up, and, in that way, attractive. Most of all, she had "interesting pipes. Quite frankly you were looking at the Quebec market at that time which had a history of young performers. So you kind of went 'huh.' And then over the years, I would see her on Quebec tv and see her on a couple of things here. And when I was in Quebec I saw her records which René produced — I think his company is called Good Feeling Productions; they've done a compilation of all the stuff recently that's out there now — but they weren't great. I mean they were okay, but they were like overly sentimental slush. Which is popular in Quebec, but stylistically it's a bit dated and also goes back to another era of pop music, the '50s and '60s, I guess. Over the top pop music. It stayed popular longer in Europe than it did in the rest of Canada and the United States."

Although many believe her rise in Quebec as an entertainer was meteoric, that she conquered the musical sensibilities of her home province right away, other music pundits say such was not the case. It took success elsewhere in the world for Quebec radio stations to give Dion's records the kind of airplay required to make her a star. "She's considered an established star here today," Jean-Claude Aubin of Trans Canada Records told *Canadian Press* as far back as March 1984. "French people love those kinds of songs. When she'll want to sing in English, she'll have to change her style." But Aubin pointed out that the Montreal-based record company invested \$1.5 million in the young singer in 1981 only to come up against a resistance on the part of Quebec radio stations who considered her an obscure vocalist whose songs "would delight an old folks' meeting."

In 1983, success came with her album D'AMOUR ET D'AMITIE,

which sold more than 700,000 copies in France and earned her the coveted Disque d'Or award, a first for a Canadian singer. At that point, Quebec radio stations had a change of heart and her popularity in Quebec soared. Even so, when the time came for Celine Dion to grow up and present an adult image to Quebec, she would carefully consider the potential for resistance in her home province. "At the beginning of my career, I was always regarded as a little child," she recalled in 1989. "I sang mostly ballads, which I still love, but my audience was mostly children and very old people. It was always very difficult for me to get my records played on the major pop stations. Which is part of the reason I decided to change my look and style."

Almost from the beginning, Dion juggled a daunting schedule of performances, interviews, and photo shoots. Early on she began to demonstrate the hard work and energy she was willing to put into her career. Recording, performing, and promoting her musical output had to be co-ordinated with piano lessons and the necessary time she had to spend in school. Where her education was concerned, she had to decide the best way in which to approach it. At 15, she gave up traditional school in favor of private tutoring which could be squeezed into her hectic schedule. School was also "taking me away from music, from my happiness from my dreams," Dion has remarked. The lack of a typical school life, however, had the effect of robbing her of a normal childhood and adolescence. "Kids today," she told Time Magazine in 1994, "want to go out and go to clubs and have a drink and try to smoke and have boyfriends. Since I wanted to be onstage, I had to go to bed early. You can't have everything. You have to make a choice." Dion professes to have no regrets about her youthful choices. If she had to rise early to rehearse or to study video cassettes of herself in action, aspects of maintaining her career, well that was simply the way it would have to be. As she told Canadian Press, "I want to be a star by 30. I'd like to stage a musical comedy with my family, give my brothers and sisters a chance to act out their fantasies."

And, eventually, the hard feelings caused by her teeth were dealt with as well. As Canadian Press reported it, "Front teeth were the issue when she was 13. When she appeared on stage, clutching a microphone, her long brown hair caught in a pony tail, she always made sure not to smile. But her prominent canines quickly became a Quebec showbiz joke. Celine Dion, one of the province's most acclaimed singers, was known as the kid with vampire fangs." As Dion puts it, "I used to cover my mouth with my hand on stage. No, seriously, it was a big problem then, with my public, with photographers. I would listen to some comedian making fun of my teeth on television and I used to cry." By 1984, the teeth were being adjusted with the help of braces and ultimately caps would also help to eliminate the problem. "Many 15-year-old girls have to fix their teeth," her mother explained unapologetically as she chaperoned her daughter through a hectic entertainer's schedule. "But for Celine it was a real problem, all these people laughing at her. You know how young girls are."

While Dion was dealing with more normal teenaged concerns like her teeth, she was nonetheless beginning to have an extremely successful career. Among the early highlights was the decision in France of the Pathé-Marconi record company in 1982 to support her career, leading to the successful release of her album TELLE-MENT J'AI D'AMOUR POUR TOI, which not only resulted in the Disque d'Or award from France, but also brought her a Canadian gold record for sales of more than 50,000 copies. At the same time, also in 1982, Dion was one of 30 successful artists, out of approximately 2,000 contestants, to win an opportunity to participate in the Tokyo Festival. She entered with *Tellement j'ai d'amour pour toi*, winning the Best Artist prize and the Gold Medal For Best Song.

Nor did the young Dion stop there. Maintaining her hectic schedule, her mother Thérèse always in tow as her chaperone, the young Celine began to rack up Felix awards in Quebec in 1983, including Album of the Year-Popular, Female Artist of the Year, Best New Artist of the Year, and Most Successful Artist Outside

Quebec. Her star continued to brighten as she appeared on television, namely on the CBC's *Les Beaux Dimanches*, and also in 1983, after representing Canada in the New Artist of the Year category at the MIDEM in Cannes, she appeared on the well-known French program *Champs Élysées*.

Two more albums came out in 1983, LES CHEMINS DE MA MAI-SON and CHANTS ET CONTES DE NOËL. A reception was held at Montreal's Bonaventure Hotel to celebrate the release of LES CHEMINS. She performed several songs from the album on that occasion, describing the recording as her favorite "because it comes closest to the real me." As for outstanding live performances during this period of 1983 and 1984, she played for six straight weeks, opening for Patrick Sébastien at Paris' famed Olympia, the hall where Edith Piaf had performed, a hallowed venue often described as the location where all French-speaking singers dream of performing. Back in Quebec, the young Dion performed with the Orchestre métropolitain at Place D'Armes, did a recital tour of the province of Quebec, and appeared, July 28 and 29, 1984 before 40,000 at the Old Port in Quebec City. This performance inspired the Quebec clergy to select her to represent young people during the Pope's visit that year and, accordingly, she sang in Montreal's Olympic Stadium in front of 65,000 youngsters and the Pope. She received a rosary from the Pontiff after the performance.

Her increasing popularity and heavy exposure not only made her a star in Quebec and in France, but most music critics agree it tended to prepare her for the international superstardom she enjoys today, serving as a grueling training ground that gives her advantages over such current pop diva competition as Whitney Houston and Mariah Carey. As Larry LeBlanc points out, "I think the thing about her that puts her a cut above Whitney Houston and Mariah Carey, certainly among any of the modern performers, is, one, she's been in training for this since she was a small child. Don't forget, when you think about it, by the time she arrived to do her first English album here, which is eight years after

she started, she was twenty-one, twenty-two, when she recorded that album. That's eight, nine years of appearing on all those Quebec tv shows, interviews. She was a very poised performer. She was quite poised at thirteen when I saw her back then, but to have eight or nine years experience . . . "

Still, not all reaction to Celine Dion's successes during that period was positive. The focus of the ambivalence some Quebeckers felt towards her and, to a lesser extent, Dion even felt herself, seems to be her appearance before Pope John Paul II. While members of her family describe it as one of the highlights of her career, at least in confirming their commitment to traditional Catholic and Quebec values, detractors saw the Dion's performance as a symbol of the old Quebec. Certainly, Celine's mother remembers as one of the highlights of her daughter's career an audience with the Pope in Rome not long afterwards. But now that nationalist fervor was rising in Quebec, many expressed embarrassment about the traditions the performance represented. The seeds were gradually being sown for Dion herself to wonder how far she could go in her career, imprisoned the way she was in the innocent guise of a traditional child performer.

As Konrad Yakabuski describes this response, "All Quebeckers remember the homely adolescent who, only a few years ago, was the subject of cruel jokes and scathing ridicule in her native province. As the youngest of 14 children born to high-school dropouts Thérèse and Adhémar Dion in tiny Charlemagne, Ms. Dion represented a parochial past that Quebeckers had long ago rejected." Noting that some Quebec analysts believed intellectual Quebeckers of the Quiet Revolution were ashamed of this past, he wrote, "Ms. Dion, with her double-digit, Roman Catholic family, suffered the brunt of their shame and rejection. Her kitschy hymns to John Paul II, during his 1984 Canadian papal visit, prompted sneers in post-Quiet Revolution cultural circles and were parodied for years by Quebec humorists. Quebec's leading humor magazine of the 1980s, *Croc*, took to calling the gangly

adolescent 'Canine Dion.' In her public appearances with 'Maman' Dion hovering over her, she gushed about wanting to be the 'biggest star in the world.' Quebeckers snickered." As Jean-Marc Léger confirms, "She wasn't simply perceived as *kétaine* [tacky, hickish], she *was kétaine*."

Despite the spin the Quebec intellectuals were putting on her parochial appeal, Celine Dion's career was moving ahead steadily and internationally. The groundwork was being laid for her transition from a girl to a woman, from child star to pop diva. This new Celine Dion would be the mature and even sensuous performer required to transport her accomplished voice to an extremely enthusiastic world. Not only was Dion building an admiring following in Quebec and in France, she was gaining the vital experience needed to make her, not only a poised performer, but gain her an advantage over her diva competition. Most of all, she and René Angélil were learning about the various cultural factors with which they would need to grapple, if they were to realize their joint dream of making Celine Dion an international star.

The irony is that when all the cultural backlashes were survived and eagerly forgotten, the Celine Dion who was selling millions of albums worldwide would become the darling of the same intellectuals who had disparaged her as a child. They would give way in their harsh criticism of the child star as a throwback to a parochial Quebec. In place of this opinion, they would begin to view Celine Dion as a symbol of a new Quebec and present her as a gauge of Quebec's new potential as a sovereign nation in a receptive international community. Although this transition of opinion would suffer some occasional bumps and hiccups, Quebec's nationalists would embrace her achievements and try to make them their own.

Widening the **O**rbit

They actually thought I was an abused child! Can you believe it? So they sent social workers to our house, where they smelled my mother's cooking, saw all the musical instruments and heard us all singing, then they knew how much happiness there was. — Celine Dion

If Celine was going to become a great artist and not just another minor one who grew up, she had to stop completely in order to allow the image that she had to fade. There was risk in changing her image, but it wasn't all that great because I knew how talented she was. — René Angélil

If Celine Dion possessed a prodigious gift for singing when she was extremely young, it perhaps had more of an impact on her life that she also possessed an exceptionally clear vision of what she wanted to achieve. She wanted, from the outset, to become a musical star. Not only did the one-track nature of her ambition include an inherent faith in her ability, but this strong sense of purpose did much to help her accommodate the unusual lifestyle stresses attached to being a teenage music star. A child without her faith and drive, without such a clear, even inflexible goal, can be less accepting of the cost of such an ambition. When barely

adolescent, people bathed in fame and riches sometimes crack under the strain of a lifestyle so radically different from their more typical peers. But Dion not only accepted willingly the high cost and hard work connected to seeking international fame, she even took it in stride. Deprived of the normal experiences young people growing up usually enjoy, she has never expressed any significant regret at what she gave up to create a successful career. Instead, with a careless shrug of the shoulders, she has admitted that this is the price one has to pay. Talent, vision, and drive, Dion demonstrated all of these qualities early.

Celine Dion has always accepted with aplomb the side-effects of living a sheltered life. A child at the time she turned the guidance of her career over to René Angélil, she spent the next few years being chaperoned by her mother, from event to event, while she performed, recorded, and received awards. By the time she decided to interrupt her career briefly as an adolescent, then return to the musical forum as an adult, she was accustomed to being protected and managed. Even when the time came for her to marry, she did so within the enclosed cocoon of her career; it was hardly surprising at all that she should marry her mentor and manager, René Angélil.

For Celine Dion, it is difficult to imagine that she considers anything to be missing in her life. Possessing an almost Disneyesque vision of the world, she is comfortable devoting everything to her career. This precocious ambition has defined her life. Virtually from the beginning, she has remained happy to live within the shelter of her career. Dion's singlemindedness explains how some of the most commonplace of activities have at times eluded her. She once noted, "I have never checked into a room myself. I don't know how to even order room service." Another time she explained, "I probably missed out on a lot of things, going out and having boyfriends, trying cigarettes and getting drunk. But because I don't know those things, I don't miss them." She was willing to endure this difference. This kind of broad

acceptance of the price of fame and success even applies to her view of privacy. "I've always said to myself, 'In life you cannot have everything.' I want to be a singer, to perform on stage, to have all my shows sold out. You cannot ask for all that and ask for privacy." As celebrity interviewer Brian Linehan once noted, "She has been alarmingly trained. Still, that's not unusual in a celebrity world where Elizabeth Taylor has never been inside a supermarket."

This may explain why she seems so natural, so apparently devoid of the pretense and artifice that all too often accompanies a successful career in music. It may also explain why there is often a child-like character to the woman who has now become an international superstar. And why first school then music authorities have found this quality of character perplexing. As Nicolas Jennings reported in TV Times Magazine a few years ago, "Dion developed an intense, single-track focus that, at one time, prompted concern from local authorities." As Celine recalls, "Every day, I couldn't wait to get home from school. I didn't want to play with the other kids. Then one day, the school sent a letter to my mother saying, 'We think Celine has a problem.' They actually thought I was an abused child! Can you believe it? So they sent social workers to our house, where they smelled my mother's cooking, saw all the musical instruments and heard us all singing, then they knew how much happiness there was." And as Konrad Yakabuski has commented, "wittingly or not, Ms. Dion cultivates this 'little girl' persona. It is there on the FALLING INTO YOU album cover, as she tugs mischievously on her T-shirt to expose her navel. It was there when, in a video broadcast at last year's Félix awards in Quebec, she addressed her fans with a large, stuffed toy in the background."

Loving music and music only, from the time she was a young child, it was inevitable Celine Dion would come up against a conventional world which, even if it can recognize extraordinary talent or prodigious ambition, succumbs to a tendency to want to interfere in it. Calling on speculative published articles in France to briefly examine the question of Dion's apparent innocence, Konrad Yakabuski observes, "One must look outside Quebec to find any press on her that does not border on the obsequious. It was the Paris-based gossip rags that first dared to print that the waif-like Ms. Dion was suffering from anorexia nervosa. The rumor gained little currency in Quebec, where even the gossip mags paint her as a secular Mother Teresa. Her relationship with her husband, Mr. Angélil, the impresario who has masterfully executed her transformation from the hokey character out of *Hymn Sing* into a sexy, sultry star, also appears to be off limits in the Quebec media. This is not the case in France."

Celine Dion's career, marked by three major turning points — her meeting with Angélil when she was 12, their decision to abandon her child star persona a few years later, and her decision to break into the English-speaking music market — have all revealed that her single ambition has been to be a star, regardless of the price. And if there was a cold strategy to be applied to reaching her objective, that too was part of the means justifying the end.

Indeed, Dion is so accepting of the price of ambition that it ceases to be a price at all. She has done exactly what she has wanted to do. It is only those of us with an affection for normalcy who tend to have difficulty understanding how such a desire can remain so strong, so exclusive. Or maybe, outside the arena of the drive and the talent, normal sensibilities still remain. Martin Melhuish believes this is the case. "I recall this image of Celine sitting on the bed, gossiping on the phone with one of her friends. Somebody did a documentary on her — maybe a piece for Newsworld her going back home, before the wedding to René, and it sounded like she was gossiping with a friend about boyfriends, you know the typical young woman doing her thing. And it was a revelation to see her in action behind the scenes with her family and the whole thing. First of all, it struck me just how normal a person she was. She just happened to have some fame and this talent." That talent led her to record nine remarkable albums in three years in

the 1980s — remarkable for their quality and for the fact she did so as a juvenile.

"The period between 1982 and 1985 saw Celine churn out no fewer than nine albums (seven in Quebec, two in France), all of which married her 'voix exceptionnelle' to an engagingly juvenile and wholesome image," notes Karen B. Faulkner in a review of her work during this period in Record Collector. "Admittedly, at face value, these early recordings (essentially a seamless series of neatly packaged, highly-melodic MOR) are probably a little too demure and provincial to appeal to today's cosmopolitan 'Célinite,' as they lacked the biting emotional edge of her later work. What does make them worthwhile, however, is the way they collectively chart Dion's early vocal development. Certainly, delivery-wise, there's no mistaking the speedy progression. Both TELLEMENT J'AI D'AMOUR (1982) and LES CHEMINS DE MA MAISON (1983) instantly demonstrated a finesse and ardor not evident on her debut discs. And by 1984 her accelerating maturity was clearly starting to translate into more sensitive and instinctive interpretations, best exemplified by songs like Melanie, Chante-Moi and Trois Heures Vingt. Not surprisingly, the tracks which stand out from this threeyear period were issued as singles. Of these, Tellement J'ai D'Amour Pour Toi — submitted by Pascal as the French entry for the 1982 Yamaha World Song Festival in Tokyo — actually saw Dion collect her first industry award. Meanwhile, after a little astute marketing, D'AMOUR OU D'AMITIÉ sold well in France, establishing Dion as the first Canadian ever to go gold there."

Dion began to collect Felix Awards in Quebec with a breathtaking rapidity. In 1985, she won five, defeating Montreal rocker Corey Hart who had only four, when Hart himself was distinctly on the rise as an international performer. Dion, then 17, was named female artist of the year and also won for the most popular song of the year — *La Colombe (The Dove)* — the song she had sung the previous September for Pope John Paul II. Dion also took home Felixes for most popular album and for album of the year for MELANIE, as well as winning best-selling single for the song of the same name.

But it was becoming clear that Dion could not cling to the child in the star much longer. Not only was she going to have to grow up in a literal sense, but she was going to have to grow up in a musical sense as well. Looming on the horizon was a year's hiatus away from her career in which she would artfully work on the transition of child to woman. Once that was accomplished, she would re-emerge as a new kind of musical star. There were a number of reasons that Dion and Angélil thought it was time to make a change in her image. Among them was the sense that her career as a child star had evolved as far as it could go in Quebec. Even more importantly, it seemed the child star was not yet able to break into the music market in France in any permanent or meaningful way.

"By the end of 1985, however, the reality of being Quebec's leading attraction began to take its toll," Karen B. Faulkner observes. "Caught up in the trappings and gruelling work-ethics of an adult world since the age of 12, Dion had had no chance to grow, to enjoy a normal, identity-shaping adolescence. So, at age 17, tired of her 'child-star' persona and determined to make up for lost ground, she temporarily withdrew from the spotlight, a move which prompted a spate of damage-limitation exercises from her record companies. Keen to keep her name afloat in Quebec, the TBS label prudently resorted to a retrospective album, LES CHANSONS EN OR, which included the previously unreleased Fais ce que tu voudras. Over in France, meanwhile, the folks at Pathe — obviously less affected by the hiatus — simply stuck to 45s, issuing material from earlier Paris recording sessions." Although in the overall scheme of things, Dion's transition from child star to adult star seems like the middle component of a

strategy aimed at breaking her into the English market, the most immediate reason for the hiatus in her career was the ambivalence of the record market in France towards her child product. As Faulkner notes, "accolades aside, though, at this stage in the game Dion seemed unable to sustain any real hold over the French, and their response to her product was ambivalent. Some releases like D'Amour . . . went down a storm, while others merely fizzed and died. Even a barrage of exhaustive promotional sessions, backed by a series of live performances supporting singer-comedian Patrick Sebastian, failed to produce a French surrender. In stark contrast, back home in Quebec, Dion couldn't put a foot wrong. Her songs increasingly monopolized the airwayes, her discs the charts, and her live shows the box office. In fact, since the only means of capitalizing on her recording successes was literally to 'circulate', much of the teenager's interstudio time now had to be spent touring, an obligation which (happily) put paid to any hope of conventional schooling."

Breaking into the market in France was indeed difficult for reasons Larry LeBlanc explains. "Dion had tried breaking over there. She toured over there and had been over there with her earlier records. She was using French writers. That was the big thing with the pop performers in Quebec in the '70s — if you didn't write your material, you quite often used French songwriters because you were trying to get into France to make connections. And that's what she did. She did so a couple of different times. It simply didn't work. It hasn't worked with a lot of performers, but you try any kind of connection through publishers. Publishers in France have quite a bit of control so she was trying to go through that route."

The contrasting popularity in Quebec with the apparent ambivalence in France made the transition period a bit of a gamble. At risk, of course, was a failure to attract the market in France after the transition and the possible, but unlikely, loss of the Quebec market afterwards. But Angélil was a gambler who believed in his

client. And, whether or not one believes his ultimate goal included English-language stardom or not, rising to the occasion of the transition gamble served as a tremendous dress-rehearsal for the larger gamble yet to come — her venturing into the English-speaking market and its potential for alienating her loyal French audience.

"Two years ago, I suggested to Celine that she stop because things could only go down hill," Angélil told *Music Scene's* François Blain in 1989. "She had no further challenges with the exception of France. If Celine was going to become a great artist and not just another minor one who grew up, she had to stop completely in order to allow the image that she had to fade. There was risk in changing her image, but it wasn't all that great because I knew how talented she was. The public wasn't aware of it, but I knew she can sing the blues, or swing, that she can dance or perform comedy."

The question became, how best to sweep out the old and bring in the new. The decision was reached that Dion would take a 12-to-18 month hiatus from performing, not only giving her time to develop a new look, but also to provide for dancing lessons and a different approach to her musical material. There would be a chic new wardrobe, a different hairstyle, and a somewhat slimmed down appearance. And while all of this was going on, René Angélil was in search of a new major label to record this *new* Celine Dion, one that could reflect the new sound and the new look, then be a partner in her career development.

Dion signed with Sony (then CBS). "I thought the best company would be that of Barbra Streisand, Michael Jackson, Bruce Springsteen and Julio Iglesias," said Angélil. Larry LeBlanc concurs that it was at least fortuitous that Dion signed with Barbra Streisand's label, Streisand being such an influence on her career. In fact, in the wake of the release of Dion's ninth French-language album, INCOGNITO, critics had begun to see strange similarities between the emerging star and the reigning diva. Said François Blain of

Music Scene, "Critics were comparing her strong, soaring voice to Barbra Streisand, whom Celine has admired for years and hopes one day to follow into acting and musical comedy. In one segment of the show she performed recently at Montreal's Theatre St. Denis (for 40 nights to 2,400 people), she paid tribute to Streisand by singing *The Way We Were* — not in her own voice, but with a flawless imitation of Streisand's." And in English, no less.

But if her signing with CBS sounded easy, it was not. CBS wanted some indication of Dion's potential for broader appeal. Again, the young star had to rise to the occasion. One such occasion was the 1987 Juno Awards where English-speaking executives had the opportunity to hear her perform — and perform in English. "We'd heard her sing in French," was the way Kim Zayac, a national sales director with the label put it, "but we were a bunch of Anglos, right? We kind of went, yeah, nice, but I don't get the words. And then she came out at the Juno Awards that year and did this song by Aldo Nova called *Just Have A Heart* and blew everybody away. There was not a piece of flesh in the audience that did not have goose bumps on it."

While Dion and Angélil were adroitly moving ever closer to a mandatory launching of the young star in the English language, the problem with ambivalence in France continued. Although INCOGNITO was a radical departure from what the child star had accomplished previously, the album did little to change attitudes in France and elsewhere in Europe. As Karen B. Faulkner explains, INCOGNITO captured Dion in a progressive mood. "Awash with driving rhythms, silky sax and aggressive vocals, it signalled a conscious shift away from the full-time balladeering of her teens and into the riskier, more challenging dynamics of mainstream pop. Indeed, with tracks such as *Jours de fievre* and *Délivre-moi* bursting with an urgency, punch and self-assurance so characteristic of today's Dion sound, there's no doubt that this disc instantly propelled her into an altogether different orbit. But would her fans follow? Surprisingly, the fact that this new remixed and

remodelled Celine had little in common — apart from that distinctive voice — with the previous version, had no real untoward effect on her popularity [in Quebec]. Both the album and a plethora of spin-off singles sold abundantly. And when 42 consecutive support shows in Montreal sold out in advance [the Theatre St. Denis shows], it became clear that Dion had merely picked up where she'd left off — on top."

It wasn't truly surprising that she would enjoy this kind of success in her home province where the new image could not deter a loyal audience. "Beyond the closed world of Quebec, however, the story was somewhat less convincing. Given the ongoing French indifference to much of her output, Dion was still struggling to maintain interest there, let alone spark it elsewhere. Indeed, despite a handful of pilot 45s having been issued in Europe during the early '80s (including incidentally one intriguing German-language coupling), little real headway had been made. And with Sony's Euro-subsidiary, Carrere, itself now reluctant to release much more than the odd market-tester single, there seemed little immediate hope of exploiting the company's international market potential," Faulkner recounts.

At that point, at least some of Angélil's gamble had paid off. The new image had not interrupted her success one iota in Quebec, in fact had only served to solidify it. As well, the officials at CBS had been stunned by her appearance at the Junos and were convinced they could work with her to enhance their market and her career. But the problem in Europe, particularly in France, had not been addressed by the image change. It was going to take something else to turn things around in France. That something else turned out to be the annual Eurovision competition in 1988 in Dublin, Ireland.

Dion and Angélil were approached, quite by surprise, by the Swiss songwriting team of Nella Marinetti and Attila Sereftug. They asked if she would perform their entry, representing Switzerland, for what is essentially Europe's Olympics of song contest. The song called *Ne partez pas sans moi* (*Don't Leave Without Me*) represented a wonderful opportunity for Dion. Although critics say the Eurovision competition isn't what it once was, some of the previous winners have done very well, groups like ABBA, solo performers such as Nana Mouskouri, Olivia Newton-John, and Julio Iglesias. The event is conducted very much like a sporting event, resembling the style of figure skating championships. After each singer performs, judges award them points. When Dion and a British competitor competed in the finals, Dion came out with the highest number of points. The victory turned out to be the key, not only to solidifying her reputation in France, but in opening new markets in other European countries.

"The night of the final, there were 600 million spectators around the world," Angélil recalls. "Even the Soviet Union and the Middle East joined the network for the telecast. The next day, Japan and Australia saw the show on tape; it's almost like the Olympics. For starters, we sold 300,000 copies of that 45 in Europe. More importantly, Celine became known everywhere in Europe as a great singer, a talented artist; it launched us into a world orbit somewhat earlier than expected. I'm convinced it saved us five years." As for Sony's French arm, Carrere, they instantly took advantage of Dion's new European popularity, quickly releasing a series of new singles they hoped would enhance her new European popularity.

When examining Dion and Angélil's courageous decision to gamble on reversing France's chilly response to Quebec by transforming Dion the girl into Dion the woman, it is rather ironic to note that Dion would be among those French-speaking Canadian artists acknowledged as leaders of this movement. As Brendan Kelly wrote for *Billboard* in 1992, in a story datelined Montreal, "the recent international successes of Celine Dion (a Top Ten record in the U.S.) and Roch Voisine (major stardom in Europe) have shaken up the music industry here, and the two artists' chart triumphs have sparked a renewed interest in attempting to break

local acts outside French Canada." Kelly quoted André Di Cesare, Roch Voisine's producer, as saying, "Now they listen to us. Europe is definitely more open to Quebec product. At least you can get the radio stations to listen to it, which is a change from a few years ago."

Billboard pointed out that Audiogram, "the most important label in Quebec," was currently working in partnership with the French record company FNAC Music to try to launch some of their acts in Europe. "FNAC, which owns a major chain of retail stores in France and Belgium, has already released albums by Montreal singer-actress Carole Laure and rocker Jean Leloup." With Dion and Voisine paving the way, Montreal singer-writer Luc de Larochellière became the first Quebecker to crack the Top 20 sales charts in France since Voisine. Reported Kelly, "Over the past few years, other French companies have also begun to take a more active interest in the Quebec marketplace. Virgin France now markets and distributes its French product in Canada using a local independent rather than Virgin Canada. The French label signed a two-year deal with Montreal-based Productions Pierre Tremblay / Disques Double last October and Tremblay's outfit now handles all but two of the French acts on the Virgin roster. This agreement was hailed as a victory for the thriving independent scene in Quebec, and confirmed that the European labels are hungry for a slice of the action here." Celine Dion's contribution to the Quebec music business takes on another dimension accordingly.

It is a matter of conjecture, in view of Angélil's feeling that the Eurovision victory had saved them five years, whether, had this opportunity not presented itself, there would have been a better time in the future to launch Dion into the English-language market so essential for international superstardom. It is also a matter of conjecture as to whether, had the launch been delayed a few additional years, Dion and Angélil would have approached the transformation — the necessary third phase of her career — in such an artful and conservative fashion, deliberately planning

each move. As a gamble with the mood of the Quebec fans, transforming Celine Dion from a child into a woman was one kind of risk. Transforming her into a English-speaking singer was a much more serious gamble. It did not matter that the time was ripe and that the transformation would have to take place at some point inevitably, if Dion was to scale the upper reaches of pop superstardom. What mattered was that it was a career move that had to be approached carefully because Quebec, by this time, was enjoying an ever-increasing nationalistic fervor. The province was more and more protective of its culture and language.

Dion feared there would be a backlash in Quebec when she switched to singing in English. In a Maclean's feature on Dion, E. Kaye Fulton relates that "around the time of UNISON's [the first English-language album] release, she had the same nightmare on six consecutive nights. In the dream, Dion said, she was on the ledge of a highrise, with police cruisers and ambulances swirling below her. As a police officer closed in to grab her, Dion recalled, she jumped and felt herself falling through the air. She awoke just before she was about to hit the ground." Some of Dion's anxiety might also have been caused by her limited ability to speak English. Any previous singing she had managed in English had been accomplished phonetically. In truth, she did not understand the lyrics and was only singing them as she thought they should sound. The answer, as far as she and Angélil were concerned, was a crash three-month Berlitz course in English, a rather intensive regime of daily classes. Nonetheless, the potential for disaster in English classes paled in significance to the possibility of a Quebec backlash over what some might interpret as her betrayal of her own language and culture.

As Martin Melhuish sees it, the short-term backlash was more of a protective reaction. "Back then," he says, "it was more of a reaction to losing one of their great stars. They thought, wrongly thought, that she was going to disappear. She proved that wrong. Because she's gone back all the time and continues to record in

French. She never abandoned it. As a matter of fact she went back and did that great album with one of the greatest contemporary lyric writers around, Luc Plamondon. She didn't forget where she came from. She didn't turn her back on the place. I think initially they thought maybe she would and she didn't. It's almost a moot point to them now." Melhuish, in fact, likens the brief backlash after her English-language recording to similar backlashes the rest of Canada displays when one of their artists achieves international stardom. There's a tendency to be over-protective, even resentful, in an analogous way, like the child who finally leaves the family nest. "It's a kid leaving the family and deciding to head out," he says. "She's never going to phone. We're never going to hear from her. And suddenly she says I'm just going on a trip, this is what I have to do. I'm coming home and I'm going to sing with you guys. I'll be home for dinner."

But Billboard's Larry LeBlanc recalls that it was more controversial at the time than we remember it now. "It was controversial at the time because you're looking at Celine going into English Canada, learning English at a time of the nationalistic rise of Quebec and the whole question of sovereignty. What I'm saying is even the fact that she sang in English was controversial. Quebec performers have either recorded in English or French, very rarely in both. Maybe back in the '50s and '60s they did with people like Pierre Lalonde and Ginette Reno, but it became increasingly controversial to do it in the '70s and '80s, certainly in the late '80s. To suggest or come out that you were going to go for the approval of the anglais in English, singing in English, that was a pretty brave decision. That was a real brave decision. I know several performers since then that want to do it and, quite frankly, they don't have the balls to do it. They're scared they could lose their audience base."

At the same time, LeBlanc admits Dion managed to overcome the controversy. "She survived it, but it was a lot of muscle and a lot of finesse, and essentially she got slapped down there repeatedly." LeBlanc cites the incident during the 1990 ADISQ (Felix) Awards when Dion turned down Best Anglophone Artist of the Year as an example of the "slapping." "I am Québécois," she said at that time, "and proud of it. You know, there are 46 categories and I was disqualified from 45 just because I sang in English. That was stupid and I don't regret what I did."

Part of the controversy as well included the nature of the Quebec music industry and its funding at the hands of the Quebec provincial government, then, as now, fiercely nationalistic. "They wouldn't let her put her English album up for Best Album of the Year," explains LeBlanc. "They created a new category for her, along the lines of Best Foreign Speaking Album or something by a Quebec artist. And she refused to take it. It became a joke among the writers down there, this 'Celine Dion Award', because no other performer could win it, it was hers. And it was intended as a slap in the face to her. It was Quebec's institution. The music industry there is quite different than the English industry. There, they are all small companies and management companies that manage the acts that run their own record companies. The artist, management, and record companies are all the same. Most in Quebec are backed by, or have been backed by, funding by the Quebec provincial government. None of these guys have a pot to piss in on their own, it's all government money, so you know, all of them were up in arms when she first recorded in English. Trust me on this, they were, they slapped her when they could. And, at the same time, she was really helped by the fact that Quebec's other biggest star at the time was making noises of doing the same thing. That's Roch Voisine. I firmly believe that if Roch hadn't done some recording in English — and he only did some recording, he didn't do his first English album until a little bit later — I think if Roch hadn't done that, I think Celine would have had a harder time with it, even though they finessed it. . . . I remember on one of the ADISQ awards they wouldn't — it was about four years ago — they wouldn't let Roch sing in English, his big hit. That was his slap. But when, in the market place, you have the king and queen of the industry singing in English, you start making allowances for them."

Voisine, for the record, is not originally from Quebec but from neighboring New Brunswick where he was born in 1963, a gifted athlete who intended to be a professional hockey player rather than a musician, until his ambition was interrupted by a serious knee injury when he was 18. Resorting to writing songs in his spare time, he attended the University of Ottawa where he studied for a degree in physiotherapy. Eventually albums such as ROCH VOISINE, HELENE, DOUBLE, and I'LL ALWAYS BE THERE rocketed the fluently bilingual singer and songwriter to international stardom. I'LL ALWAYS BE THERE, in 1993, was his first all-English album.

Regardless of the brief backlash against Dion's singing in English, it was soon apparent that Angélil had successfully gambled again. But while Martin Melhuish feels Dion was like a young adult leaving home for the first time, creating protective worries in her cultural parents (worries which were ameliorated by her return home to French-language recording), LeBlanc views her return to recording in French as at least partially motivated by shrewdness, notwithstanding his acknowledgment that her Quebec roots are part of her musical soul. "One of the smartest things she ever did was cutting that Plamondon album," he says.

Finesse it is exactly what Dion and Angélil did. In their quest for pop superstardom, they somehow emerged from the gauntlet of linguistic, cultural, and political conflict virtually unscathed. But it was going to take a little more time yet before Dion would enjoy the staggering success FALLING INTO YOU eventually assured her. There were still some astute moves to be made on the chess board of Celine Dion's career.

New Words, New Worlds to **C**onquer

When people make jokes in English, I laugh because I want to be nice. But sometimes I don't understand everything, or else I really want to say something but it doesn't come out as well as I want. — Celine Dion

On the second album I said, 'Well I have the choice to be afraid one more time and not be 100 per cent happy, or not be afraid and be part of this album.' This is my album. It's OK to say I feel like doing it my own way. — Celine Dion

With the Berlitz crash course in English now behind her, Celine Dion soon learned there was more to mastering a new language than merely taking a course. Becoming comfortable in English, she soon discovered, was going to take a great deal of practice, especially for someone so dedicated to a public life, with a heavy schedule of public commitments and performances. As Martin Melhuish has already pointed out, it takes a great deal of courage to bring a new language to interview programs and the intrusive, microscopic glare of television. "When people make jokes in English, I laugh because I want to be nice," Celine has admitted. "But sometimes I don't understand everything, or else I really

want to say something but it doesn't come out as well as I want. . . . I have to pretend I am a strong person. But really I am so afraid of making a mistake." As Dion began to make more and more media appearances outside of Quebec to promote her English-language career, much was made of the various faux pas that couldn't help but occur. Critics also noted a difference between her English and her French performance style, concerts in English seeming somewhat more contrived and less spontaneous than her more comfortable French concerts.

As late as 1992, E. Kaye Fulton observed that "the Quebec singer still encounters some difficulty with English-speaking interviewers and members of the industry. . . . In her native language, Dion is known for her passion, wit and a rollicking sense of humor. Her French material tends to be more substantial, with fewer songs about love and loss." Fulton noted the difference in live performances as well. "She sprinkles her French concerts with devastating impersonations of Streisand and (Michael) Jackson. The English concerts, by comparison, are frequently stilted by a rehearsed patter." Her rehearsed routines in English, though helpful in some interview situations, occasionally backfired. As Lyle Slack has reported, "On the set of Good Morning America, cohost Charlie Gibson jokingly asks about the lineup for the bathroom in a family with 14 kids. Dion doesn't get the joke and instead answers by launching into one of her set speeches about how loving and supportive her family has been. Dion has a number of these rehearsed bits. They are her shield against the world. Truth is, for all her outward self-confidence, Dion remains as shy today as when she walked into Angélil's office. . . . Around strangers, she will fall silent, letting Angélil do the talking."

And then there was the U.S. talk show on which Dion asked the host if her penchant for buying so many shoes was a *vice*. He suggested that *fetish* might be a more appropriate word. Even producer David Foster recounts an incident where a misunderstanding took place between himself and Dion because of her discomfort with English. When Foster, during a recording session, wished to express his satisfaction with her musical efforts that day, he told her, "That's bitchin." She immediately grew upset, unused to the meaning of the slang expression. In fact, she assumed Foster was cursing her, his way of criticizing her performance.

Even her September 1996 appearance on the *The Rosie O'Donnell Show* demonstrated, this time with a kind of American talk show slant, the focus on her English. But it also demonstrated that Dion had come a long way in mastering the language. After her performance of *It's All Coming Back To Me Now*, the studio audience gave Dion a standing ovation, an ovation O'Donnell noted was the first to take place on her program.

"I'm telling you, you have a heck of a crowd!" said Dion.

"And you have a heck of a voice!" said O'Donnell.

"Thank you."

"Celine Dion, that's incredible, I have to tell you. I have all of your CDs. Remember when I met you the first time and I kinda scared ya?" asked O'Donnell.

"Yes, yes. You spoke French to me."

After O'Donnell asked Dion if she wanted her to speak a little French, she did come up with a sentence or two. "You know what that means?" asked O'Donnell.

"Aah, yes."

"What does it mean?"

"Michelle, what are you doing? Are you watching tv? Why? I don't know."

At that point, the two performers exchanged the different approaches employed by people learning another language, in this case the tapes used to teach French in America and English to someone from Quebec. "What I did to learn English," explained Dion, "I didn't use those tapes. I went to school for two months, every day, nine to five, five days a week. I had a teacher and they only spoke English to me. I didn't understand nothing."

70

"Really, cause you speak really well!"

"Well, I'm trying to. Every day I learn new words, you know I'm getting there."

But if the difficulty of learning to speak English in interviews and to operate in a primarily English-oriented international recording industry was one thing, the problem of applying Dion's passionate, French-trained singing voice to English-language pop songs, which tend, generally speaking, towards more contrived material, was more pressing. In the years since Celine Dion has begun to record and perform in English, a debate has continued as to which body of work is superior, her French or her English. The debate applies as well to her live performances. Purists maintain her French work has more passion. New fans maintain she performs within the parameters of English pop with an ever-developing passion and zeal, as well as an accelerating gift for interpretation of the melody and English lyrics. Most feel, if she has not arrived at her destination with English material vet, it is simply a matter of time until she can apply the energy of her French material to the English material. As E. Kaye Fulton reports, for example, "Hugh Wyatt, pop music critic for the New York Daily News, describes her sound as 'natural and virtually pure.' But he and others contend that much of her English material is banal and overproduced. . . . Dion recorded UNISON when her command of spoken English was shaky, and she admits that she was intimidated by the reputations of her producers."

Larry LeBlanc maintains that part of the reason for the difference between her French and English material, especially on the first couple of English albums, is that Dion is still committed to her original French base of fans and, at the same time, that Quebec is quite literally part of her identity. "I firmly believe the 200,000 or 300,000 people who bought her albums in Quebec are probably more important than any other part of Celine's career. I think they're probably the most important fans in her life. I wouldn't be surprised if they aren't the ones she thinks of even

when she's cutting records. Certainly that's why she records the French albums, there's no question about that. I don't think she was served well on her first two English albums because her English wasn't good enough. She didn't know what the hell she was singing on the first album. If you really notice, on the first two albums, there's not much nuance in the voice. They're straight now don't get me wrong, there's the vocal acrobatics and all that there — but the first two albums didn't have the nuance you get when you get into a song. They were straightforward read throughs. The third album is a lot better, the newer one. She really took apart those songs, vocally broke them down. And that's as close to the French material as you get. Now, however, when you listen to the French stuff, she certainly, up until just lately, and I would argue with you even now, not only sings better in French, she is more comfortable in French. Which is understandable. That's her background. And I think that's why the first two albums are seen in some ways as a little over-polished and a little not real, plastic almost. The third one, you can argue is the same, but I think it's just better material. However, you get into her French albums and they touch her soul. I mean they really bloody do. They're more believable. One of the reasons she's keeping that side, besides the fan thing, is I think the French material touches something within her that she doesn't want to lose, maybe her identity. I know that it gives her some kind of sustenance that she wouldn't perhaps get somewhere else."

Dion herself recognized something of this development from the first English-language album, UNISON (1990), to her second, CELINE DION (1992), when she commented, "On the second album I said, 'Well I have the choice to be afraid one more time and not be 100 per cent happy, or not be afraid and be part of this album.' This is my album. It's OK to say I feel like doing it my own way."

Both Dion and Angélil were aware that the transition to English would have its awkward moments, not only taking into consideration the potential for a nationalistic Quebec backlash, but in

the haste with which she would have to learn to speak English and instill legitimate meaning into her performance of English music. Nonetheless, on the eve of recording unison, they were faced with the fact that the die was cast, that they were now signed to Sony and poised to exploit her European popularity as well on the heels of her Eurovision victory. Not wanting any opportunities to be missed, they went ahead with the English experiment, despite the language difficulties.

The Eurovision victory had been good fortune, opportune timing. Being with Sony, notwithstanding the effort it would take to get international support throughout the conglomerate recording company, also proved to be timely, as Larry LeBlanc points out. At the time of Dion's signing, Sony was flagging. "It didn't have a lot going for it. If anything, a lot of its older groups weren't doing much of anything and a lot of the younger bands hadn't really panned out. They got involved with the whole alternative scene and most of the groups, outside of the Stone Temple Pilots and a few other things, didn't pay off. They weren't there for Nirvana, they weren't there for a number of different things. Oddly enough, all of this made a gap for a person like Celine to come along. In all truthfulness, when she arrived on their doorstep, they didn't have a helluva lot going on. Her timing was good."

There were a number of compromising factors at play as Dion prepared to record UNISON. It was more than just a case of her shaky English. Sony demanded a certain amount of artistic control over the project, more or less in return for its commitment of a whopping one million dollars to promote the star to the English market. In addition, Angélil had been cautious about how he eased her into the English market, taking into consideration all of the things that could go wrong. His tactic was to set up duets with a number of other Sony artists early in 1989, including *Wishful Thinking* with Dan Hill, *Can't Live With You, Can't Live Without You* with Billy Newton-Davis, and *Listen To Me* with Warren Wieb, which was licensed for in a movie soundtrack and led to

Dion's first contact with super producer David Foster. Foster would not only work on her first album, but also become the driving force behind most of her English language output since.

An inside look at the way the recording industry works reveals that opportunity and good fortune continued to play central roles in Dion's English-language career. "What was interesting, even when they signed her in Canada," Larry Leblanc notes, "it took a good six months before they got a commitment out of the States from Epic on her. I know for a fact her album in Canada, her debut English album, had over 400,000 units." According to LeBlanc, the president of Sony Canada, Bernie DiMatteo, had been brought to Canada "to clean up a mess that had happened here before with the previous president. . . . Bernie was sort of parachuted in here to take care of the operations. It was under his regime that Celine was signed. And he also — and this is really important — okayed what was at that time — and even today — is an extraordinary budget of a reported one million dollars to record that first album. Now put it in contrast. Most albums in Canada, even at the high end, are recorded at \$100,000 to \$150,000, even at that time. Now can you imagine? I mean what they got off her was obviously some kind of major commitment. Somebody saw something to commit a million dollars."

At the same time, the risk on Sony's part wasn't quite as uneducated as it seemed. "Now, in fairness," says LeBlanc, "they also had a sales base they knew in Quebec. With a lot of Canadian artists you don't have that sales base. If you sign, say, an unknown English Canadian act, you have no sales base, you're starting at ground zero. So you take someone like Celine who has already been on stage and had record success to some degree in Quebec, probably 100,000 to 200,000 records, that gave Sony some ammunition. So you figure what goes back to the label is 200,000 sales representing about \$200,000 back to the artist, roughly, in their recouperables. So they've got an artist, even before they started out, who was a quarter of the way to recouperable, or a

fifth of the way. . . . They must have been very sure of themselves and very sure of her talent."

Nor did Celine Dion's good fortune with Sony end there. A further personnel change within the giant record company, specifically in its Canadian office, would provide Dion with all the advantages when it came to shopping her first album around the Sony subsidiaries worldwide. Dion, despite her track record in Ouebec and, to a lesser extent, in Europe, still faced the same obstacles that most artists face when they sign with a multi-national label. To gain exposure, the artist must be "shopped" to the conglomerate's other labels in the various countries in their network. If the artist is signed in Canada, an international career is out of the question without co-operation from a label in the United States. "It isn't one thing to sign with a label. People think you sign with a record label and they press some kind of stupid big button and it happens," says LeBlanc. "That is not how it happens at all. What happens is you've got to sell yourself within the company and then you've got to sell yourself overseas and then you've got to sell yourself with all the individuals in different parts of the company. Worldwide. Just to get a release. You don't get an automatic release. And that's exactly what happened with her." When DiMatteo was replaced at Sony as its Canadian president by the well-traveled and well-experienced Paul Burger, Dion was already at least on the way to a successful marketing of her album to the United States and, by extension, other nations in the world.

"Paul Burger's history — and it's really important to Celine is he's a New Yorker who's been with Sony for all of his professional life," LeBlanc continues. "He started out in New York and then he was sent over to run CBS operations in Israel and then was sent to London and then eventually headed up Sony International for Europe. Very important for her that he was brought in here, and the reason why it was important and why it's different from any other label is he had connections throughout the Sony family. When some of the people here sign Canadian acts, they don't know anybody worldwide. That's one of the reasons why Canadian acts have so much problem outside the country. A lot of people here haven't networked. But here's a guy who's been in four or five different positions within Sony around the world, as head of Sony International for Europe. Now he was in a position to know all the A & R guys, all the company presidents throughout Europe. . . . When he arrived here, she wasn't finished her album and I believe Paul had her go back and record a couple of new songs. Well, anybody else would have panicked at this point. A million dollar budget and, Christ, they went and found a couple of more songs for the album. He came in and the album was finished under his watch."

LeBlanc maintains that before the album was finished, it is likely Burger and a colleague, Richard Zuckerman, a vice-president with Sony who also had international connections, left for the U.S. to market it there. But response was not overwhelming. "They could not get a release," says LeBlanc. "Now I don't know who else gave them commitments, but they probably got a few commitments in Europe. Anyway, they would have probably got a couple of releases where they had some kind of background, but the release they couldn't get was the States. And it was huge. I mean if you don't get the States, you don't get the rest of the world, it's as simple as that. You can get Australian or English releases, but quite frankly the media over there doesn't pay any attention until they look and see if you're on the Billboard chart. And if they know that the Americans didn't pick it up, they're not going to lift a finger for your record. It just doesn't happen that way. Eventually they got the deal, but I do know when they went around to the companies first off, nobody within the Sony family in the States wanted them. And then they finally ended up at Epic. They had a helluva problem, a helluva problem."

Although American hesitation may seem startling to Canadians, probably much more so for Dion's loyal audience in Quebec, LeBlanc maintains that, as is usual, no one in the States was paying

any attention to what was going on in Canada. "No," he says, "they weren't watching her album. Americans do not care about Canadian sales. She wouldn't even have showed up on their radar at that point. Paul would have been down there and there would have been a word and a listen, but essentially when you're starting out, you're an orphan. When you're a success, you've got a lot of aunts and uncles and mothers and fathers. She'd been an orphan. She'd been adopted by Bernie DiMatteo and Paul Burger, but in all essence out there within the Sony family, she was an orphan."

If not for Dion's good fortune in having Paul Burger, a man with so many connections, fall into her lap, the United States might have been an even harder sell for a couple of other reasons. The first reason? "The first album's not a fabulous album," LeBlanc explains. "It's a good album, but it's not fabulous. I'm not sure anybody could see the talent." But if that was a potential reason for American hesitation, it pales in significance to the possibilities in the second reason. Says LeBlanc, "The other thing was Epic's feeling — and there's some truth to this — they had Mariah Carey who, at that point, was the protegé of Tommy Mottola, who's the head of the label. He married her, for God's sakes. So how would you feel, if you were Tommy Mottola? Somebody came to you that could be a possible rival to your (future) wife? How would you feel? It wouldn't be the quickest signing I'd make. He's on the Columbia side, but essentially it's all within the family. What you have to do is go to the individual Sony labels, Epic, Columbia. She ended up in the end on Five-Fifty. . . . Five-Fifty is headed by Paul Anthony, but it's a subsidiary of Epic. They did well, of course, with the first album, okay with the first album. Much better bounce-off on the second album."

Paul Burger remained a key factor a few years further along in her career, after he went to England to run Sony there. "Burger went to run Sony England and, if you notice, that's where she really took off with the second album," LeBlanc continues. "The second English-language album, even though it didn't do as well in the States, did very well internationally. The other thing was the album D'EUX is the first French album to go on the English chart. And that's only because of Paul Burger. . . . It was a stroke of luck that the guy who helped break her out of Canada moved back to England and helped work her internationally. . . . Paul Burger may be one of the most important people in her life."

With a large budget allocated by Sony to the production of UNISON and with David Foster, perhaps the world's premier producer, on board (whose reputation would give her access to other internationally renowned producers like Chris Neil, Walter Afanasieff, and Ric Wake, as well as songwriters like Diane Warren and Aldo Nova), Celine Dion's career in English seemed to be guaranteed, according to some observers. David Foster, a Canadian like Dion but from Vancouver and a perennial winner at the Grammy Awards, is one of the most sought-after producers in the business — Billboard magazine ranks him as the No. 1 producer of pop music. He has worked with Barbra Streisand, Natalie Cole. Frank Sinatra, Billy Joel, Paul McCartney, and Neil Diamond, among others. Hired to enhance the vocal work of the artist with lush and often synthesized arrangements, Foster possesses a recognizable style of his own, perhaps most characteristic in his production of the St. Elmo's Fire sound track. During the recording of UNISON, Foster himself believed that Dion was about to become "the world's next superstar." For others, however, the presence of David Foster did not present a guarantee of success. According to Larry LeBlanc, Foster is "sort of a soldier of fortune. I wouldn't suggest that he would work with an untalented artist, however he's a soldier, a hired gun. And he probably committed to her on some level on the first album, but he's a busy guy. Right now he's much more in her camp because she's a star. In truth that was a bit of a feather in her cap back then. So it didn't mean as much on UNISON as on FALLING INTO YOU when you have producers like Jim Steinman coming in who aren't known as money players. Diane Warren

is not a money player. They can go to a number of other different people all at the same time. And they'll work with them. They're known for being credible and known for working with what they want to work with. Jim Steinman would work with her tomorrow. In fact, he'd love to do a whole album with her." Although Meatloaf may bear little resemblance to Bonnie Tyler and Barry Manilow, Steinman's "Wagnerian" production can be heard in the work of each of these performers, prominently on Meatloaf's bat out of hell album and again on Dion's FALLING INTO YOU.

Although UNISON did extremely well in Canada, supported by the fan base in Quebec, response in the United States was sluggish. The gamble that the Americans would quickly come round was at risk. However, the ballad single *Where Does My Heart Beat Now?*, released in late 1990, broke into the *Billboard* chart in January the following year, eventually peaking at Number 4 and remaining there for 24 weeks. In Canada, just a couple of months later, Dion was rewarded for the success of UNISON with two Juno Awards, her first ever, for Female Vocalist of the Year and for Album of the Year.

With the Canadian and American markets secured, now the ticklish problem of Celine's French career had to be addressed. In what was either a labor of love or a shrewd tactic of musical strategy — perhaps a mixture of both — Dion went back to Paris in 1991 and recorded a number of songs featuring the work of celebrated Quebec lyricist Luc Plamondon, author, among other things, of the 1978 French rock-opera Starmania. The result was DION CHANTE PLAMONDON, called DES MOTS QUI SONNENT for the French market and in other European countries. The album enjoyed tremendous sales in Quebec, where it went gold, and in France, where it went platinum. Part of the force of the album was attributable to Plamondon. "There's no equivalent to him in English Canada," says Larry LeBlanc. "He's the equivalent of Gordon Lightfoot and Bryan Adams all rolled up into one. He's a lyricist, but he's so popular that he's actually got a double album of all his works recorded by other people."

The two-year period between 1989 and 1991 was pivotal for Celine Dion. In both the sense of learning to speak the language and the sense of breaking into the all-important English music market, a great deal had been accomplished. Although there was still more ground to be gained, especially in the United States, she had managed to survive a brief churlishness from the Quebec music industry and had demonstrated that she was prepared to conduct two musical careers, both of them successful, one in English and one in French, as she established her reputation in English-speaking Canada and in France. Sony recognized the gains she had made by offering her a new contract, reported to be worth \$10 million, for a further five albums. The contract was then the largest ever signed by a Canadian artist, and, as Paul Burger said himself, "she's the first internationally successful Canadian artist in many years to be [still] signed to a Canadian label."

The final achievement of this period in her career fell into place when the Disney Corporation invited Celine Dion to perform a duet with Peabo Bryson for the theme song of their movie, Beauty And The Beast. The recording and the movie were hyped virtually to death by the time the song was released in early 1992. Nonetheless, to a vast array of fans, it lived up to its hype. The song became a massive international hit, finding space near the top of every musical chart from Canada to Australia. To add even more exposure to the young Dion who had so tentatively entered the English-speaking market, the song was nominated for and then won an Oscar. Before millions of people, she and Bryson performed the song as part of the Academy Awards presentation. In addition, Dion and Bryson won a Grammy Award for Best Vocal Performance by a Duo. Back in Canada, at the 1992 Juno Awards, Dion was named for the second year in a row Female Vocalist of the Year.

Still, 1992 would be a year containing new challenges. Soon, she would have to deal with an antagonistic press in Quebec now speculating about the true nature of her relationship with René

Angélil as they continued to plot her course towards becoming a pop diva. Soon, she would need to address the question of Quebec-Canadian politics, specifically whether or not it has, tactically or practically, much place in the world of pop music, while proving that she could maintain two linguistically distinct musical careers, without offending either audience.

For now, she seemed to be enjoying the economic fruits of her burgeoning career, visiting her parents at one of two homes she bought them near Montreal and in the Laurentian Mountains. But in a sense, music had by now changed for her. Celine Dion was a professional adult singer with virtually her entire focus resting on her career and the precautions needed to maintain her voice, the golden key to all her success. In one instance she did not speak for three weeks, on the advice of a New York throat specialist, after she lost her voice during a concert in Sherbrooke, Quebec. Communicating with her manager and family members during that time by writing on scraps of paper, she began to give up speaking on the day of a performance, began to travel with two humidifiers, and developed the habit of exercising vocally for several minutes every day. "When Celine stopped singing for the sheer joy of it in the car, in the plane, wherever she was, I knew she had what counted to be a star," said René Angélil.

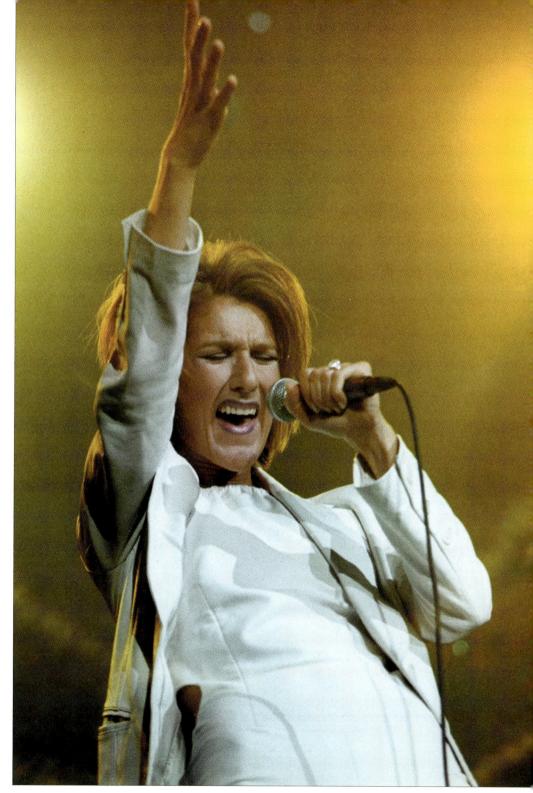

Live in Montreal

At ease in California

Rehearsing in Las Vegas

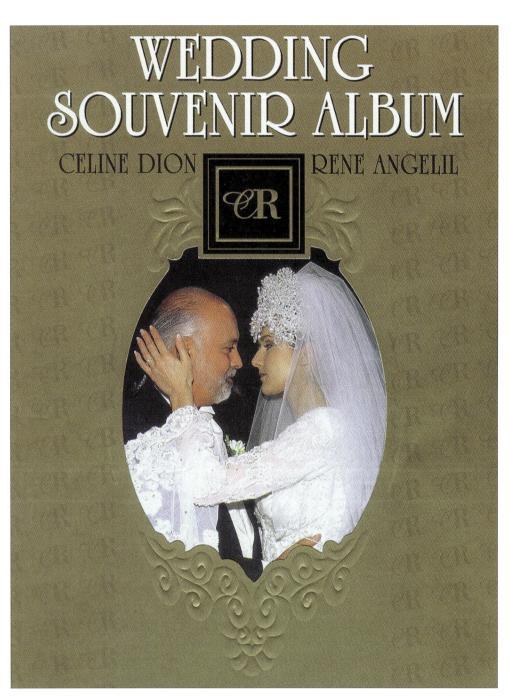

Cover from the Wedding Souvenir Album

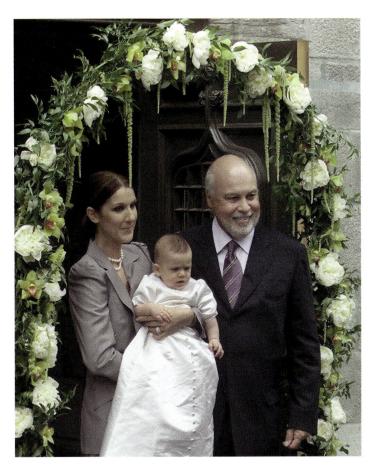

The baptism of René-Charles

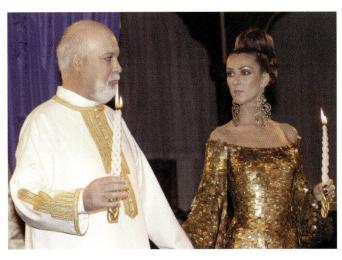

Renewing wedding vows at Caesar's Palace

Live in Las Vegas

Live on the *Today Show*

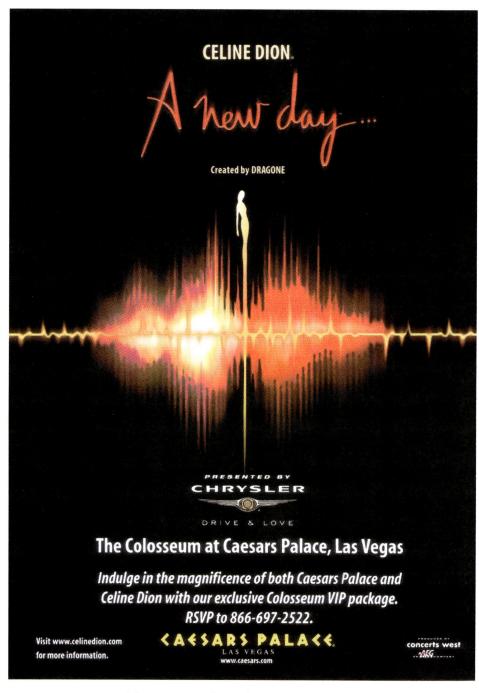

Disneyland

There's always a new thing happening to me that's even more extraordinary, so the pressure gets harder. But I like it when it's hard. Anyone can do it when it's easy. When it's hard and you can do it good, you're proud of yourself. There's going to be more pressure as the years go by, that's for sure. But I think I'm a hard worker and I'm ready for that. As long as I believe in what I'm doing, the pressure is OK with me." — Celine Dion

Nickels, the chain of family restaurants Celine Dion, René Angélil, and a number of other business principals operated in Quebec for the past few years, have begun to spread in Ontario, tucked into the eastern corner of the province, next door to the 30-odd locations in Montreal and the rest of Quebec. Almost parodying rather than imitating the 1950s, the restaurants are as '90s as you can get, right down to the <code>www.nickels.ca</code> on the paper place mat. In the entrance, the walls are lined with copies of awards and other Celine Dion memorabilia, the collection reminding everyone of the tremendous musical success she has achieved so far in her career. Inside, an assortment of servers — bobbysoxed and sneakered, pink-skirted and often pony-tailed — wait on tables designed to look like a '50s malt shop. The breakfast menu offers a

wide variety of items from the usual to the unusual, the unusual being, for example, French toast, waffles, or pancakes with chocolate chips. Desserts can be ordered from a menu in the shape of a long-play record. Noticeably, there is a six-layered chocolate cake called simply "Celine." At the counter, the cake is gigantic, lurking like a small mountain behind the glass where it can be ordered for take-out. On the walls of the restaurant are photographs of the popular culture figures condemned to their place in our memories of the 1950s — Marilyn Monroe, Elvis Presley, James Dean — including the popular cultural toys of that era, cars and motorcycles mainly, Cadillacs, Edsels, Harley-Davidsons. It's kitsch and materialism at its best. But then, that was the '50s. That, like or not, is also the '90s. Depending on your view of the merits of materialism, it doesn't feel like we've come very far over the past 40 years.

The two decades seem to hold one another's hand, like an aging couple still enjoying a happy marriage, they have so much in common. They are decades that not only toast the superficial, but go so far as to transform it, however briefly, into a new ethic. Both decades have cherished technological advancement to the point where it has become iconography. Both have focused on materialism as the single corporeal definition of success. Both have conveyed, yes, a view of the world which possesses a Walt Disney innocence, ignoring the fact that such innocence is the front line of Disney's corporate stranglehold on the entertainment market. Disney leads the industry in translating creative art into commodities such as serviettes, toys, and coffee mugs one can buy in the neighborhood department store. In this way, it is not so strange that Nickels symbolically straddles the two decades of commodity accumulation, making only a heartbeat of the distance in time between the two decades.

The music business, after all, is just that, a business. It is a wise performer, therefore, who translates the vast fortune garnered from album sales, performances, and touring into other business ventures, as a hedge against the passage of time and its fickle companion, the changeable tastes of the music-buying audience. Dion and Angélil have applied this kind of wisdom to Dion's name and career, investing shrewdly in the fruits of Dion's abundant talents. Over the years, when someone has wanted to utilize Celine Dion as a spokesperson for a product, Dion has been there to do it. She's not afraid to drive herself to maintain her popularity and do whatever else is required to keep the revenues coming in. Entertainers in the '50s were largely commodities. Entertainers in the '90s are a little more cynical. They are entrepreneurs. Entrepreneurs have become the only respectable definition of human success in this society as we near the end of the millennium. Even Dion's mother, Thérèse, markets a line of pâtés and associated products.

In Dion's case, all of this attention to the business of being a star has less to do with her personality as a pop diva than it does with the times. And the times are fraught with cultural comparisons. These days, the entertainment business is unabashedly profit-minded. The artistry remains, the talent, the gift, the creativity, but no one bothers to pretend that they are a little shame-faced by the profits involved. These days, one can admit to a delicate greed and no one blinks an eye. The era of profit as religion, as perhaps the point of human life, has finally arrived.

Culturally speaking, however, it is in the area of business and the arts that one encounters the different correlations between cultures in North America. Quebec, like the United States it so often emulates, endorses the business approach to the arts, generally speaking. English-speaking Canada applies, instead, a kind of underhanded hypocrisy, as if to be politically correct about envy. English-speaking Canada apparently deplores the crass commercialism. But it does so sitting in the booth in the restaurant, as if, as a patron, it doesn't go there for the food but to remind itself of its disapproval. Not so in Quebec. In Quebec, Celine lives the fruits of the American dream. And everyone there would do the same thing if they had the chance. So too, perhaps, English

Canada. But English Canada, unlike Quebec, can't quite come out and admit it. To admit it, isn't polite.

As for Dion, ambition and business acumen are apparently forgivable because she remains a woman with a great deal of energy. She draws on energy resources other pop divas do not seem to have. A typical Celine Dion day would exhaust a normal person. From promotional tours to concerts, from interviews to a heavy recording schedule, flying here, flying there, appearing here, appearing there, she is at all times a star. She enjoys the pressure, she says. This is what she has always wanted to do. Because of her energy and drive, she does not turn down the endorsements, does not hesitate to enlarge the business arm of her career. There's almost an innocent humility in her ambition, a kind of anxious-to-please naïveté compelling her to appear at the site of Nickels restaurant openings, something other stars of her stature would likely never consider. Dion and Angélil may have a Walt Disney view of the world, but they're not afraid to apply an exhausting work ethic to their efforts to reach Disneyland.

As far back as 1988, Dion was willing to attach her name and musical profile to advertising campaigns for a number of unrelated commodities. That year, Chrysler Canada put 30 percent of its Canadian promotional budget into a campaign directed solely at Quebec. The key to the promotion, designed to "pick up the fabric, the heart and soul of the (Quebec) market," was Celine Dion, who then signed a three-year contract to promote Chrysler in nine different television commercials, newspaper and radio ads, magazines, and billboards. For Chrysler, Dion reflected the image that the car company wished to convey. "She has energy, she's aggressive, she's a great performer," the company boasted.

Dion also signed to promote Diet Coke for Coca-Cola in 1991. As part of the deal, the company sponsored a tour of 37 concerts, including a special concert with the Montreal Symphony Orchestra that year, on June 19. This performance was set up to celebrate her 10th anniversary as a popular entertainer in Quebec.

Coca-Cola was pleased as well that a portion of each ticket sale was donated to the Cystic Fibrosis Society. The tie-in with cystic fibrosis fund-raising efforts was a natural for both parties because it was the company's national charity and Dion, herself, has donated heavily to the organization, having lost a niece to the disease. In the years since, she has been connected to products such as the liqueur *Kahlua*, American Express, and Proctor and Gamble. Proctor and Gamble promoted tours in early 1996, linking these to her endorsement of such items as soaps and feminine hygiene products. Dion also joined Anne Murray for a promotional campaign for The Bay department stores this decade.

Over the years, music journalists have wondered about the gruelling pace Dion has set for herself, the pressures it can create, even questioning the philosophical compromise which may or may not be reflected in her various efforts to pursue economic success along with her singing achievements. But then, pop music is conservative in that way. There is, after all, an ingrained conformity involved in its performance. One is compelled not to drift very far outside the traditions of pop divadom, and, in the modern era, crass commercialism appears to be quite acceptable within the parameters of that ingrained conformity.

Liam Lacey, in a review of a Celine Dion television special on CTV in December 1993, mentioned that conformity, noting its place within the ill-defined cultural territory known as the American Dream. Wrote Lacey, "'It's the classic American dream,' says Canadian producer David Foster about the success of Quebec singer Celine Dion. Why did that bizarre line remain in *The Colour of My Love*, the CTV concert film of the young chanteuse (tomorrow at 7 p.m.)? Was it because, in a sense, Foster is right? If you understand the American Dream as success through conformity, Celine Dion may indeed be a shining example. She has successfully adapted to the most homogeneous elements of the U.S.-global pop musical marketplace. . . . As a singer, Dion has everything but personality. Like Whitney Houston and Mariah

Carey, her voice is one of those modern four-octave wonders that's somehow much easier to admire than to believe."

But while critics have been scratching their heads over whether to admire Dion's efforts in the pop marketplace or whether they should believe there is substance behind her success, it keeps coming back to the apparent acceptance on the part of both Dion and Angélil that pressure, hard work, and uncommon ambition reflect who they really are. As Brendan Kelly noted in the Financial Post on the eve of the 1993 Juno Awards program, Dion seemed compelled to ride the roller-coaster that sped up during the three years after she entered the American show business sweepstakes. "There's little hustle and bustle on the streets of Toronto on this quiet Sunday morning. But Celine Dion doesn't have time to notice — it's the day of the Juno Awards and the 24-year-old Quebec singer is in full pop-star mode. She is perched in the back seat of her limo, which is winding its way to the O'Keefe Centre for the final Junos dress rehearsal, and she looks anything but relaxed. It's only a five-minute drive from the hotel to the theatre, but manager René Angélil has lived up to his reputation as a whip-cracking impresario by scheduling an interview in the limousine. Angélil who is almost always by her side — and Sony Records executive Vito Luprano sit inches away from Dion, and, almost as soon as she starts talking, you can feel the pressure from them to get this over with so they can whisk their star into the rehearsal."

Dion admitted then, "The pressure has gotten heavier. There's always a new thing happening to me that's even more extraordinary, so the pressure gets harder. But I like it when it's hard. Anyone can do it when it's easy. When it's hard and you can do it good, you're proud of yourself. There's going to be more pressure as the years go by, that's for sure. But I think I'm a hard worker and I'm ready for that. As long as I believe in what I'm doing, the pressure is OK with me."

For his part, Angélil balked then at the notion that Dion might be "missing out on anything as a result of their year-round workaholic schedule." Said Angélil, "There's no dilemma. We both feel the same way. What we do, we do it seriously, and with respect for show business. To do that, you must have discipline and you must love your business. After a while, it's not a sacrifice to do the things you do. You do it out of love. It's like any business: you're going to do what you have to do to succeed. To other people, it looks like she's working like a slave. But to us, it's not that way at all. We love what we're doing."

Ironically enough, if anyone was showing the strain of the heavy schedule in 1992, it was René himself who collapsed with a heart attack early in May while the pair were in Los Angeles. Dion managed to get into a cab with him and they rushed to hospital. It was the second heart-related incident for Angélil who, it was reported, suffered some other kind of undisclosed heart crisis in 1988. For Billboard's Larry LeBlanc, the 1992 event is fresh in his memory because it served as the catalyst for more than one revealing glimpse of the lifestyle of Dion and Angélil. For one thing, this was his first clue that the professional relationship between Dion and her manager might also be a romantic one. For another, this "event" demonstrated that if Dion and Angélil never cease striving for success in the world of pop divadom, they at the same time possess the grace to remember who has helped them along the way. While there appears to be a somewhat crass commercial motive behind Dion's attempt to reach the top, at the same time the almost natural down-home feeling the couple exudes makes us forgive the artfulness in the exhaustively-planned way they have achieved their objectives.

A few days before Angélil suffered his heart attack in L.A., Larry LeBlanc's feature on Dion appeared on the front page of the American edition of *Billboard*. The article not only began on the front page, but was continued on the inside, taking up another entire page. For both LeBlanc and Angélil, the story represented a major coup and an indication of the success that Dion was likely to achieve in the United States from that point onwards. As

LeBlanc tells the story, "They were down in L.A. As I recall, they were doing a tv show down there — they were down there for the week, which is very rare when you're doing work. And that's the week my article came out. René called me and said, 'Larry, you've almost given me a second heart attack.' And I'm laughing. He phoned me on a Friday night, I remember. He was staying at the Beverly Willshire Hotel — it was amazing to me that they sold *Billboard* in the hotel lobby. I hadn't even got my copy yet. *Billboard* comes out at noon on Friday and here this guy's got the damned thing. I had a copy faxed to me. We honestly did not know it was going to be a front page."

"I wasn't aware of their romantic relationship at that time," LeBlanc recalls. "That's the first time in my mind that it kind of went 'ping' — they were there on their own. Even then I thought, 'they're working together.' It didn't shock me when they announced that they were together (romantically) or anything like that at all because there were plenty of signs before that. But it surprised me."

LeBlanc attributes part of the reason for the story running on the front page to the fact that Billboard editors from the U.S. had been in Montreal for the release of her second English-language album, CELINE DION. The ensuing fanfare had left quite an impression on them. "It was like a coronation — for every album it's a coronation; it's gotten bigger and bigger — her picture was everywhere." Another reason was the lobbying efforts of a Sony publicist. "It was in her interest to get it up further and it was in my interest — I had a belief in Celine. I thought that her time was right in the States, which proved to be right. We thought, at best, we'd end up with a page three or four. And, because I'd only been at the publication a year, I over wrote the article, maybe three or four times too much. To my surprise and everyone's surprise, they used the whole damned thing. To this day, I've never had a page one story that went off and was an entire page by itself with no ads. And you know how big a *Billboard* page is. That's a lot of reading. The label was just stunned and so was René." Hence the phone call

from Angélil and the crack about the second heart attack.

In the aftermath of the article, LeBlanc was sometimes confused as to whether the couple's apparent accessibility was the result of the article or just the fact that they naturally friendly. "I always felt in the early days that Celine was coached by René. She walked into a room — you're going to meet this person or this person," LeBlanc observes, but now "I can literally get her on the phone in five minutes from here. I have her private number and they actually live in West Palm Beach most of the time these days. I can probably get hold of Bryan Adams directly — I've got Bryan's home number as well — but it would take me maybe a couple of hours. And that's only if Bryan wants to talk to me. She'd get on the phone even if I didn't have, you know, a purpose for calling. Certainly René would as well. He has called me many times when I'm doing articles or I need some research material or something like that. He's called me in the middle of the night from Germany when I know he's trying to sleep. So you go figure. That's a bond."

Strangely enough, Dion and Angélil have used this confusion over apparent natural warmth and artful skill in manipulating opportunities to handle a number of issues to their satisfaction, chiefly in the areas of Quebec-Canadian politics and in the hubbub created when Quebec media began to speculate about their personal relationship.

Commenting on the ability of Celine Dion and René Angélil to handle scandal mongers, Larry LeBlanc says, "Like a good politician, they've co-opted the media. They've also made themselves accessible and inaccessible at the same time. That's a cute trick to do because, quite often, when you're inaccessible, people get ticked off, particularly if they helped work you in the early level. You'll very rarely see bad press on her. A part of it also is she is not afraid of making fun of herself, when she's gone over the top. The way you see her on stage is the bloody way she is. When I saw her in Montreal, she brought on all the Quebec athletes who

performed in the Olympics. And then she brought on her mom and dad, René. When you see her making jokes and fun, I mean that's the way she is. She's that way off stage. So they know it ain't no act. And in the Quebec music industry, she's their hopes of international recognition to a large degree for a lot of other performers there."

But there was no joking and laughing when Dion finally reacted to media innuendo over the nature of her relationship with her manager, making much of the fact that he is 26 years her senior. During an appearance in 1992 on television with talk-show host Lisa Payette, Dion broke down and wept over the treatment she had endured from members of the Quebec public over the issue. For some, this marked a turning point in the attitude of her home province towards Dion. Since then, very little has been said that could be construed to be even gently critical of Celine Dion.

Yet a tactical strategy persists, especially in the world of politics. Dion has learned to maintain a political silence where the issue of Quebec sovereignty versus Canadian national unity is concerned. "I don't talk about it because I don't know a lot about politics," she told Brendan Kelly. "I'm not a politician. I think the less we talk about it, the better it's going to be." But as Kelly reminded everyone in response, political controversies had dogged her over the past few years. "It started with the 1990 ADISQ Awards — Quebec's answer to the Junos — where she refused the Felix trophy as anglophone artist of the year, proclaiming that she was not an anglophone but 'proud to be Québécoise.' That infuriated the anglo media in Quebec, who interpreted the comment as a put-down of their community. It was the local French media's turn to make a fuss last summer when Dion made some fairly mild-mannered pro-Canada statements during the World's Fair in Seville, Spain. Her plea for Canadian unity caused a furore in the province and, at the time, a clearly distressed Dion vowed never to mention politics publicly again."

Dion has stuck to her word. By the end of 1992, when she was

one of 12 notable Canadians highlighted as achievers by *Maclean's* magazine, she could only say that she was both from Quebec and from Canada. "Dion has been criticized for recording English songs that are more calculated, less passionate than her French material," wrote Carl Mollins for *Maclean's*. "But she has never denied her desire to be an international megastar — and Quebecers by and large now seem to accept that. The singer . . . has also sidestepped issues that could have torpedoed a politician's career. The exclusion of the accent on her first name on her latest album cover caused more of a ruckus in English-speaking Canada than in Quebec."

More revealing, however, from the standpoint of how calculated her persona might be or whether, indeed, she is as natural as she seems to be, were her remarks in the same short article about her personal highlight for 1992 — namely performing *Beauty And The Beast* with Peabo Bryson at the Academy Awards on her birthday. Sounding absolutely starstruck, the singer underlined the fact that, from the very beginning of her career, she has wanted to reach the top and to mingle with the others who rise to reside at or near that summit. "It's the biggest television show and it's very prestigious and the song won and it's a classic and I was part of it. I congratulate Anthony Hopkins as he passed by me backstage and then I go onstage and Barbra Streisand is sitting in front watching me. Then, Liza Minnelli goes by and later I'm eating shrimp with Patrick Swayze and I meet Paul Newman at the elevator. It was too much."

In truth, Celine Dion's international career, which truly began in 1992-1993, is a mixture of naïve ambition, blind faith in the potential for success, and a strong work ethic combined with artful manipulation of opportunity. Success of this kind does not come easily. The chances are drastically improved when one is able to recognize when the right moves present themselves and then knows enough not to hesitate. If there seems to be something crass in the effort, this perhaps is the price one pays to emerge from a large family in Charlemagne, Quebec, to live life in a Disney-inspired dream. For

both Dion and Angélil, this is what they always have imagined life could be.

Notwithstanding all the energy Dion put into endorsements, business ventures, interviews, and promotional work, the period 1992 to 1993 was also a time of heavy musical output. By March 1992, with the duet with Peabo Bryson now topping the charts virtually everywhere there is music, she released her second English-language album, simply called CELINE DION. To a few shudders in English Canada, of all places, the accent was dropped from the first "e" in her name for the benefit of English-speaking international audiences. The duet with Bryson served as the foundation of the album, and like UNISON, her second English-language effort incorporated a mix of dance music with provocative ballads, many of which were released as singles, including *If You Asked Me To, Nothing Broken But My Heart*, and *Love Can Move Mountains*.

Dion took to the road with intensity during the 1992-93 period, still trying to make the most of her budding appeal to the American public, the cornerstone of her English-language career. Activities included guest appearances on a variety of television programs and a series of concerts where she opened for male pop star Michael Bolton. One of her triumphs included the overwhelming success attached to her function as host of the 1993 Juno Awards, an event which can be demanding enough for someone who speaks English as a first language. Dion not only passed the test in English, but impressed both English and French Canada with the aplomb with which she accomplished the feat. Dion also took home four Junos herself that year, transforming the event into an even bigger triumph. She won the Juno for Best Female Vocalist of the Year; Best-Selling Francophone Album (DION CHANTE PLAMONDON); Single of the Year (the duet with Bryson); and Best Dance Recording for Love Can Move Mountains.

Working with a tour band which had been with her for at least three years, Dion was now able to translate the lush intricacies of her recorded pop sound to the live stage. Under the leadership of keyboardist Claude Lemay, the group included Yves Frulla, responsible mainly for synthesizer and organ keyboards, drummer Peter Barbeau, guitarist André Coutu, and bassist Jeff Myers. All are experienced musicians, with a broad understanding of the electronics required to translate the complex orchestration in the background of pop music into the live venue. The group members were selected for their professional experience and for their ability to meld their respective instruments with Dion's use of her voice as an instrument of another kind.

LeMay, responsible for arranging material in preparation for the tour, focuses mainly on piano. One of the background vocalists, he is also known for his music written for film and tv. Though humble about his virtuosity, he claims that Keith Emerson is one of his major influences. "The main goal of the arrangements for this particular project is to have the songs sounding like the album," he told writer Shauna Kennedy of Canadian Musician in 1994. "We're only five musicians, but we want it to sound as big as on the album and, of course, there's a lot of overdubs. But we're going there, we're doing it." As a result, there's an electronic component to this kind of music which, when it is explained, sounds more like the shop talk of a club of computer nerds than it does a group of dedicated musicians. Main keyboardist Yves Frulla, for example, describes the advance programming of material for a concert in this way: "Everything goes through a MIDI interface that maps all my sounds for my keyboards — all my splits and everything else are stored under a pre-set, so MIDI is a big part of what I am doing as far as patch changes between songs, samples — it plays a dominant role. We use sequenced tracks, mostly for percussion and sound effects. The drummer plays with a click and we'll have a lot of percussion going on, drum loops, so there's a sequence for just about every song. I'm programming mostly everything that

you hear with the help of soundman Denis Savage. When we start a new tour or there's a new album coming out, we request the charts from the various arrangers and the master tapes. We go into the studio and sample various things and also, with the masters, make dedicated mixes of only certain instruments to hear clearly the sounds we have to get — that's why our sound is so punchy and close to the records."

In pop music, the drumming too has a programmed aspect. The man at the helm of the drumming, both live and programmed, is Peter Barbeau, who, like Frulla, came to the Celine Dion touring band as an alumnus of Sass Jordan's back-up group. Barbeau, who also plays guitar, has written the song *Lost Without You*, recorded by Roch Voisine who happened to walk by one day when Barbeau was playing it. "I like to hear Celine in case she's back-phrasing or she's playing a bit on a song that's not sequenced — I can push and pull with Celine and really be sensitive to what she's singing. Celine has massive ears — she hears everything! . . . There's a lot of things to learn from working with a big artist. They all have a certain thing in common and it's a real hard work ethic. They're relentless, they don't stop and that's something you can really absorb by being around them. I truly believe that it has a lot more to do with hard work, in terms of success, than luck."

Guitarist André Coutu, however, modifies the view that a live performance for Celine Dion is purely a matter of advance programming. "I think it's being able to adapt to every situation because you very often will have things to change — fast. . . . I would like to stay with Celine for as long as possible. We have a nice band, a nice crew. I'm having fun and Celine is great — she's the best. She sings like . . . (sighs); and plus, the human aspect — she's fun to work with, she's always in good humor — never a bad vibe."

Kentucky-born Jeff Myers, the group's bassist, agrees that the important aspect of playing with Dion's band is the respect the group has for one another and the instruments they play. "A lot of it is less about music and more about personalities," he says. "I've

got to this point where I really don't feel there's any separation between playing music and just living life — it reflects back and forth. Everything I do affects playing — I feel like it comes out in the music."

With a professional touring band behind her and with her selftitled second English-language album gradually broadening the markets unison had first opened in the English-speaking market, Dion was soon back in the recording studio in 1993. The result was her third English album, THE COLOUR OF MY LOVE, which continued the lush balladry of CELINE DION for which she was known. THE COLOUR OF MY LOVE introduced some new musical wrinkles developed from her growing ability to apply to English the eclectic enthusiasm she had always been able to apply to her French material. The album not only contained When I Fall In Love, a duet with Clive Griffin commissioned for the Sleepless in Seattle movie soundtrack, but provided her with her first hit single in the English-speaking market, The Power Of Love, which rose to No. 1 in the United States, topping the Billboard chart for four weeks. With this song at the helm of the album, it sold extremely well in Canada and in the U.S., prompting a brief headlining tour throughout the American market.

A score of further music awards and nominations followed in 1994 and 1995. With COLOUR OF MY LOVE selling a million copies in Canada alone, she received the Juno in Canada for Female Vocalist of the Year in 1994, the fourth year in a row that she had won this prestigious award. She also won two Junos in 1995 for the album in the categories of Album of the Year and Best Selling Foreign or Domestic Album. Nineteen-ninety-four also saw her dominate the ADISQ Felix Awards in Quebec, where she won three more to add to the 12 she had already earned during a her long career in that province. She won Female Singer of the Year, a Felix for the Quebec artist earning the most acclaim outside of Quebec, and for an album in any language other than French. Her duet with Clive Griffin received a Grammy nomination in 1994 for

Best Pop Vocal by a Duo or Group.

Dion's appearance to collect her hardware at the 1994 Juno Awards demonstrated that she was no shrinking violet either where giving her opinion was concerned. As writer Peter Howell reported that March, "Best female vocalist winner Dion rebuked them (the Canadian Academy of Recording Arts and Sciences) on national television for failing to nominate her producer, David Foster, as well as superstar rocker Bryan Adams. Earlier this month, Foster won four Grammys, all for material the Junos honored last night, including Dion's When I Fall In Love single from the Sleepless in Seattle movie soundtrack, which was named in her vocalist award, and Whitney Houston's The Bodyguard soundtrack, which received the Juno for best-selling album. Adams was likewise shut out of the nominations, despite the fact his song, Please Forgive Me, sold millions internationally. Holding her Juno close to her, her sole win of three nominations, Dion pointedly remarked that Foster is 'the best producer in the world, including Canada . . . and I also think Bryan Adams is the best in the world, including Canada.' Backstage, Dion was reluctant to assign blame, saying, 'I just felt sad and disappointed' about the lack of recognition for Foster and Adams."

While, overall, North America and France continued to admire the work of Dion, there was some new reticence elsewhere in the European market for her work. In the United Kingdom, despite the success of *The Power Of Love*, the album for a time was not popularly received. Then, upon the release of its third single, *Think Twice*, THE COLOUR OF MY LOVE began to soar towards the top of the charts. *Think Twice*, penned by Englishmen Andy Hill and King Crimson-Emerson, Lake and Palmer alumnus writer Pete Sinfield, spent 16 weeks on the British charts before climbing to No. 1, where it spent a further seven weeks. The album also reached the top spot, permitting Dion to join the likes of The Beatles, Cliff Richard, and Elvis Presley as a double-top spot charter there. In fact, the single *Think Twice* became only the fourth

million seller by a female in United Kingdom musical history.

On the horizon was another outstanding success, this time with Dion's other musical career in French. And here, at last, she would become an international star in the broadest meaning of the term. Yet 1994 would be a stressful year for Celine Dion and René Angélil. Coming up was one of the most ostentatious events of their respective lives, an almost aristocratic wedding to take place in Montreal. Surrounding this event, there was a great deal of opinion, pro and con, not only over the wedding itself, but over the appropriateness of the marital match. When René Angélil and Celine Dion broadened their relationship into the state of marriage, much of Canada had something to say about it. Their private lives were private no longer.

The Colour of Their **L**ove

René, for so many years I've kept our special dream locked away inside my heart . . . but now it's getting too powerful to keep this inside of me . . . René, you're the colour of my love. — Celine Dion

Celine Dion and René Angélil would be happy to share this very special day with you Saturday, December 17th 1994. You are invited to attend the wedding ceremony to be held at 3:00 p.m. Notre-Dame Basilica 110 Notre-Dame Street West Montreal. A reception will follow at the Westin Mount-Royal Hotel 1050 Sherbrooke Street West. Tuxedo. Long Dress. — Celine Dion and René Angélil

The wedding of Celine Dion and René Angélil seemed like a fairy tale come true. The ceremony at Notre-Dame Basilica was lavish yet traditional, incorporating all the aristocratic details such an event inspires in most people's imaginations. Notre-Dame is the most famous Catholic church in Canada, situated in the old section of Montreal, where one, at times, can almost reach out and touch history. The perfect setting, not only for Dion's lush wedding dress, but for the tails and top hats worn by the men taking part in the ritual. The guests were treated to a "royal" procession up the aisle to the front of the church, headed

by Dion's eight sisters, her eight bridesmaids. Music was provided by the Montreal Jubilation Gospel Choir, accompanied by the Morency Quartet.

The ceremony was conducted in the old style, with Holy Communion, officiated by Monsignor Ivanhoe Poirier. Often, during the ceremony, Dion's emotions showed. Often she wept. The ceremony was a combination of strict religious solemnity and unabashed celebration, the former observed in the humble Catholic tradition, the latter demonstrated by Dion's apparent elation as the elaborate ceremony drew to a close. At one point, she turned and gestured with a thumbs up sign. At another, she and Angélil hopped a dance step as the gospel choir sang the ceremony to a close.

The reception, at the Westin Mont-Royal Hotel, took place in a large ballroom, lavishly decorated for the occasion, including a head table littered with Dion's favorite flowers, roses. As they had during the wedding ceremony, Dion and Angélil observed all the reception traditions, including the first dance. Friendly competition at gaming tables, music, and celebration carried on well into the night.

Like a fairy tale princess, Celine Dion had loyal subjects waiting outside of the church, legions of Quebec fans who wanted to be on hand for the occasion when their daughter celebrated a rite of passage reserved for adulthood. If the wedding was closed to the public, the public could nevertheless identify with the occasion having watched over a decade ago the royal nuptials of Prince Charles and Lady Diana. The ceremony somehow conveyed Dion's unwillingness to renounce the family-oriented traditions of her childhood, and while it seemed to some a touch decadent, the wedding was unabashed enough about the fun lurking inside the largesse to convey a sense of hospitality even to people who could never have attended. It seemed an unusual bridge between working class virtue and aristocratic pretension. Neither class was permitted to forget about the other.

Still, the glamorous marriage of Celine Dion and René Angélil, the manager who had guided her career since that first day she performed into a pen in his office when she was 12 years old, tended to cause debate and, in some instances, controversy in 1994. Most of the discussion seemed to focus on two separate issues. One was Dion's choice of wedding partner itself. About 26 years Dion's senior, Angélil had been married twice before. Dionwatchers in Quebec and in English Canada wondered about the true nature of the relationship, how it had evolved from business to mentor-protegé and then to romance. Of more importance to some was the question of when it had become romantic, in view of her young age. There was a touch of scandal in many reports. Dion's life had been insular from her childhood and the marriage seemed to be a means of perpetuating that insularity. Whether this was psychologically healthy or not seemed, for some, open to debate.

The second issue was a reaction to the Dion-Angélil wedding ceremony itself. Not only did it rival in cost and ostentatiousness a royal wedding, but it included a business arrangement which, for some, seemed exploitive, namely a special publication reporting the event. The publisher paid a six figure sum for exclusive rights. Although sales of the wedding album were extremely successful, especially in Quebec, Canadians were split in their opinions over whether events like the wedding were tasteful or tacky. In the opinion of a large number, the wedding extravaganza did not seem like a Canadian kind of event. Certainly, to English Canadians, it represented more of an American kind of indulgence. Hadn't Mariah Carey, 24, married her mentor Tommy Mottola, 43, the previous June in Manhattan under similarly-grand conditions?

Their wedding may have seemed self-indulgent but it was a self-indulgence both had admitted coveting for much of their lives. At the same time, culturally speaking, the style of the wedding ceremony reflected quite clearly, beyond Dion and Angélil's views

of the nature of success, the differences between Quebec and Canada and even the United States and Canada, in what is perceived as culturally acceptable. The wedding, somewhat garish to the majority of English-speaking Canadians, was not viewed as negatively in Quebec. One could almost call Quebec's view, like America's view, the "republican" perception of such events. English Canada does not, generally speaking, construe such events as "republican" because it, ceremonially at least, is part of the British monarchy. In other words, to many English Canadians, royal weddings are for legitimate royalty only. Anyone else is an upstart.

Although much was made of the difference in their ages, tabloids in both Quebec and the United States began to insinuate publicly that Dion and Angélil had been intimate years prior to that, even when Dion was underage, an unlikely possibility when one considers the pains her mother took to chaperone her during all of her activities in the years she spent as a teenage performer. Dion and Angélil demonstrated patience when dealing with the subject of their age difference, but took legal action over implications that they had been indiscreet when Dion was underage. The couple announced their engagement in November 1993. It came at approximately the same time as Dion launched THE COLOUR OF MY LOVE album which carried a liner note referring to her romantic feelings for Angélil "as our special dream locked away inside my heart." "It's true, I love René and he loves me and we hope to get married within a year," said Dion at the time of the engagement announcement. "I can't keep the secret any longer. I've known that it will get out one day and I've told that to René but he's hesitated." René was shrewd in his reticence. It was only a matter of six months before tabloids were attempting to smear the couple.

"In Quebec, Celine Dion's love affair with her 52-year-old

manager was treated like a slightly naughty fairy tale," reported The Montreal Gazette in May 1994. "But as the 26-year-old pop diva continues her climb up the U.S. charts, news of her romantic life has made a different impression in the world of U.S. tabloids. 'Globe blows the lid off singing sensation's bizarre love life,' trumpets the U.S. magazine this week. The two-page article in the Globe, which quotes 'close pals' of the singer, suggests that a tryst began when Dion was still a teenager and her manager, René Angélil, was married to another singer. After Angélil's ex-wife filed for divorce, 'she blamed the young singer for being a homewrecking Lolita,' says the Globe, which plastered eight photographs around the article. Their relationship was an open secret in Ouebec for years, but discreet reporters rarely wrote about it. Last November, the love affair was made public when the couple's engagement was announced." Although the Dion story made the front page of the Globe's Canadian edition, U.S. readers of the magazine got the article but not the cover photograph of Dion leaning on balding, white-bearded Angélil. Instead, the U.S. edition featured 'Oprah Winfrey's dress and diet secrets' on its cover."

By July of that year, however, Dion and Angélil had had enough. As Geoff Baker of *The Montreal Gazette* reported, "Pop star Celine Dion and her fiance yesterday launched a \$20 million libel suit against *Photo Police* newspaper for writing that the couple lived together before the singer turned 18. The lawsuit contends that in its May 20-27 edition, the weekly crime tabloid published damaging comments about the relationship between Dion, 26, and René Angélil, 52, her longtime manager and mentor. 'René Angélil and Celine Dion became engaged on March 30, 1993, and it wasn't until that date that they started to live together,' the lawsuit states. The front page of the contentious edition of the paper, published by Les Editions du Boisé Inc., featured photographs of Dion and Angélil with a headline reading; 'Punishable by two years in prison!' "

The lawsuit also focused on a sidebar story in which Angélil

supposedly defended himself against the allegation, while, in fact, he did not comment to the newspaper, nor did he agree to give an interview. "Dion, the suit claims, has suffered 'humiliation, shame and dishonor' because of the article, which characterized her as a 'Lolita' and homewrecker." Dion's mother also claimed the adverse publicity could hurt her professional reputation. "She recently signed a deal with food distributor Maple Leaf to produce Maman Dion's pâté and other products," noted *The Gazette*. "In the first eight months of production, sales have topped the \$2 million mark, the lawsuit states. Besides asking for \$20 million in damages, the lawsuit requests that *Photo Police* be forced to publish the entire text of any future judgment against it, using the same space and headline sizes used in the edition carrying the Dion article. *Photo Police* has yet to file a response to the lawsuit."

The Montreal Gazette even went so far as to run a story itself about Angélil's annulment of his second marriage in a story in January 1995, after the Dion-Angélil wedding, in the guise of examining the annulment procedure in Quebec in general. "The dissolution of Angélil's second marriage was a much simpler affair. . . . Both he and his second wife are Catholics, they had a civil wedding, and the church recognizes only church marriages between Catholics. So no annulment was needed, just a certificate granted at the request of either of the parties on presentation of documentary evidence of the Catholic baptism of the partners and the civil wedding."

Despite the controversy exacerbated by the tabloids, most media took a decidedly non-controversial approach to the event. The *Canadian Press* wrote, "Celine Dion, Quebec's pop princess, married her long-time manager René Angélil on Saturday in 'the ceremony of my dreams. It was magic,' the singer declared at a news conference shortly after marrying the 51-year-old Angélil in the Quebec show-business equivalent of a royal wedding, which cost an estimated \$500,000. . . . The 26-year-old singer entered Notre Dame Basilica to shouts of 'Celine! Celine! from about 500

fans pressing against security fences. Her form-fitting gown was an explosion of tiny pearls and white sequins with a plunging neckline and an enormous train that required the attention of two bridesmaids."

And, in England, a few months after the wedding, newspapers there were intrigued by the wedding as well as the personal relationship between the couple, a relationship which, even in romance, can turn to business. "Although Canadian Celine recoils from listening to her own songs, a strict orchestra played the title track from her album, THE COLOUR OF MY LOVE, as she walked down the aisle. It was a grand affair with 13 brothers and sisters and 37 nephews and nieces and lots of other guests. The ceremony was at Montreal's Notre Dame Basilica, followed by a fivecourse champagne supper. The wedding cake was an alarming 12-foot high pyramid of profiteroles," London's Daily Mirror reported. Celine told the newspaper about her audition in Angélil's office when she was 12: "He asked me to sing in front of him and cried as I sang. He's a very sensitive man, he cries when he sees beautiful things. I love a man who cries a lot." She also confessed that she had begun to realize her love for René in 1989 but the pair kept their feelings under wraps. "We didn't want people in the music business to know about us, and I wasn't sure how his children would react. I had grown up with them and didn't want to lose their friendship. But then he got divorced, it didn't work with my boyfriend and I started to realize that we were meant to be together."

As the *Mirror* article observed, "Celine has remained good friends with René's children — Anne Marie, 17, Jean Pierre, 20 and Patrick, 26 — since she married and Patrick will roadie for her when she tours Britain in October this year." Noting that her album THE COLOUR OF MY LOVE had sold five times platinum in the United Kingdom, an achievement that put her on top with Whitney Houston, Barbra Streisand, and Mariah Carey, the newspaper acknowledged that her big break into the British

charts coincided with her honeymoon. "We were meant to have two months off, but the English record company called to say I was number one," said Dion. "So I came over, shot a video and did *Top Of The Pops*. My husband was very understanding, but then he is my manager."

From the outset, the wedding was designed to be of the fairy tale variety. Even with respect to Dion's wedding gown, no detail or expense was spared. The fashion pages of some of Canada's newspapers described in meticulous detail the creation of the gown. "The fairy-tale dress singer Celine Dion wore to her recent wedding was one of the fashion world's best-kept secrets," wrote Iona Monahan in The Montreal Gazette. "But the people behind the dress agreed to talk to The Gazette about the fantasy, the 90 yards of fine Italian silk and French lace, its shape and its inspiration. Mirella and Steve Gentile, owners of Bella di Sera, a St. Leonard boutique specializing in bridal gowns and evening wear, can thank their friends Della and Tony Meti for one of the biggest bridal-fashion contracts Montreal has ever seen. It started as one of those tell-a-friend things with the Metis recommending the Gentiles to Dion and her then-fiance René Angélil. 'Our first call, on a Sunday, came from Florida,' recalled Steve Gentile, who is also a caterer. 'It was from René. At first, I thought it was a joke. He said, 'Celine wants a fairytale wedding . . . do what it takes to make her happy.' No one mentioned money then and the tactful Gentiles declined to talk price, but an educated guess would give the gown a \$25,000 price tag." According to The Gazette, "for their first meeting, both Dion and Mirella Gentile came prepared with sketches and ideas. Dion, who has a model's figure, wanted 'a princess dress,' a romantic, full-skirted gown with a pretty sleeve. . . . Sketches were approved, fabrics ordered and fittings started with a muslin of the proposed style: a small-waisted, crinolined gown with a tight bodice, big sleeves, a 10-meter train and a curved decolletage designed to show a little cleavage. With the designer's cut, Dion's 23-inch waistline looked like 19, reinforcing

the singer's idea of an Age of Innocence style."

Approximately 1,000 hours of work would go into the sewing, beading and pearling of the gown, ultimately including two 10-meter trains, one of them detachable, a long veil and two wraps, one of white silk organza and another of white mink. Each time she met with the designers, Dion asked for more skirt for the dress so that the designers kept adding petticoats and crinolines. "The last fitting was two days before the wedding. Thirteen of the boutique's seamstresses and embroiderers worked that time through the night and on to 1:30 a.m. Saturday — sleeping in the store and cat-napping every now and then," said *The Gazette*. Added Steve Gentile, "Normally, we are not finishing a wedding dress in the middle of the night. We are used to doing the big lineups but this was different. It was very special for us. She's more than Quebec's daughter, she's Canada's daughter!"

"Three months before any dress had been discussed, Dion and her hairstylist, Louis Hechter of Salon Orbite, had ordered hairpieces in Paris 'just in case' for a bridal coiffure," The Gazette reported. "At the same time, the singer started to let her hair grow. 'Let's say she was projecting toward the end of the year,' said Hechter, who worked with Stefan Malo to design the braided hairstyle to go under mirella's bridal headdress of 2,000 Austrian crystals (over a wooden frame) that weighed approximately seven pounds! Enough to gouge into Dion's hairline. At 2 a.m. on Saturday, in the Hotel Westin Mont-Royal, Mirella (who also dressed the bridesmaids and other members of the bridal party) called Celine Dion to say the dress of her dreams was finished and waiting for her final approval. Dion invited her to her room where they talked dress and headdress and makeup (the singer does her own makeup but was guided by makeup artist Lorett Chiesa). 'I hope he will find me beautiful,' Celine said. He did and so did thousands of her fans who lined the streets of Montreal for the closest thing this country has ever had to a royal wedding."

Dion and Angélil skirted a middle ground with the wedding

where it came to balancing privacy with the public image that a star like Dion possesses. A press conference before the wedding reception, for example, was designed for public consumption while the actual reception was not. Sandro Contenta of The Toronto Star reported some of the more interesting aspects of the event, not covered in the official wedding album. "Celine Dion says she always dreamed of a fairy tale wedding. Yesterday, the queen of Quebec pop music got one, but she complained that it came with a price. 'I wanted the dress of a princess, like the one we dream of in our dreams, but I'm paying the price for it today because it's not easy to get around with this. It's very heavy,' said the 26-year-old, showing off her white, low cut, pearl studded silk dress with a train that trailed meters behind her. 'But I'm very happy to do it, especially for you, René, because I love you so much,' she added, turning to her tuxedo clad manager and now husband. . . . Then, with photographers snapping furiously at a news conference before the wedding reception, Dion gave Angélil three kisses and made as if to faint. . . . With those kisses, the public portion of the most talked about wedding in Quebec history came to pass."

The Star added, "There was so much pre-wedding hype in the Quebec media that even Angélil — a show business veteran who is credited with having packaged Dion into a multi-million dollar industry — was surprised. The much publicized names — Michael Jackson, Michael Bolton, Elizabeth Taylor, Barbra Streisand, Mariah Carey and, yes, even Bill Clinton — didn't show up. But none of that mattered to some 400 fans who waited for the bride's appearance at the Notre Dame Basilica in Old Montreal. When the only star they cared about emerged from a brown Rolls Royce and began her march up the historic steps, her fans screamed their love.

"Before Dion arrived, six buses and several limousines dropped off the 500 or so invited guests. There were a handful of Quebec artists but the only nationally known celebrities were former prime minister Brian Mulroney and his wife, Mila, and they were booed. . . . There was some controversy when Angélil banned all journalists and photographers from the ceremony and sold the exclusive photo rights to the gossip tabloid, 7 *Jours*, for \$200,000. The weekly will publish an album. About six hours before the wedding's start, a judge upheld the couple's right to keep uninvited reporters and photographers from entering the church."

As for the wedding album, it did provide an insider's view of the ceremony and the reception which followed. With regard to the primary cast, Dion was, of course, given away by her father, Adhémar, and was supported up the aisle and beyond by her eight sisters who were posed in an official photograph of the group. Angélil, for his part, had eight best men, including his brother, André, Vito Luprano of Sony, Paul Sara, his lawyer Jacques Demarais, Pierre Lacroix, Guy Cloutier, Marc Verreault, and Ben Kaye. The album photographed all of the guests, many of whom seemed to have as much to do with Dion's and Angélil's business arrangements as with old friendships, though it appeared many of these relationships coincided. In attendance, for instance, were principals like Lawrence Mammas, a partner in the Nickels restaurant chain, record producers like Christopher Neil and Barry Fryer, various individuals from Sony including Paul Burger and Richard Zuckerman, representatives of The Bay like Margaret and Bob Peter, and Carley and Barry Agnew. Band member Claude Lemay was there and so was legendary lyricist Luc Plamondon. Other principals represented the CBC, the Quebec Nordiques, the Montreal Canadiens, MuchMusic, MusiquePlus, and CTV. Also on hand were various personal assistants such as Dr. Gwen Korovin, Celine's ear, nose, and throat specialist. Notably present, too, were representatives of Cystic Fibrosis, who received a large donation at the reception. For the most part, outside of relatives and friends, the bulk of the representation originated in the music industry, not only in Canada and the United States,

but from Europe as well, not to mention music journalists and personalities. Notable was Claude J. Charron, editor of 7 *Jours* and the souvenir album of the event, and writer Georges-Hébert German, official biographer of Dion. Reception photos expanded the guest shots with Brian Mulroney and his wife, Mila, and Patrick Roy and his wife, Michele Piuze.

Reception entertainment included a roving magician and gaming tables, the cards for some of the games bearing the happy couple's "CR" logo. The wedding cake was monstrous. Much of the album, however, surrounded family tributes written for the couple, either separately or together, sibling reminiscences and testimonials outlining everything from nicknames to childhood incidents to frank admissions that people do not get together as much as they should, generally because of Dion and Angélil's busy schedule.

It was the rather homespun nature of the testimonials that served as fodder for media reports on the wedding and reception once the actual souvenir wedding album finally was published. If anything, however, the album reflected the innocence behind the extravaganza. Although Dion had wanted the wedding of a princess — lavish, expensive, memorable — it could not conceal an innocence about the notion of what that kind of display involves. In short, it ran the risk of being absurdly tasteless, yet seemed somehow tastefully, even childishly motivated, which tended to moderate the tastelessness a great deal. In a sense, it created in Canada, especially outside of Quebec, a kind of old wealth embarrassment over the shenanigans of the nouveau riche. In the end, it was the sentence of excess commuted by innocence.

At the same time, the event represented another mini-industry of profit and success surrounding the Dion-Angélil team. Writer Sue Montgomery was one of those to report the event to English-speaking Canadians, on behalf of the news agency, *Canadian Press*. "Celine Dion's father has had a loose piece of flesh on his tongue ever since falling on a nail as a child. Sister Denise has a birthmark

on her back that extends from her kidneys to her neck, while sister Claudette's left arm has a nasty scar after a run-in with a washing machine wringer," wrote Montgomery. "Mundane details to some, but enquiring Quebecers want to know it all. A limited release — 400,000 copies — of a glossy album of the singing superstar's wedding extravaganza last weekend, flush with such tidbits, sold out in just two hours Wednesday. Some store owners who didn't receive their shipment of the \$6.95 magazine, spent the day calming irate customers. Another shopkeeper said the magazine sold faster than lottery tickets on a multi-million-dollar jackpot day."

In Quebec, at least, there was a romantic notion behind all the interest, an expression of kind-hearted envy and even optimism that the potential for a wedding like Dion's might lie in anyone's future. "Just down the street at Inclination news stand," wrote Montgomery, "Francine Meloche was frantically taking orders for the album which she hadn't received. 'I could've sold more than 200 just this morning,' she said, adding that she wants a copy for herself. As she spoke, two more customers asked if the album had arrived. 'It's giving me goosebumps just talking about it,' said Diane Lamy, a Quebec government employee who described herself as a 'hopeless romantic. It's like the black duck who becomes a beautiful swan,' she sighed. 'She's going to be the next Barbra Streisand.'

"Publishing company Trustar Ltd. paid a mere \$200,000 for the exclusive rights to cover the nuptials. A souvenir newspaper of the wedding followed by the album Wednesday. Not everyone was as keen as Lamy to get a copy. 'Tacky,' said Patricia Girard at a lunch counter. 'It looks like it was hell and she (Celine) doesn't look happy at all.' Some people obviously care. Trustar can't keep up with demand. A paper shortage and a breakdown of the presses limited the first run to 400,000 copies but another 300,000 should be printed today, said president Claude Charron. He wouldn't reveal how much the company was making from the exclusive

product which combines the work of seven photographers." The article went on to review some of the rather mundane information the wedding photo album included, who likes to play bingo and go to the casino, the nicknames, just who got their fingers caught in a mousetrap.

But if this quaint — we're just like the rest of you except our daughter is a singing star — approach to the event was intriguing to many in Quebec, it was only because Quebec is generally so enamored by the American dream. Quebec isn't hypocritical about it either. The admiration is frank, though innocent, not taking into consideration that even the briefest of trips into Disneyland has an admission price. Rather, Dion's approach to the wedding of her dreams reflected the culture where she was born as much as it rather ostentatiously displayed the lack of true substance which actually exists when the dream becomes a reality. But no one in Quebec seemed to mind very much. It was a dream too many people could share or imagine emulating.

In English Canada, however, there was a cultural reaction of a different kind. Romance is repressed by the inherent propriety of the average WASP Canadian. For an English Canadian, if you're going to envy someone's lusty sampling of the American dream, you'd better do it in the privacy of your own bathroom. That way, everyone who actually wants material success can pretend they don't really want it at all, or if they do, they are at least *tasteful* about it. Although not typical in any way of Toronto's more politically-correct view of this kind of display, Marc Weisblott in *Eye Magazine* took a look at the wedding album too, applying a rather satirical gaze to the event, though in the end it became, in quite another way, as much without taste as some of the wedding fanfare itself.

"Zut alors! Or, loosely translated, what is this shit?" he wrote. "Hot off the presses, just over a month after the blessed event, published in both official languages, it's 100 pages of puritan wedding porn; a storybook-style chronicle of the vows, exchanged

between René Angélil, he of the unsavory orange glow and wagging gray ponytail, and Celine Dion, she of a gargantuan clan from Charlemagne and arguably the most ballyhooed bride since Lady Diana Spencer. Hence, the official Wedding Souvenir Album, assembled by Quebec dish rag 7 Jours, boasting a \$6.95 cover price — a sum that should quickly offset the \$200,000 shelled out for exclusive fawning rights. Presumably, the event's press embargo suggests Celine's core (read: French) following hasn't wilted in the wake of her big-time global (read: English) crossover, but rather has become even more voracious for further insight into every nuance of her existence. Better still when the 7 *Jours* publisher, editor, reporter and photographer are among the plethora of invited guests. It remains a wee bit perplexing as to why a prodigious 26-year-old pop singer, I mean chanteuse, would want to wed the manager who's exactly twice her age after having worked together since she was prepubescent — but this lavish commemoration of their nuptials strives to stifle such conjectures.

"Yes, it's just like being there, sort of: pics from preparations on that fateful Dec. 17 morning, the 3 p.m. ceremony at Notre-Dame Basilica, and the reception in a Montreal hotel ballroom; penetrating snapshot captions ('Even the dishes spoke of love,' 'No one dared disturb the happy couple,' 'These wonderful photographs speak for themselves'); and portraits of a slew of semi-notable guests (including Brian and Mila, Bob Peter from The Bay and Joely Fisher, neurotic sidekick to tv's Ellen). No sign of A-list wedding invitee Mariah Carey, though — maybe she was detained by Celine for sage advice on how to stay happily married to your manipulator. Of course, it's the father of the bride who ultimately knows what's best for his little girl, as implied in this ornery personal anecdote from 71-year-old Dion patriarch, Adhémar: 'When I was young, I pierced my tongue with a nail while tobogganing. I've carried the scar ever since.' Now that's cool."

Interestingly enough, Weisblott's "satire" was condemned by some as reflecting an anti-French sentiment in English Canada, a kind of sour-grapes because Dion hails from Quebec rather than somewhere else in Canada. The divisions in Canada, based on language and culture, sometimes are aggravated by the truly self-indulgent, the politically motivated. The afterglow of the Celine Dion-René Angélil wedding only served to expose that fact.

Celebrity weddings bring out the beast in many of us. For some, it is the extravagance. For others, it is the embarrassment that occurs when working class ambition collides with aristocratic self-indulgence. For others, it reflects an envy more easily denied by assuming a reverse snobbery. For others, in the case of Celine Dion's wedding event, it clarifies the bitter focus of the wide rift between two cultures who view a larger, more imposing American culture from two different points of view. In the end, there is little that is safe to say about the wedding of Celine Dion and René Angélil. Except that it was expensive, it was lavish, it was good business — and, in a strange, perplexing way, it was without hypocrisy. For much more than a decade Dion and Angélil had made no bones about their ambition. The wedding was in part a celebration of the fact that Celine Dion did not have much further to go to become the queen of pop divas.

Divadom

A diva's potential for sales are stronger than most people's because pop music, unlike rock music, travels worldwide. Someone like Celine is a global artist. She's really a dream for an international record company. Now you might ask, why there aren't more Celine Dions? But they're the hardest type of artist to launch, they're the most expensive artist to launch. But once you've got them in the orbit, you can go anywhere with them because you can take those power ballads anywhere. — Larry LeBlanc

There are no pop stars singers without pop songs. In our era of pop music, the genre is monopolized by songwriters and producers like David Foster, Diane Warren, Kenny (Babyface) Edmonds, and Jim Steinman who represent a revival of the heyday of producers like the legendary Phil Spector and who are teamed with singers by the record labels. These people hold the magical formula for making the melody of pop. There's a sense of theater built right into the music. It's less like hearing a song than seeing a brief theatrical exhibition. Each song is a kind of short one-act play, a postcard play. And when the lyrics are finally added, they complement the melody line, accentuating this sense of theater.

The presentation begins in the structure of the music. True

rock 'n' roll, focusing more on a primitive expression of dance, relies on repetition in its melody, generally speaking. Even if it incorporates a refrain, it tends to repeat the refrain. Modern pop relies on a kind of musical plot, a scaled down (some pop songs can stretch into seven minutes) opera, if you will. "Wagnerian" is the current term applied to the pop music penned by Jim Steinman, for instance. Whether or not the accompanying lyrics always complement the melody, the melody is constructed in layers, often beginning softly, gradually crescendoing into passion, before it either exits at a high pitch or returns to its soft beginning to accomplish its conclusion. Lurking inside these layers, there is a catchy melody which often refuses to leave one's consciousness. Afterwards, you keep humming it over and over. Afterwards, whether you're cynical about the fact or not, you feel somehow inspired.

Because this is the key to modern pop music — it is based on inspiration. It may not be a complex inspiration, a deep one, but it is inspiration just the same. Inspiring songs about love, about triumph, about patience. Inspirational anthems to be inserted into the religious service of our lives as a kind of comfort from the compromises we repetitively make each day. The melodies reach out, in a rather passionate fashion, to inspire us. After we hear a modern pop song, we come away inspired by the theatrical nature of the melody's plot.

But if there are no singers without songs, there is no theater without actors. No matter how inspirational the melody and the accompanying lyrics might be, pop music requires a theatrical performer to interpret it. This is where the likes of Barbra Streisand come in. This is what Whitney Houston does so well. This is what Celine Dion can do, arguably even better than her peers. They take the post card one-act play of the melody and interpret it for us. And they do it better than anyone else. The writers of these songs and the interpreters of these songs know how inspiration should be conveyed. The writers write songs specifically for individual pop singers to perform. The performers work with

songwriters who can create a melody to challenge their abilities, not only to convey the inspiration, but to accomplish the vocal acrobatics the various layers of the melody require. In the end, these singers are truly divas. The music, after all, is opera, theater, an inspirational story told in melody and lyric. Without the divas, the songs would not quite be theater. Without the songs, the divas would have nothing to perform theatrically.

The 1996 Olympic Games in Atlanta, for example, not only presented sport at its inspirational best but also pop music at its inspirational best, with Celine Dion performing The Power of the Dream (scored by David Foster, Linda Thompson, and Babyface) at the opening ceremonies and with Gloria Estefan performing Reach (written by Diane Warren) at the closing events. As Richard Corliss in Time magazine commented, who better than Celine Dion "could deliver the first song's potent, potentially risible message ('And since the dawn of man / the strength of just I can / Has brought together people of all nations') with Dion's strong voice, clear heart and straight face? Who but Estefan, brave survivor of a 1990 bus crash that broke her back, could give such autobiographical grit to her song of resilience? 'So I'll go the distance this time,' she intones. 'Seeing more the higher I climb.' And the audience soars with her." Yes, contemporary pop music is inspirational, though potentially sentimental, performed by talented singers who have adopted the glamorous trappings of operatic divas.

The word "diva" is Latin. It means goddess and was originally intended to refer to the likes of Venus or Hera. It belongs to a fraternal club of words whose paid-up members include "divine" or "divinity." Diva meant goddess until the year 1883, according to the Oxford English Dictionary, when we modernized the word by applying it to vocal music. The idea, it appears, was to come up with a single word to provide us with a goddess of song. Post 1883, "diva" comes to mean a distinguished female singer, a prima donna. This definition appears straightforward enough on the surface; pop divas are therefore distinguished female singers in

the popular mode. As for the concept of prima donna, this is a term still more accurately applied to opera.

But the definition of diva in the world of popular music becomes a little more complex when we examine some of the issues lurking underneath "divadom's" glossy surface. Perplexing questions arise. For instance, why are our divas generally imprisoned in a conservative middle-of-the-road world of values and behavior? Why do pop divas diffuse the impact of women on our society by imprisoning them in a middle ground which is, by definition, designed to be essentially ineffectual? And one also has to ask whether this middle ground exists because we, as a society, are truly comfortable there, or whether it exists instead to define a glamorous standard which, as some feminists insist, is nothing more than a marketing device intended to sell glamorous fashion commodities. Because where else do we find divas these days but in the glamorous world of pop? It is the women of pop music, whether wrongly or rightly, whom we elevate to the dizzying heights of glamorous aristocracy. These women are the entertainers we anoint as our standard of female beauty, sensuality, and femininity. More than that, married to the physically appealing standard of glamor, pop divas must deliver a product which does not offend our conservative tastes. Whether we are latently conservative as an audience or whether our conservatism is the result of successful manipulation of our tastes is another issue.

Few would disagree that pop is the kind of music that ultimately offends no one; it can travel a very conservative planet without rocking the cultural boat or seriously violating any ethnic sensibilities. As *Billboard's* Larry LeBlanc points out, "outlaw" diva Alanis Morissette can't really overcome the old-fashioned abhorrence of the revolution underlying rock music to rule the charts in, say, Southeast Asia the way that Celine Dion's MOR pop music can. Never mind that both women have beautiful voices and a talent for applying their interpretation to a piece of music until it explodes into an emotional pitch so agonized and passionate it ends up

residing outside the realm of mere melody. The voice may be the primary requirement for scaling the heights of female pop music, but in the world of *divadom* there are a wide range of other standards to be met. To be the goddesses we wish them to be, they must adhere to a perceived comfort within the middle ground. They must reinforce a status quo in which most of us can safely hide.

As Richard Corliss notes in a special feature in *Time* magazine on contemporary divas (featuring Celine Dion on the cover), "thrushes from the West like Carey, Houston and Dion, make music that is meant to be liked. Most of their music is not just middle of the road; it tiptoes on the white line in the middle of the middle of the road. And in social norms, the pop diva adheres to the proper side of the gender split in music. She is expected to be a sister before a lover; the operative slur word is 'nice.' Pop is the boarding school where the good girls live. Rock is the shooting gallery where the naughty boys hang out....You will find no mosh pit at a Celine Dion concert. Police dogs could patrol the place without detecting a hint of incense, marijuana or egregious body odor. Few safety pins impale the eyebrows of those attending. Even at her concert last week in Madison Square Garden — a building where a riot recently erupted at a boxing match, in a town not noted for its decorum — Dion's New York fans were as well behaved as churchgoers. And indeed they were true believers in the movable Cathedral of Celine. Bathed in this soft rapture, one member of the faithful occasionally exclaimed, 'We love you, Celine!', but so discreetly that the star couldn't hear him. It was a prayer that needed to be expressed to the deity in the limelight. No reply required. . . . Still, the Garden crowd responded to her theatrical passion with an almost too muted reverence. Finally, halfway through the fifth song — All By Myself, the Eric Carmen torching of Rachmaninoff's Piano Concerto No. 2 — Dion shattered the devotional quiet. By pushing the last note of the phrase 'Don't wanna be all by myself anymore" up an octave, putting a

scalding rasp into it and finding the perfect pitch for rage, she transformed the song's silky sulkiness into an ecstasy of agony. A vocal trick, yes, but an effective one, for at that moment the Garden theater jolted to raucous pop-concert life. It became a place of cheers and applause — aural gratitude for a pop diva supreme."

Corliss is aware of the need for the goddess to comply, parodoxically, with the status quo to achieve a divine nature. "It's a small miracle — cynics would say a miracle of marketing by canny record executives — that the divas have flourished." In truth one hardly needs to be that cynical to notice the skill and persistence of the marketing. It comes at you from so many directions, as Corliss notes. "There's no ignoring divadom these days. If you don't listen much to pop music, you will still hear the top thrushes at the movies," he said. "The insistence of the melodic lines in these songs, and the persistence of their air play, makes them part of the sound track of modern life. If you don't hear these tunes on the elevator, you may well be humming them there. And if you avoid the movie house, divas will find you at home. Billions of tv viewers watched Dion provide the climax to the Atlanta Games' opening ceremony with a hymn to the Olympic spirit. . . . Another billion or so tuned in this Sunday, aiming to see Estafan close the Games with the anthemic Reach. . . . Divas can't climb much higher. They nestle at or near the top of their country's music charts. Some, like Dion, Houston and Mariah Carey — not to mention, for the moment, Canada's crack-voiced outlaw diva Alanis Morissette — have been on the Top 10 lists in Europe, The Americas and the Pacific Rim simultaneously. More important, most of these women are damn fine singers. They are a link between the great voices of the past (think of Ella Fitzgerald, Ethel Merman, Edith Piaf) and the ears of people who can't get attuned to the howling self-pity of much contemporary rock but aren't ready to give up on pop music." Corliss raises the key question about the nature of divadom — the balance required between natural talent and manufactured glamor in the diva's creation — while pointing to the history of divas and images

of women in the 20th century as a way of understanding this pop culture phenomenon.

In the January 1950 issue of Life, Winthrop Sargeant reviewed the role of women in American society during the first half of this century, with special attention given to "Gibson" girls and "Glamor" girls, predecessors of our pop divas. Included is a photograph of a, yes, very sultry, sensuous, even glamorous Ethel Merman who debuted in 1930 in George Gershwin's Girl Crazy, featuring the song I Got Rhythm. "A prejudiced survey of their role in the first half of our century," Winthrop wrote, "shows that, like cycles of history, they rise and fall — and are falling now." The article breaks down the first 50 years of American women into five distinct decades: 1900 to 1910 was the age of the Gibson Girl; 1910 to 1920 was a dark age, Dark Age One, to be precise; 1920 to 1930 was the age of the Vamp; 1930 to 1940 was Dark Age Two; 1940 to 1950 was the age of the Glamor Girl. 1950 was the dawning of Dark Age Three. "The two main current theories about the women of today may be roughly outlined as follows," wrote Sargeant. "Theory No. 1 is that women are getting more and more freedom and hence are getting better and better; Theory No. 2 is that women are getting more and more freedom and hence are becoming a group of hopeless neurotics. To these I should like to add a third theory, based on an objective and comprehensive study of woman's physical appearance. This dispassionate, scientific study would indicate that women are getting neither better nor worse, but that they go through cycles of civilization and decline very much like the cycles of history described by Arnold Toynbee and Oswald Spengler. My theory has an advantage in that it can be readily checked by anybody with a comfortable chair and a pile of old magazines."

The key words here are: *a comprehensive study of woman's physical appearance*. Sargeant maintained that these cycles of female rise and fall had a relationship to war or hardship, that when war or hardship took place, women become more feminine and seductive

in response to men becoming more heroic. The Gibson girl, for example, had dignity, "a quality woman always has during periods of civilization and that she rapidly loses in periods of decline," especially since she was responding to the "ideal male of the period" who was "dominating, masculine and impressive." Said Sargeant, "When Anna Edson Taylor went over Niagara Falls in a barrel and Carry Nation sold miniature hatchets in the Senate gallery, the Gibson girl saw these revolutionary gestures as what they were — symptoms of neurosis and impending decline."

Mr. Sargeant approaches the subject of women mostly from the standpoint of glamor. In the nearly 50 years since little emphasis has been removed from the importance of glamor. All that has changed is that we are a little more subtle about it. We apply a politically correct standard of behavior to our refusal to change, but pop divas continue to be required to bring glamor to their performance. There's something artful about it all that is only made excusable by their powerful voices and legitimate talent.

Even a cursory examination of the history of divadom this century points out its relevance to feminist issues. Feminism may have come quite a distance towards popular acceptance in the past one hundred years, but so has the backlash against it. Our pop divas are presented as tending to straddle both sides of the issue; on the one hand, they convey an assurance and independence that any feminist would want to espouse; on the other, these stars are glamorous by a male standard which feminists are quick to point out should be rightly outside the male domain. Their songs may voice some kind of deep emotional truth but they do so in a non-revolutionary way. Even possessed of great wealth and career acumen, even self-assured and confident, they do not threaten the status quo. Instead they reinforce it. And this appeal is marketable.

The question of marketing becomes a matter of pure economic investment and return when one examines the business end of developing a pop diva. As Larry LeBlanc points out, "A diva's potential for sales are stronger than most people's because

pop music, unlike rock music, travels world wide. Someone like Celine is a global artist. She's really a dream for an international record company. Now you might ask, why there aren't more Celine Dions? But they're the hardest type of artist to launch, they're the most expensive artist to launch. But once you've got them in the orbit, you can go anywhere with them because you can take those power ballads anywhere."

What this all boils down to is that the long tradition of pop divas has been defined, not only by the economic factors in their success, but by the related suggestion that their music maintains its popularity by clinging steadfastly to the middle of the road. Further, the middle of the road is the territory that broadens their global acceptance. The tradition clings to the attributes of glamor, not only as a direct and indirect marketing tool, but as a reflection of what the middle of the road world seems to want in its stars and to want to emulate itself. It is no wonder, therefore, that the pop diva has resisted change since singers like Ethel Merman popularized Broadway's elaborate musicals. This traditional conservatism continues because each generation of diva tends to influence profoundly the next generation of performers.

In addition to their inspirational message, glamor, and apparent faith in the status quo, pop divas have one other common characteristic, an appreciation for and ability to sustain a long career. Going all the way back to Ethel Merman, for example, career longevity has been a major factor in their success. So too with Barbra Streisand. By contrast, rock singers have a tendency to come and go. In Canada, in the early days of her career, Anne Murray confessed that she wanted to be a rock singer, but she didn't pursue that musical direction, because she wanted a long career. "I don't want a hit. I want a career. I want to sing all my life," Celine Dion herself has said. One has to wonder if the longevity of the performer has more to do with the inherent longevity of the status quo than with the talent of the performers themselves.

Placing such speculation aside, there is no doubt that our

contemporary era in pop music has witnessed a major revival of the cult of the diva. As Lee Chestnut, vice-president of music programming for VH1 remarked in *Billboard* concerning Dion's success, "her emergence has come at a time when people are tired of hearing doom and gloom and 'I hate myself.' I think pop music has been positioned for a comeback for a while. Celine was in the right place at the right time and rode the wave." The success of Celine Dion and cohorts Whitney Houston, Mariah Carey, and Gloria Estefan surely announces the comeback of pop music and recalls the last great era of pop when Barbra Streisand was queen.

Celine Dion may have been born in Charlemagne, Quebec, but she comes from a long line of pop divas, including Edith Piaf, for example, and more immediately, Barbra Streisand. Should there ever be a movie about Piaf, several critics have suggested that Dion would be the natural choice to play the part because of her respect for Piaf and because her own glamor would likely translate well to the movie screen. Dion herself has hinted for some time that she would like to give movie acting a try, following in the tradition of Barbra Streisand, who has served a a model for her own career. As Larry Leblanc comments, "certainly the two biggest influences in her career have been Ginette Reno and Streisand. There's probably a slew of others I'm not aware of, but those are certainly the most apparent. She certainly eclipsed Ginette, but I think somebody like a Streisand, to Celine, is a career marker. In fact, there was a picture of them together at some kind of function last year, and I was kind of chuckling. It was a charity function of some sort. She would have been like a little eight-year-old around Barbra. She holds her in such awe." LeBlanc finds that Dion, like Streisand, is able to take a song and make it her own. Like Streisand, "she's a great actress" and "a singer's singer."

Dion has admitted to being star struck by Streisand during an

interview with E. Kaye Fulton in *Maclean's*. "Dion recalled that three bars into *Beauty and the Beast* at the Academy Awards, during a brief moment before two billion television viewers, she almost lost her breath when she opened her eyes and saw Streisand's green eyes staring back at her from the audience. Declared Dion: 'I don't admire Streisand just because she's American. Singers are like members of one big family, like athletes and actors.' "Dion has indeed invited Streisand into her own musical family, recording a duet with her on her forthcoming album, the follow-up to FALLING INTO YOU.

Still the reigning bestselling performer of popular music, Barbra Streisand is a logical choice for Dion to emulate, straddling the way she does the eras of the musical comedy divas of the past and the touring divas of the present. Most of all she presents Dion with a model of the intensity of will needed to remain on top. It's not, after all, according to Dion, a matter of competition. It's a matter of being the best you can be. "I'm not in competition with anybody but myself," she has said. "My goal is to beat my last performance."

Singer and songwriter, then actor and filmmaker Barbra Streisand was born on 24 April 1942 in Brooklyn, New York, to Diana and Emanuel Streisand. Her father, who was known as a scholar and teacher, died when his daughter was barely a year old. Like Dion, Streisand came to the music business at a young age; unlike Dion, she managed to maintain high marks at school. But the call of the performing arts soon grew too powerful to be ignored and she decided to try her hand at show business. Reportedly arriving without encouragement or guidance of any kind, she entered a singing contest at a small club in Manhattan, called The Lion, and came out the winner. As early as 1960 she began to develop a dedicated and continually growing audience which followed her to more visible and prestigious night club venues in New York. There, she came to the attention of music industry talent scouts.

Shortly she was appearing on Broadway and received a great deal of public attention for her performance in *I Can Get It For You Wholesale*. Eventually she was awarded Variety's 1962 New

York Drama Critics Poll Award and received a Tony nomination. At the same time, she embarked on a recording career, signing with Columbia Records. Her 1963 debut album, THE BARBRA STREISAND ALBUM, was so successful it became the top-selling record by a female singer in the United States. Her success was soon acknowledged by the recording industry when she became the youngest recipient of two Grammy Awards, one for the album and one as vocalist of the year. Ultimately she would go on to win eight Grammy awards in a number of categories. After her debut album, her success continued. Both the second BARBRA STREISAND album and the third album went gold, then PEOPLE became a number one album.

While succeeding on record, Streisand continued her Broadway career, portraying Fanny Brice in a lavish production of *Funny Girl* in 1964. The musical, along with its leading lady, became a massive hit. Soon she was on the cover of *Time* and had been nominated for yet another Tony. The musical was also a hit in London and critics there voted her the Best Female Lead in a Musical for the 1965-66 season. Having conquered the worlds of vinyl and Broadway, Streisand soon signed a 10-year contract with CBS Television to star in and produce a series of television specials. It is important to note she was able to negotiate complete artistic control over these projects. The first special aired in 1965. *My Name Is Barbra* won five Emmy Awards including a personal award for Streisand herself. She followed the special with four others, including *Color Me Barbra*, which was also an outstanding ratings and critical success.

Recording albums which ranged in genre from classical to pop, Streisand has, over the years, had 37 albums certified gold, 21 platinum, and seven multi-platinum. JUST FOR THE RECORD . . . , a 4-CD boxed set of numerous unreleased numbers, became one of the bestselling boxed sets ever released, reaching platinum status. Her most successful album has been GUILTY, which was released in 1980 and teamed her with Barry Gibb. Streisand has amassed

millions of album sales to the point where she is the world's largest-selling female vocalist.

Although it is now common for pop divas to be attracted by the movie industry, Streisand was virtually a pioneer in successfully adding acting in movies to her list of youthful achievements. And over the years she would move into the complex areas of movie production and direction as well, while continuing to maintain her successful recording career. She was still only 25 years old when she arrived in Hollywood to appear in the movie version of *Funny Girl*. Her debut was nonetheless auspicious. She received the 1968 Oscar for Best Actress, as well as a Golden Globe Award. A soundtrack from the film was also a tremendous success and, since then, most of her movie endeavors have been accompanied by hit albums.

Among her other early movies were 1969's Hello, Dolly! and 1970's On A Clear Day You Can See Forever. Venturing into comedy she also starred in films such as The Owl And The Pussycat and What's Up, Doc? before forming her own film production firm, Barwood, which soon produced Up The Sandbox. For some, this film was an early indication of a feminist sensibility which would later be the flagship of her interest in political issues, a direction which has been somewhat uncharacteristic of the pop divas who have followed her. She was nominated for a second Academy Award as best actress for the film The Way We Were and the song of the same name topped the charts. Then she continued in the fields of comedy and musicals with For Pete's Sake and a reprisal of her Fanny Brice role in Funny Lady, before winning another Oscar, this time for co-writing the song Evergreen from the movie A Star Is Born. Her next two movies include The Main Event, again with Ryan O'Neal, and All Night Long, a rather unique comedy endeavor with Gene Hackman. But Streisand was just coasting at this point; her most demanding project lay ahead.

That project was the movie *Yentl* based on an Isaac Bashevis Singer short story. And it was the first time a woman directed,

produced, wrote, sang, and performed a difficult role in a major motion picture. The film was apparently worth the arduous labor which surrounded it. It earned five Oscar nominations and won for Best Original Score. It also won a Golden Globe for Best Motion Picture Musical or Comedy. Of interest, however, bearing in mind the way success and critical acclaim have always come to Barbra Streisand early, was the Golden Globe she received as Best Director on her first time out as a director of a film.

More awards were to come, however. After her 1987 movie *Nuts*, Streisand produced and directed *The Prince Of Tides*, as well as taking one of the starring roles, and the film earned seven more Oscar nominations. Streisand became only the third woman ever nominated as Best Director by the Directors Guild of America. In addition, while serving as the executive producer on the televised *Serving In Silence: The Margarethe Cammermeyer Story*, the program earned three Emmy Awards and a Peabody Award. Since then, she has directed and starred in the romantic comedy, *The Mirror Has Two Faces*, coincidentally composing the film's main love theme and performing a related hit duet with Bryan Adams.

In the last decade or so, Streisand has performed in public again, after a hiatus dating back to 1972, but the motivating force behind the concerts has been political or charitable fund-raising. The first of these full-length concerts took place just prior to American elections in 1986. Her goal was to raise campaign funds for candidates who shared what were termed "her social concerns." The result, *One Voice*, was staged at the Streisand Center for Conservancy Studies, formerly her home in Malibu, California. The funds raised in this concert helped elect five candidates to the United States Senate and generated \$7 million in revenues which were channelled through The Streisand Foundation. Even when, in 1994, she did a concert tour of 26 performances, some of the funds were directed to various charities. According to reports, more than one million phone requests were received in the first hour that tickets went on sale. More than \$10 million was raised

for significant charitable causes in the various locations in which she performed. As well, \$3 million went to AIDS organizations, while additional gifts found their way to other socially conscious movements. At the same time, *Barbara Streisand: The Concert* became the highest-rated musical event in HBO history, earned five Emmys, a Peabody Award and other honors, while the double album recording, BARBRA — THE CONCERT, went platinum.

Other noteworthy achievements include receipt of the 1992 Commitment To Life Award from AIDS Project Los Angeles and the American Civil Liberties Union Bill Of Rights Award. Streisand has also spoken publicly about the obligations of artists to participate in the political process, chiefly during a 1995 address to Harvard University, sponsored by the John F. Kennedy School of Government. Brandeis University has bestowed on her an honorary degree, Doctor of Humane Letters, and she has recently donated her 24-acre Malibu estate to the Santa Monica Mountains Conservancy.

While on the one hand, Streisand is a fitting career model for anyone in the pop diva realm, some of her additional achievements make duplications of the feat difficult. Although Dion can suggest there are similarities in her career to developments in Streisand's career, especially in the vocal hit category, to suggest she is in pursuit of such a level of accomplishment tends to broaden the parameters of the pop divadom genre considerably. While Whitney Houston has rather easily adapted to movies as a byproduct of an extremely successful singing career, it is Streisand's influence as a political activist and philanthropist, as a film producer and director, that makes surpassing her astonishing achievements difficult.

Anne Murray is another female performer Celine Dion has cited as a model for her career. During the 1997 Juno Awards, where Dion received the International Achievement Award along with alternative diva Alanis Morissette and country diva Shania Twain, Dion acknowledged Murray for paving the way for those who now follow

along her path. Dion was reminding the Canadian musical community that Anne Murray was the first Canadian female entertainer to become an international star. Murray, who has developed a long and lasting pop career out of what began as a folk and country leaning, came on stage to share a moment with Dion, acknowledging the acknowledgment. Certainly, it seemed appropriate. Over the years, Murray has chocked up more than 40 million in album sales herself and is appreciated in many corners of the globe.

But this acknowledgement, as Martin Melhuish sees it, is of a different kind than the influence Barbra Streisand represents for Celine Dion. He doubts Anne Murray was a musical influence on Dion the way artists from Quebec like Ginette Reno certainly were or, for that matter, the way someone of the fame of Barbra Streisand could be. "I still believe Dion was being polite," he says. "I can't believe that Anne Murray was a major force in her life. She's a great example, if you're Canadian, of a woman who's sustained a career. But I can't see it from the early days. I'm not sure she even knew Anne Murray existed."

But polite may understate Dion's motivation too. After all, Dion's acknowledgment of Murray has a certain amount of truth in it. Differing levels of talent, creativity, and career management aside, it is still only a relatively recent development that the international market has been receptive to Canadian performers, especially if those performers have been female. If Celine Dion has, for much of her young life, been keeping an eye on Canadian performers who have appealed to the international market and who have sustained a long career, she would have to include Anne Murray in that scrutiny.

If Celine Dion has earned the place of Anne Murray as Canada's most popular performer, a few million in sales above her Canadian contemporaries Alanis Morissette and Shania Twain, she also shows the potential for becoming the most popular diva in the world, reigning over fellow international stars Whitney Houston, Mariah Carey, and Gloria Estefan.

Global Diva

Celine exceeds the boundaries of talent. I don't know if she will reach the heights of Barbra Streisand, but there's nobody else in the race. — David Foster

I really like Mariah and Whitney and all those great talented people, come on! They're amazing. If people think I'm similar to them, it's a wonderful compliment. I'm trying, of course, to do my own style, the way I feel my songs, of course. I'm not trying to copy. There's one Whitney Houston, there's one Mariah Carey and I think I'm doing what I feel about my songs. — Celine Dion

"Global Diva" is the title *Time* magazine gave to Celine Dion in the 1996 feature "Viva the Divas!" The article briefly profiled the careers of "Prima Diva" Whitney Houston, "Diva Du Jour" Mariah Carey, and "Diva Gloriosa" Gloria Estefan, with passing reference to "AntiDiva" Alanis Morissette, "Diva Angelic" Enya, "Diva Dramatic" Annie Lennox, and "Country Diva" Shania Twain — a sort of quick taxonomy of contemporary pop divas. While Dion had been dubbed "Queen Celine" several years previously in Canada's premier news magazine, *Maclean's*, receiving the highest honor in divadom from the world's premier news

magazine, Time, indeed announced her coronation globally.

While the international press in 1995-96 seemed to be staging the "Diva" Olympics, with Dion, Houston, Carey, and Estefan the front runners in the most glamorous of entertainment events, Celine Dion remained humble, even as she appeared to be leading the race. Billboard's Chuck Taylor noted that Dion had crossed "the elusive line into superstar status around much of the world, joining a short list of female vocalists — Mariah Carey, Madonna, Whitney Houston, and Gloria Estafan who have achieved genuine household-name status in the past 10 years." He also noted — along with her "soaring, cinematic soprano" — her "warm, accommodating personality." When news journalist Alan Corr compared her achievements to those of Whitney Houston and Mariah Carey, she took this as a compliment. "Any time! It's an honor. Hahhaa! I really like Mariah and Whitney," Dion has said, "and all those great talented people, come on! They're amazing. If people think I'm similar to them, it's a wonderful compliment. I'm trying, of course, to do my own style, the way I feel my songs, of course. I'm not trying to copy. There's one Whitney Houston, there's one Mariah Carey and I think I'm doing what I feel about my songs. Of course it's a compliment." As Billboard editor Larry LeBlanc comments concerning Dion's place in this competition of divas for supremacy, "She's probably the most unshowbizzy of any performer I've come across." A global diva yet still homespun — this is the image we have of Dion once placed in the gallery of contemporary pop divas. A tour through this gallery with special attention paid to the profiles of Whitney Houston, Mariah Carey, and Gloria Estefan not only enhances our understanding of Celine Dion's character but also takes us into the heart of contemporary pop culture.

If any performer can take credit for ushering in the modern era of the pop diva, it is Whitney Houston. Like Celine Dion, Houston emerged from a musical family which tended to encourage her youthful interest in singing and her drive to become a musical star. Born 9 August 1963 in East Orange, New Jersey, Houston's mother, Emily (Cissy) Drinkard had also begun singing in a family environment. Music was already her professional career. Houston's father, John, was his wife's manager for some of her career, but he elected to stay home to look after his daughter after she was born. "He was mom's support network while she was out on tour," Whitney has said. "He changed diapers, cooked, did my hair and dressed me, all the while providing Mom with advice and answers."

As for Cissy, her career began as part of the family gospel group, the Drinkard Sisters, who were signed to RCA She also performed with Dionne Warwick's first group, the Gospelaires, and formed the four-piece group Sweet Inspirations which provided session work for such acts as Elvis Presley and Aretha Franklin. As Whitney recalls, "being around people like Aretha Franklin, Gladys Knight, Dionne Warwick and Roberta Flack, all these greats, I was taught to listen and observe. It had a great impact on me as a singer, as a performer, as a musician. . . . It was so natural to me that when I started singing, it was almost like speaking." At the same time, Cissy maintained a solo career, releasing three albums from 1977 to 1980. It was in her function as Minister of Music at the New Hope Baptist Church, however, that Cissy provided the initial musical opportunity for Whitney, where she first performed in public, at the age of 11. "I was aware of people staring at me. No one moved. They seemed almost in a trance. I just stared at the clock in the center of the church. When I finished, everyone clapped and started crying. . . . God gave me a voice to sing with. And when you have that, what other gimmick is there."

Like Celine Dion, Houston is described by many as down to earth and, like Dion, makes much of the influence on her of her close family ties, in this case augmented by a strong Christian faith. Her brothers, Michael and Gary, are both involved in her career. The former handles business responsibilities while the latter is also a singer who shares the stage with her, singing back up or duets with her.

But Houston first drew public notice because of her beauty. She enjoyed a successful career in modelling while her singing career was in the developmental stage. Appearances on the covers of such magazines as Glamor and Seventeen and inside the pages of Cosmopolitan and Young Miss also led to some acting roles on television, in comedies like Silver Spoons and Gimme A Break. By the time Houston was 20, she was signed to Arista Records by its president and founder, Clive Davis. Davis was so intent on his discovery and his personal involvement with her career, he added a provision to her contract that requires her to go with him if he ever moves from Arista. Although critics have implied that Davis controls the strings of Houston's career, Houston denies it. "I don't like it when they see me as this little person who doesn't know what to do with herself — like I have no idea what I want, like I'm just a puppet and Clive's got the strings. That's bullshit. That's demeaning to me, because that ain't how it is, and it never was. And never will be," she told Rolling Stone. Nonetheless, Davis did take a great deal of control of Houston's career, investing a reported \$250,000 and two years in the song-writing and production of her first album WHITNEY HOUSTON. The album debuted on Valentine's Day in the United States in 1985. At first, response was slow. Eventually, however, the album took off, selling 14 million copies, a debut mark that was not shattered until Alanis Morissette's U.S. debut with JAGGED LITTLE PILL. Aiming Houston's first major single at the African-American market, You Give Good Love was released in July, becoming not only an R & B hit, but a crossover mainstream pop hit as well, peaking at number 3. This was followed by Saving All My Love For You which, thanks to a stylish video, eventually caught the attention of radio stations and album buyers, despite a slow start. Houston received the Grammy Award in 1986 for Best Female Pop Vocal Performance for the song, an award presented to her by her cousin Dionne Warwick. She was also nominated for *The Greatest Love Of All* at the Grammy Awards in 1987.

Shortly after Houston embarked on a world tour which included not only all of the material from her debut album, but incorporated songs previously recorded by such artists as Frankie Laine and Jennifer Holliday. By the time she toured a second time, Billboard in the United States had named her their Artist of the Year in 1986 and she had won five American Music Awards in early 1987. Nineteen-eighty-seven also saw her release the single, I Wanna Dance With Somebody, which not only topped the charts in the U.S., but earned her another Grammy Award for Best Female Pop Vocal Performance. Her second album, WHITNEY hit the top of the charts in both the United Kingdom and the United States, this latter achievement in the first week of release, making her the first female solo artist ever to do so. The album sold five million copies in its first six months of release and produced four number one singles, eventually becoming one of the bestselling albums in the U.S. Strangely enough, her first album continued to sell nearly as well, accounting for its reign as a record-breaking debut album.

Despite critics who claimed she did not truly feel the pain that her material seemed to require in its presentation, she continued her Grammy nomination spree in 1987 for Song of the Year for Didn't We Almost Have It All. For her part, Houston replied, "I do sing from my soul. I'm only 24, so I haven't gone through as much as Billie Holiday. I wasn't a drug addict, I've never felt dark and melancholic. I had a good childhood, no tragedies, and I can only sing from my own life experiences." Houston, until this time, expressed a wariness of the world of politics, but soon she became involved in the 1988 Nelson Mandela Tribute Concert in the United Kingdom, joining such luminaries as Phil Collins, Al Green, Peter Gabriel, George Michael, Stevie Wonder, and

Roberta Flack, though the American version of the telecast of the event edited out references to the concert's political motive. Houston, it was noted, while she was a model, had refused to promote firms which had branches in South Africa. Houston did some additional touring when she appeared with the musical duo The Winans. Luther Vandross and Dionne Warwick also appeared periodically in what was primarily a gospel tour.

The Grammy nominations continued, one for Best Female Pop Vocal Performance in 1990 and again in 1991 for *I'm Your Baby Tonight*. She was beaten by newcomer Mariah Carey's *Vision Of Love* that year. Said Houston, "People who go out and buy me, buy me for me. Furthermore, I come out first anyways. . . anybody that's gonna come has got to come after. They don't say I sound like Mariah Carey, they say Mariah Carey sounds like me, you get what I'm saying?"

Houston's third album, I'M YOUR BABY TONIGHT, did not sell well, however, and the results of a tour in the early 1990s was also disappointing for promoters. Critics were scathing, noting the lack of passion in her performances. Nonetheless, Houston was now utilizing her reputation as a performer on a series of fundraising concerts and recordings, raising funds for such causes as the civilian victims of the Gulf War and for Kurdish refugees, providing her with recognition from the American Red Cross for her efforts.

Like Celine Dion's marriage to René Angélil, Houston's decision to marry rap artist Bobby Brown resulted in a great deal of controversy. Brown, the father of three illegitimate children, a man reputed to be a womanizer, seemed a strange choice of mate for a gospel singer turned pop diva. Tabloid and newspaper writers had a field day, not only sentencing Brown to charges of adultery but accusing Houston of a gay relationship with a close friend from her late teens. Briefly separated, the couple reunited. But Brown's fascination for the gospel-belting Houston remains a mystery. Incidents like the death of his chauffeur in a hail of

bullets in 1995 do not help the cause. As Houston explains their relationship, "I know that Bobby loves me and I love Bobby. We're very much in love and we're having a great time. That comes and goes. It doesn't happen like that all the time. Sometimes I wake in the morning and it's, like, Get away from me today. It's normal. I don't know how else to explain it. Bobby and I are very, very normal people. You know, like married couples, we go through our shit and we fight like dogs. But it's very normal. We don't have any open relationships. That's bullshit. You think I'm going for that, you're crazy! No way! Either I'm number one or nothin' at all. I don't play second fiddle for a guy. And neither does he."

Houston continued to endure, moving grudgingly into the movie business in the film *The Bodyguard*, produced by Kevin Costner, the movie's co-star. It was reported that Houston delayed on the project. Telling *Rolling Stone* that she was "scared" and that she was worried about failing, it took her two years to finally decide to make the movie and this only after Costner promised to help her. The movie was a great success, however, especially at the box office. The song *I Will Always Love You* from the movie was also a tremendous success, while the movie sound-track went on to sell 22 million copies worldwide.

Houston's musical output, compared to other pop divas like Celine Dion, has been less than some fans appreciate. But she has managed to appear in two more movies, *Waiting To Exhale* and *The Preacher's Wife*, and has made much of parenthood in recent years, as mother of Bobbi Kristina, an experience she has described as "the ultimate." On a number of other occasions, she has lamented being near or at the top of the pop diva realm, confessing that it isn't "fun" and suggesting she questions the motivations of those around her. "You know, they say it's lonely at the top — they ain't lying. It is. You've got all these people around you, but in the long run, you don't know what their agendas are," she said in the January 1997 issue of *Premiere*. Celine Dion shows no such reluctance.

Like Whitney Houston, Mariah Carey has had difficulty keeping her personal life out of the tabloids and the mainstream media, a fact further complicated by her reputation for being spoiled and difficult. Like Dion and Houston, she possesses the multi-octave voice, the prerequisite for all aspiring pop divas. Like Dion, she married the man who did the most to make her career a success. Unlike Dion, she was unable to make the marriage last. In late May 1997 *The Washington Post* confirmed rumors that Carey and Sony music executive Tommy Mottola "are moving on and away from each other. In a joint statement, the couple said they had 'mutually and amicably' agreed to a trial separation, but would remain friends and continue their professional relationship."

With a new album from Sony expected in August of 1997, as well as a new single expected a month earlier than that, both of them called Butterfly, Carey was reported at her difficult worst where the album was concerned, the result of a battle for creative control which quite literally took to the streets at the end of April when she reportedly was involved in a shouting match with her long-time producer Walter Afanasieff. According to The New York Daily News, Carey was witnessed on the streets of New York screaming at the producer which culminated with her firing him. Speculation surrounded jealousy on the part of Carey over Afanasieff's romantic interest, Samantha Cole, who is making an album with producer David Foster. Later, however, it was denied that Afanasieff was fired and that the fight was over Cole. Instead, the disagreement was termed a conflict over her creative position on the album. Said MrShowBiz, "she should have been protecting her voice. We hear that she can curse you out in seven octaves. That's murder on the vocal chords, dear."

Born 27 March 1970, on Long Island, New York, Carey is the daughter of a white opera singer and a black Venezuelan aeronautical engineer. The story goes that Carey demonstrated her musical abilities early, when she was only two and a half years old, picking up a cue her mother had missed while rehearsing, then

singing it perfectly in Italian. Her mother would later say that her daughter possessed perfect pitch, and, believing she was gifted, enrolled her in voice lessons when she was only four. Her parents divorced when she was three, apparent victims to familial racial prejudice. Carey was raised by her mother alone. The result was an insecure childhood aggravated by the family's continued moving from one Long Island and New York City location to another. As a result, she has admitted to growing up with a great deal of instability in her life. "It was scary growing up like that," she told Q Magazine in 1994. "I never really felt stable. I always felt the rug would be pulled out from under me. I guess when you're part Irish and part Venezuelan, you're not completely connected to any one thing. You grow up like that in a suburban neighborhood with rich kids, you're not popular because you're different. And I never had any financial security. I dreamed of possessing things. Lucky for me I had my music to hold onto as a goal. It was like, these people may not think I'm as good as them, but I can sing!"

Encouraged by her mother to fulfil her early ambitions to be a singing star, Carey was a fixture with professional musicians and studio types in Manhattan by the time she was 15 years old. Accordingly, like Dion, music tended to smother her educational life. Beyond creative writing courses at school, she did not excel, yet translated the writing ability into the early production of song lyrics which would eventually show up on her debut album. Utilizing some money from her brother, Morgan, Carey cut a demo which was shopped around to various recording studios. Among the nibbles received was one from a publisher offering to send one of her songs to Whitney Houston. Carey apparently refused, not wanting another artist to do one of her songs.

Living on her own in New York at age 17 and supporting herself with odd jobs as a waitress and coat-checker, as well as working as a hairdresser, Carey became a back-up singer for Brenda K. Starr, with whom she developed a close friendship. Then, in 1988, at a party hosted by CBS Records (now Sony), Carey gave a

copy of her demo tape to a record executive for another label, a transaction which was literally intercepted by Columbia Records president Tommy Mottola. After Mottola listened to the tape, he tracked Carey down and signed her to a contract.

Carey's confrontational personality became evident right from the beginning as she battled for control of her debut album, a battle which led her into conflict with producers like Narada Michael Walden, Ric Wake, and Rhett Lawrence, whom Mottola had brought in to work on the album. She has been straightforward about her frustration with her producers. "It took away some of my identity," she told *The Washington Post*. "When I go back and listen to the demo, in some ways it's better than the album ended up being. Just in terms of the simplicity, it seemed to be more real and innocent and, once we got big-name producers involved, it took on another quality. It did very well for me, so I'm not saying anything bad about it."

The self-titled album, released in 1990, resulted in each one of its singles reaching number one on the charts. The album sold more than six million copies in the United States alone. Carey also received two Grammys for Best New Artist and Best Female Pop Vocal Performance. Soon, however, Carey was back in the recording studio, this time getting the control over the product she had initially wanted. With Mottola serving as executive producer, EMOTIONS went on to sell eight million copies world wide and netted her her fifth consecutive number one hit in the title song. By this time, she and Mottola were connected romantically and the same year that MUSIC BOX, her third album, was released, selling more than 24 million copies world wide, she and her mentor were married.

Like Celine Dion, Carey opted for the extravagant wedding at Manhattan's St. Thomas Episcopal Church. Among the guests were Robert De Niro, Barbra Streisand, William Baldwin, Bruce Springsteen, Ozzy Osbourne, Michael Bolton, Gloria Estefan, and Billy Joel. The tab for the wedding was a half million dollars. Carey wore a family heirloom redesigned to resemble Princess Diana's tiara worn during her royal wedding years before. Carey's satin shoes alone cost \$1,000.

Rather late in her recording career, she embarked on a major tour and was soundly thrashed by the critics at the outset. As the tour continued, however, the reviews improved. Still, Carey has never denied that she is happiest in the recording studio, declining to tour very often because "I'm very paranoid and overprotective about my voice. Even if I feel slightly hoarse I won't perform." In the studio, "I love to go in and sing all the background parts and then hear like 20 tracks of my own voice coming back out the speaker." Her various recordings have sold a reported 85 million copies and she differs from most of her pop diva competition in that she is also involved in her career as a writer, producer, and video director. "I don't do it because I want to be in control," she has said. "It's just that I think it's part of the creative process for me. It's part of my enjoyment of making music and singing. It's not going in there after someone has written and produced a track and just putting vocals on it and leaving. I don't know, I just don't feel comfortable with that and I love writing almost as much as singing and it's just a part of me."

But if Celine Dion has a reputation for co-operation and for being a natural person, Carey's reputation is quite the opposite. Critics portray her as spoiled and difficult, wilful and self-centered. And her marriage to Mottola has enhanced media and industry criticism, with critics suggesting she has reached the top because of the promotion she receives courtesy of her husband. Her response? "I buy albums and records because I like the songs. Sure, heavy promotion may get me to notice the artist. But if the songs suck, I won't care the least bit how much they spent promoting them. If more people feel that way, the songs will disappear from radio and all the promotion will amount to nothing. The important thing to me is all that happened before Tommy and I were involved other than professionally and he believed in me and

obviously he was right. I had a great push from the company, but if I didn't come through myself, I wouldn't be here right now."

Carey has learned that the pop diva title does not come without a price. She has been sued by her own stepfather, who claimed he was responsible for her success, and by a number of people accusing her of stealing lyrics or music from a song they had composed. As well, family tribulations have surfaced, primarily surrounding her sister Alison, a known drug abuser and HIV patient. Her sister charged Carey and her mother with kidnapping her son Michael at one point. The result of the ensuing court appearances, however, led to Michael now living with his grandmother. Alison has also authored a book alleging her prostitution contributed to funds her sister required to help launch her career. So far, the book has not found a publisher.

Of all the pop divas with whom Celine Dion is in apparent competition, the one some musical pundits feel particularly compares to her — in career direction and loyalty to her roots — is Gloria Estefan, the singer who, coincidentally, closed the same Atlanta Olympics which Dion opened. Larry LeBlanc of Billboard, in particular, notes some of the similarities in career design between the two performers. "Gloria Estefan would probably have the closest parallel to Celine yet she doesn't have the universality that Celine has and also she doesn't have the elasticity of material that Celine has. I think Estefan has handled her career pretty well. She does Spanish albums similar to how Celine does French albums. She's got both careers. What Celine has done that I think has been really important. A lot of artists could make that first English album and never record again in French. Why record again in French? It's a lot of work. She's done it and she's maintained it, and her argument is she has two careers, her English career and her French career. And part of that is — I gotta believe her on this — is not to disappoint the base of fans who have been with her since day one." All of which applies to Estefan, 39, who has sold more than 45 million albums worldwide and who, it

is said, still possesses a return ticket to her native Cuba in the hopes of someday returning to see the place where she was born.

Briefly, Estefan's background was originally a harsh one. Her father, Jose Fajardo, was one of the Cuban exiles who participated in the 1961 Bay of Pigs invasion, the unsuccessful attempt to oust Fidel Castro from power in Cuba. As a result, he spent a year and a half in a Cuban prison while his wife and daughter resided in a Cuban ghetto in Miami. Eventually released, more bad luck dogged Jose, who was seriously poisoned in Vietnam by the defoliant Agent Orange. While her mother worked, Gloria Estefan served as nurse to her invalid father, relying on the time she could spend with a guitar, singing alone in her room, as a break from caring for him. Before her father's death in 1980, Estefan would send him tapes of her singing and he responded once that she was destined to be a star.

During a wedding, at the insistence of her mother, Estefan performed some songs in 1975 which brought her to the attention of Emilio Estefan who was entertaining at the wedding with a local party band called the Miami Latin Boys. Emilio hounded her to join his band and eventually, albeit reluctantly, she agreed to sing on weekends. The band was renamed The Miami Sound Machine. Although it enjoyed some modest success during the next decade, in Central America and in Puerto Rico, a period in which Emilio married his discovery, their exposure in Miami was limited to wedding receptions and bar-mitzvahs. Then, in 1983, the group recorded a Spanish-language record which included an English dance tune called Dr. Beat. The song made its way to Europe, where it became a hit, then doubled back to sell well in the United States. Because of this success, two English-language albums appeared, EYES OF INNOCENCE in 1984 and PRIMITIVE LOVE in 1985. The second of these included a single, Conga, apparently the only song to ever appear on Billboard's Pop, Latin, Soul and Dance charts all at the same time. PRIMITIVE LOVE sold two million copies, while LET IT LOOSE in 1987 sold four million

and CUTS BOTH WAYS in 1989 sold 10 million.

Then, on the morning of 20 March 1990, while she slept in her tour bus, the vehicle was struck by a semi on the Pennsylvania Interstate Highway. Estefan was knocked unconscious and her back was broken. Doctors inserted two steel rods into her spine and she narrowly escaped paralysis. After a year of arduous recovery, she was back on stage, singing and dancing as part of a 29country world tour. But the accident was more than a painful interruption in a successful career. It altered Estefan's musical style and her music became more reflective as she began to acknowledge her Spanish-language roots. In 1993, she released MI TERRA, a Spanish-language album which included five of her own songs, recalling the Cuban music of the 1930s and '40s. The album went on to sell more than eight million copies worldwide, nearly two million of those in the U.S. alone, and won her a Grammy Award. A 1995 album, ABRIENDO PUERTAS, also in Spanish, incorporated the music of a number of Latin American countries and sold more than 2.5 million copies.

Like Celine Dion, Estefan has been able to cross into the English-language market and then cross back into the market of her original musical roots, without damage of any kind. In fact, both artists have sold their foreign language material with amazing success in the English market. More recently, Estefan recorded the album DESTINY, which includes the Olympic anthem *Reach*. As Estefan confessed to *Time* in 1996, "People told me at the beginning, 'You're too Latin for the Americans, too American for the Latins.' But that's who I am. I'm Cuban American; I'm not one thing or the other. I have an American head and a Cuban heart. . . . destiny is a synthesis of everything that we've done in the past five years. We're offering the same Spanish flavor to our English-speaking fans with words that they can understand. But it's a different feeling. You can't just switch on and off from one language to the other."

In this regard, Estefan understands what Dion understands.

Where the heart is, where the roots lie, often exists the most profoundly inspirational musical fodder. As Larry LeBlanc points out, "I think the French material touches something within her that she doesn't want to lose, maybe her identity. . . . I know that it gives her some kind of sustenance that she wouldn't perhaps get somewhere else. I think that's really important, again, to her success."

Both divas also provoke an ongoing debate among musical purists as well. Is there something special in the material they do in their native language which cannot be reproduced in English? LeBlanc, in Dion's case, thinks there is, although he sees her continually evolving into being able to convey the same sense of soul and sensuality in English that she presents in French. "I know people that only listen to her French product," he says. "I know people that know her English stuff that don't like her. I say 'Look!' I send them a copy of a French album and they go, 'Holy shit!' Because you're not prepared for it. She's catering to the English market, no question, with her English product. There's no question about it, those power ballads and stuff like that. She's very good at it obviously. But if you want to really know who Celine Dion is, listen to the French product. Quite frankly, as I said, I've sent the French product to people who don't like her English product — I mean they recognize that she's a good voice but they don't like that kind of polished pop — and that stuff has just overwhelmed them. Because at that point she becomes another dimension. And I think that same dimension is starting to come into her English side. I think that's what you're really looking forward to in the next little while." It's a kind of developing maturity that some writers see in Estefan as well. Wrote Christopher John Farley and Michael S. Serrill in Time, "Estefan's destiny, as her cheering fans confirm, lies in the growth and maturation that has taken her artistic journey onward."

There are several obvious similarities in the lives and careers of these contemporary "touring" divas. They all demonstrated an early promise as singers, and even though they are still relatively young, they have already enjoyed long careers. Houston, Carey, Estefan, and Dion have in their own way remained true to their unique culture while working in the international pop genre. If they work hard at being singers, they work equally hard at being glamorous. They use the same 'stable' of songwriters and producers to record their inspirational ballads. They use the same musical and promotional formulae to please their middle-of-the-road audience.

There are differences, though, beyond the obvious questions of ethnic background, that set them apart, especially in the case of Celine Dion. David Foster suggests in an article in Maclean's that the difference is in talent. "Celine exceeds the boundaries of talent. I don't know if she will reach the heights of Barbra Streisand, but there's nobody else in the race." There may be one additional cultural consideration that makes Dion somewhat different from her more American-oriented peers. And this is a distinctively Canadian trait. As Larry LeBlanc points out, "She's probably the most unshowbizzy of any performer I've come across. And somebody who doesn't know her will laugh at that — they see the polish, they see the patina, they see the drive — but what I see is a 'realness' there. I don't know if it comes back from being one of 14 kids or what it is. She's described being involved in some big family dos, where there's 40 kids hopping around. She can connect naturally with people and be shy at the same time, a vulnerability that is real. She's got the ability to take people with her — and this is an important part of her career — and have them bond with her. The early people at the record label level and journalists have been able to bond with her. She's gone out of her way to do it."

LeBlanc tells another story of a time when he was invited back stage with his son, Robin, to see Dion. "They had invited us to Massey Hall after I gave her an international achievement award for Billboard, about two or three days later. When the concert ended, René turned up behind our seats and took us right through everybody. Now that's very unusual. Most people say, 'meet us back stage.' Right — fight your way through 30 people. In a lot of cases, we don't go because the performer doesn't give a shit one way or the other. In this case, not only did they care, but they cared enough that they went out and got us to make sure we got through. It's pretty interesting. To be back talking to her three minutes after she got off stage. At one point, I said, 'Look, you know, you're real busy, we're going to let you go.' She said, 'no, no, no.' And kept us there for ten more minutes. It was a genuine interest, and, I mean, the cynic in me will say: René told her it was important. That's the cynical side of me. And it's possibly true, you know that he's her eyes and ears, and, much like a politician, would steer her. But I do know when I ran into her six months later at a party in Quebec City, she turned to me: 'How's Robin?' I went: 'uh.' Because most of these people don't remember your name when they leave you, never mind what your kid's name is a few months later."

Nor is this incident the only one of its kind LeBlanc can relate. "We went down and saw her last year at the Molson Amphitheatre. And back stage there were 200 people from Sony — they were having a huge convention up in Muskoka and they bussed them down to the concert. I walk backstage with Robin and two of his friends, to whom we said, 'Look, we'll get to meet Celine.' I look backstage and I just go, 'Oh, shit,' because there's everybody there. I take two of the kids and I go over and stand at the side of where they're meeting and greeting. They're taking one picture after another of Celine getting gold records. They've got people from different territories giving her double diamonds, triple diamonds. But at one point she looks over at us and says, 'Robin,' and waves. Her hand up around her head, how big he's grown, she gestures. About five minutes later, they're still taking pictures, and she turns at one point and says, "Look, stop the pictures,

there's some kids here who need to get home for bed. Larry, come over and bring the kids, get their picture taken.' The kids came in and got their picture taken. Then she grabbed me, at one point, took me aside. She said, 'So how was I?'"

LeBlanc has encountered the well-known Celine Dion sense of humor as well, a sequel, if you will, to the picture-taking story. "I got the pictures done and the two kids from the Karate Club, they just adore her. So the father, when I got the pictures back from Sony, said, 'Can you get these signed?' I said, 'Oh, boy, I guess so, when I next see Celine.' We were flown down to see her at the Montreal Forum for the end of the tour. Backstage, I've got the pictures and, again, she's in a line-up. All these people. She takes a minute and she signs it. The photographer asks, 'Do you want your picture taken with Celine?' I said, "Nah, this is good enough.' She says, 'Oh, c'mon. C'mon.' So, anyway, I've got my arm around her, she's got her arm around me. And the guy goes to take the picture and she just grabs me. Comes in for the closest hug you've ever seen. No woman except my wife does that. That was her idea of a joke."

In fact, anecdotes about Dion's unusual down-to-earth nature are not uncommon at all among writers in the music business. "Despite her glamorous appearance," wrote Betsy Powell in a *Canadian Press* story after a restaurant interview, "Dion, true to anecdotal tales, displays a common touch that would actually be put to good use in a down-home diner. After a hotel steward arrives with some hot milk, Dion looks embarrassed as she scans the room. 'Here, I'll get you some water,' she offers instead to the visiting interviewer. As she pulls off her jacket, displaying tanned arms, she asks softly, 'Do you mind?'"

Nor is the down-to-earth aspect of her personality reserved for Canadian journalists, as an ingenuous gimmick to mollify Canadians awed by or resentful about the international strength of her following. Wrote Pete Clark in England for the *Evening Standard*, "The 27-year-old woman sitting opposite me is the new

version of the classic pop diva. She is currently the UK's favorite lady vocalist, selling an extraordinary 3.5 million records here last year. She has the lung power of an angelic lumberjack, despite her tiny size. Yet, if I am to believe Celine Dion, she is only truly happy at the business end of a vacuum cleaner, sucking up the dust that not even the rich can banish from their houses. It's hard to take exception to Celine, even if talking to her can occasionally feel like sitting behind a bull. As I enter the room, she pounces on my suit, which is stroked and admired. It would have been churlish to mention that the suit was made of Bulgarian cardboard and cost about \$2.50. Celine Dion successfully projects a form of turbo-charged ordinariness."

Alan Corr from *RTE Guide Magazine* in Ireland noted this quality of character as well during an interview with Celine and René. Husband René saw it as perhaps one of the characteristics that gives her so much appeal. "Yes," said Angélil, "but aside from being a great performer and a great artist, first of all Celine is a great person and that's what people see in her, that's one of the reasons for her success. It's not only the voice but the whole personality."

Celine Dion is able to remain humble in spite of enormous adulation and wealth, something her fellow divas do not always manage. This ability to keep her feet on the ground and to remember politely everyone she meets along the road may reflect a Canadian amelioration of the diva's necessary drive to succeed, combined with a tough Canadian conservative perspective. Canadian artists tend to keep both feet on the ground, tend to maintain a perspective reflecting traditional values of modesty and polite behavior. This may be the one character trait that has enabled Celine Dion to become the queen of pop divas.

Deux

The pun works two ways — 'of them' and the numerical reference — because of all the dualities that are Dion. She sings in two languages, has two careers, and therefore has to work twice as hard as her peers 'n' pals on the anglo charts. She just got married, it's an album of love-and-loss songs, and she worked with Frenchman Jean-Jacques Goldman on the record, so the couple thing is on her mind. Deuces are wild. — Mark LePage, Montreal Gazette

I think that's the most important thing in life . . . to share your happiness and be with the person you love. That's fantastic. If my career was to stop tomorrow, even right now, I'd still be the happiest person on earth because I have found the man of my life and I still have my family and I know that I can always go back to them. And that's to be rich. — Celine Dion

Following the English-language success of THE COLOUR OF MY LOVE in 1993-94, Celine Dion returned her attention to her French-language career, recording D'EUX in 1995. Surprisingly, this album did as much to elevate her reputation as a superstar in the English market as it did to increase her popularity in the Francophone world. Released on the heels of her rise to the top

spot on the charts in the UK with both the single *Think Twice* and the album THE COLOUR OF MY LOVE, her efforts in French on D'EUX broke records again in Britain. Within seven weeks of its release D'EUX was the best-selling French-language recording in British history. D'EUX became the first ever French-language album to be certified gold in Britain. A single from the work, *Tu m'aimes encore*, also did extremely well, climbing to No. 7 on the charts there. In France, D'EUX became the best-selling album of all time, earning Dion the prestigious Medal of Arts from the French government.

Legendary French superstar Jean-Jacques Goldman, described by Dion and many others as the Bruce Springsteen of France, offered to compose an album especially for the Quebec artist. Goldman wrote a dozen songs for the album, ranging from pop tunes through folk and jazz to soul. Although originally intended to showcase Dion's voice, D'EUX revealed much more than that, her complex emotional range. In fact, Dion later expressed astonishment at how well the material seemed to touch her personal psychological space at the time. "To be face-to-face with your own emotions is pretty amazing," she said. The European response to the album was so immediate that Dion launched a 50-date, 11-country tour of the Continent, the tickets selling out well in advance, to take advantage of this opportunity in the global market.

Even in Japan, Dion reached the top of the charts, the first foreign artist to do so in a dozen years there, although in this case not for any material on D'EUX but rather for a theme song from a new Japanese television drama called *Koiboto Yo'* or *My Dear Lover*. The song, written by David Foster, was called *To Love You More*. His cowriter was a surprise to the industry — wealthy Canadian businessman and MCA owner Edgar Bronfman. Recorded with Japan's Kryzler & Kompany, the single sold a million copies there and remained at the top of the charts for nearly a year.

While D'EUX ensured Dion's global supremacy in French-language music worldwide, a nagging analysis began to grow back in Canada — where uneasiness between French and English was also growing with the prospect of yet another referendum in Quebec to decide if the province wanted to separate from the

Confederation — as to her motivations in releasing a Frenchlanguage album while THE COLOUR OF MY LOVE was still reining in the North American English-language market. Music pundits wondered about the timing, even the need. For example, Mark LePage in The Montreal Gazette was confounded: "Celine Dion turned 27 on Thursday and the news made it all the way into the little Celebrity Birthdays segment on Entertainment Tonight. She's right in there now, a name of note on the American timeline, supermarket-tabloid currency like Tom Cruise, Donald Trump, Susan Lucci, Zsa Zsa and Di. This is the big time. THE COLOUR OF MY LOVE hovers around seven million sold worldwide, and every one of Sony's wildest dreams and calculated maneuverings has paid off in cold hard cash. . . . In the last 12 months, she's been on more awards ceremonies than Streets of Philadelphia and more talk shows than an O.J. lawyer. And now comes the francophone album, the only one she will release in 1995, and the question: Why? Why bother, to be exact. THE COLOUR OF MY LOVE is fourth on the Australian chart this week, after Green Day, The Cranberries and Pearl Jam. Yes, it's just Australia, but it proves there is always one more anglo territory to conquer."

In response to his own rhetorical question, LePage cites the duality of Dion's career, perhaps even her personality. "The answer is in the title of D'EUX . . . the latest instalment in the Tale of Two Celines. The pun works two ways — 'of them' and the numerical reference — because of all the dualities that are Dion. She sings in two languages, has two careers, and therefore has to work twice as hard as her peers 'n' pals on the anglo charts. She just got married, it's an album of love-and-loss songs, and she worked with Frenchman Jean-Jacques Goldman on the record, so the couple thing is on her mind. Deuces are wild. The subtext is what matters, though. In D'EUX, Dion touches on the dilemma of the hometown girl trying to make it big but assure the countryfolk she won't leave them behind like so much lard. . . . The magnitude of Dion's celebrity in the real world makes her more than just a star to the people here. Francophone Quebecers, cut off from the linguistic mainstream of the anglo masses, live vicariously through her. She proves they can not only compete, but triumph, just like all the hockey players from the bush who've been labelled 'too small' to play in the NHL since the days of Aurel Joliat and have still gone on to paper the walls of the Hall of Fame. . . . On every rose, a thorn, and in every heart the secret fear that Dion will ditch her hick roots for the beautiful people. Is she *Celine out*? She reassures them. *Je fais partie* is the understood prefix to D'EUX. *I Am One Of Them*. Politically, it's a great move on the home front. It's also good marketing, since the combined populations of Quebec and France offer over 50 million potential Célinites."

A year later, when responding to a comment from Alan Niester of *The Globe & Mail* that she "seems to have two careers, with the recording, promoting and touring cycles being constantly repeated in two different arenas," Dion said, "I don't really consider it two different careers, more I consider it one full career. I do the French albums because it's my blood and it's my origins and it's my roots. It is a must for me to sing in French in my life. Don't forget I started to sing in French. I have 11 French albums. The English? I started to sing in English because I was interested to travel the world, and because I love singing in English too."

The deuces continued to run wild as Ouebec approached the referendum in October 1995. The media tried to make Dion declare her political preference for Quebec separating or remaining within Canada. This focus on her politics may have a lot less to do with Dion than it has with the Canadian media which, aware of the iconographic stature of the singer to her fans in Quebec, cannot help analyzing what she does in the context of political speculation. In truth, since the apparent faux pas in 1990 over the ADISQ awards and her unity remarks in Spain in 1992, Dion has clammed up where the world of politics is concerned. In fact, as the divisions between Ouebec and the rest of Canada continue to grow so too does Dion's insistence that she will not be volunteering political opinion. As Betsy Powell of Canadian Press noted in 1996, "separatism and Celine Dion are two things the world associates with Quebec — but the international superstar prefers to discuss her chart-topping ballads over politics. Not that Dion

doesn't have an opinion on the divisive question of whether Quebec should stay or go. She does. But not one for public consumption." Said Dion, "Some people think one way and other people think another way and I don't want to upset anybody."

Whether or not it really matters if Dion has federalist or sovereigntist leanings, or whether she is politically non-committal out of an expedient wish to court both English and French musical markets, does not mean that Dion's silence reflects a lack of integrity. Actually the issue of French versus English demonstrates instead that, yes, there are some dualities in her nature and that they affect what she does in the same way they affect who she really is. Most of these apparent contradictions tend to originate in a paradox in character: on the one hand, the world superstar is a consummate performer and a career-driven person, attuned to the fact music is a business; on the other, she has emerged from her homespun roots as one of the most natural people to deal with in the pop music business. This baffles people used to the more normal aloofness or spoiled brat behavior displayed by other entertainment stars. And the corollary to this proposition is that Dion has had such a single-minded ambition for virtually her entire life, the world of politics, beyond superficial awareness, may lie virtually outside her field of interest. It becomes one of the contradictions, similar to the fact that she is seen by and performs for millions, yet is somewhat of a recluse. Beyond the stage or the recording studio, how worldly can a woman be when she was raised in a tightly-knit family, then graduated into a marriage with the man who guided her career from its inception? She is a strange mixture of the courageous and the timid, seems motivated by both a spunky ambition and a need for safety, possesses a great deal of confidence in her ability and yet is prone to shyness. This, then, is the dual nature of Celine Dion only symbolically applicable to the duality inherent in the divisions between Quebec and the rest of Canada — or suggested by the title of the album D'EUX.

Another duality has appeared in Celine Dion's life over the past two years as her inherent domestic nature has surfaced to rival her career ambition. There's a new complexity to Dion's life, new values directing her desires, now that she has arrived at the top. She has begun to expand the perimeter of her life to position a home and family life on the same important plane as her skyrocketing career. "A few years ago, Dion told me her career was the only thing that mattered," wrote Brendan Kelly in a 1996 Chatelaine feature. "Now, she says there are other priorities — including having a baby. 'The true values are the foundation of your family. . . . I used to dream of being a singer. Today, my dream is just to be healthy and happy." "As Kelly explains, "the past decade has been a tumultuous ride for Dion, and the big changes — marrying Angélil, becoming a multiplatinum-selling diva — have transformed her into a more secure, sophisticated woman. But there is a dark edge to this pop fairy tale — and again, it's all about the fear of loss. When asked why she wants children so badly, she says it would be the best way 'to make this love live as long as possible.' As she talks about her affection for Angélil . . . there is an unspoken sense that she has been thinking about mortality. Angélil had a heart attack in 1992, heightening Dion's fear of losing loved ones, something she felt growing up the youngest in a large family." Dion herself admits, "It's a scary thought. I don't like being the youngest all the time. It's being frightened sometimes of losing everybody."

This shift in values, whether motivated by a fear of loss or sense of mortality or basic maternal instinct, is remarkable given her former love for the stage. "She once told me that the most fulfilling moment was onstage, belting it out for her fans," Brendan Kelly recalls. "But now, she says, the peak moments are much more intimate — the last seconds of the day when Angélil turns the tv off and she curls up against his back in bed." According to Dion, "There's nothing happening and everything's there. No noise. Darkness. Hearing his breathing. When you're in love with someone, it makes you go wild. If you put your head on his back, you hear his heart. And you always wonder, 'Is it going to stop?'"

Kelly paints an endearing image of Dion's domestic desires as he recounts how a late night interview with Dion ended. "By now, it's nearly two in the morning and, as if on cue, Angélil, who's been watching hockey in the next room, saunters in, dressed only in a white bathrobe. Dion seems caught somewhere between an angry flush and hysterical laughter. 'Oh, please, René, make yourself comfortable,' she quips as I gather my belongings for a hasty exit. The last glimpse is of a smiling Dion, her slender arms tight around Angélil, holding on as if she'll never let go."

James Muretich has also noted this change in her character. "So far Celine Dion has shown an uncanny knack for touching people with her music. She admits she feels 'more pressure' than before, not only because people expect more of her but because she, too, demands more of herself, to make each album, each performance better than the last. As ambitious as she is, though, Celine admits that when all is said and done, the most important thing in her life is her family and her husband."

"I don't go to bed at night thinking why is all this happening to me and I don't wake up wondering what's going to happen," said Dion. "I wake up in the morning and can't wait to eat my peanut butter and toast, and when I go to bed at night all that matters is being in bed with René my husband. I think that's the most important thing in life . . . to share your happiness and be with the person you love. That's fantastic. If my career was to stop tomorrow, even right now, I'd still be the happiest person on earth because I have found the man of my life and I still have my family and I know that I can always go back to them. And that's to be rich."

Yes, Celine Dion seems to be enjoying exceptional joy in her marriage, as she made clear in response to Alan Niester who wondered aloud if she found being married to her manager suffocating. "I don't know because it's really the only thing I know. René has been my manager for 15 years. This is the only man of my life, I don't know anything else. With other people, they haven't been all their lives together. Me, I don't know nothing else. I cannot imagine having another husband or manager. I am perfectly

happy." Happiness also seemed at the root of her remarks to *Q Magazine*'s John Aizlewood who seemed a little puzzled by her apparent joi de vivre during a recent interview. Aizlewood asked Dion if if she had ever had sex to her records. "Wow," Dion responded. "I've never thought about anyone making love to my music, but I like the idea of sharing people's most intimate moments. I personally don't do it to music but, mmmm, it sounds good. If I was making love and listening to music, I'd probably stop in the middle and go, 'Ooh, listen to that. Isn't that nice?' Then it would be, 'Aaagh . . . oh no,' and it would all be over. Then, we'd have to do it again . . . Maybe I'll try it."

So, yes, there is a homebody trait in Celine Dion's character. "The things I really enjoy, maybe more than anything else, are cooking at my house and cleaning my house. I do! I do! I love cleaning. When I'm home, I do it myself and it relaxes me. I cook for my husband, but I don't have any recipes! I open the fridge and take out the leftovers - half a chicken, say, some roasted potatoes, anything that looks good and yum-yum tasty. Then I make it better. I take this chicken and put in some peppers and some capers, things like that." René Angélil confirms that "yes, she likes to cook. She is a great cook and she likes to take care of all the things in the house. She doesn't like to hire a maid, she wants to do everything. She wants to cook, she wants to clean and she enjoys it, she loves it and it relaxes her." At the same time, Angélil tries to maintain his sense of humor over the apparent passion she has for shoes. "Celine has to buy shoes. She is like a shoeaholic. She cannot pass in front of a boutique and see shoes without going in and buying. With her, it's not only looking, it's buying. She has over 600 pairs of shoes at the house, it's unbelievable. She has shoes that she never wears. She just likes buying shoes."

In an interview with Alan Corr published in *RTE Guide Magazine*, Dion and Angélil revealed that they would like to have at least one child of their own. "Yes," said Angélil, "we are planning to have a baby as a matter of fact. We don't know when exactly but pretty soon. We'd love to have at least one child." For her part,

Dion confessed that marriage had taken a great deal of weight from her shoulders. "There's a lot more pressure in this business and I just feel that I've stopped turning around. I'm going forward now. I'm pretty much in love and I feel very powerful and strong about myself and I'm set for life and it's wonderful when you feel like that."

Of course, there had been no child yet. But it was still the big topic for Dion at the end of 1995. "We are trying so hard to have a baby. A family would be the thing I want the most at the moment," she told The Daily Mirror in England, admitting that she and Angélil had spent a two-month honeymoon in their Florida home, trying to conceive. "It didn't work," she said. "So we keep going. We've been on many honeymoons since, and we keep waiting. Besides, I enjoy the practice! If we don't have a family, then we don't. But we still hope." Explaining that Angélil's children by his previous marriages have more than accepted her relationship with their father, she said, "there has been plenty of time for them to get used to it, and anyone who knows us can see how right we are for each other. Sure that is the most important thing. Age, race, religion — none of those things are as strong as love. It will always win in the end, and it did for us. But if we did have a baby, we will only have one, because of René's age. Besides, I couldn't have 14 children like my mother — I would never cope. And if we can't have children of our own, then there are plenty of babies in the world who need love. When this is all over and my work is less busy, I will open a special school in Quebec for children with learning disabilities. I can give them love and understanding. I realize that I may not be able to have a family with René, but I've always known that I love him and I wouldn't be without him for the world."

While Dion was talking children, she was preparing to release FALLING INTO YOU in 1996. No matter how ordinary she might be in behavior outside the studio or off stage, there was nothing ordinary about what she could accomplish musically when she set her mind to it. Celine Dion, always ambitious, always competing with herself to surpass her previous professional endeavor, was

still consummately the entertainer. By the time the smoke cleared, by the time a minor controversy among the producers of the album had been forgotten, FALLING INTO YOU would sell more than 25 million copies worldwide, making her the most popular singer in the world before she was 30 years old, just as she had predicted while a young child star.

The Power of The **D**ream

"Probably on stage is the best way to get to know me. It's who I am really. This is where I feel good. I feel strong. I feel happy. Nobody can come on stage and tell me what to do. So I can be myself and have a good time. In person, maybe I can be frightened a bit or be shy... on stage is the place to meet me. — Celine Dion

I'm not in competition with anybody but myself. My goal is to beat my last performance. — Celine Dion

Released in March of 1996, FALLING INTO YOU covers a wide range of musical genres — soul, country, rock, and blues, in addition to Dion's trademark ballads — though all of them are safely tucked inside the broad category of pop. The album debuted, incredibly, at the No. 2 spot on the *Billboard* album charts, then managed to hit the top spot in France, England, Switzerland, Belgium, The Netherlands, Norway, Austria, and Australia relatively quickly after its release. In Canada and the United States, the rise to No. 1 was blocked momentarily by fellow Canadian Alanis Morissette's JAGGED LITTLE PILL. The single *Because You Loved Me* — from the Robert Redford/Michelle Pfeiffer movie *Up Close And Personal*, a song ultimately nominated for an Academy

Award and which she performed on Oscar night in 1997 — was a massive hit for Dion, residing on the Billboard Adult Contemporary chart at No. 1 for 18 weeks, a record-breaking length of time. The single, penned by Jim Steinman, It's All Coming Back To Me Now, also found the No. 1 spot on that chart.

Part of Dion's success with FALLING INTO YOU in 1996 was the extensive television exposure she received. Dion and Sony were both ecstatic when she received so much space in television commercials for the movie Up Close and Personal. Some commercials gave Dion as much exposure time as the movie's stars. Then, of course, literally before billions of people, her performance of The Power Of The Dream at the Summer Olympic Games in Atlanta in August served to ensure that she would remain a household name.

FALLING INTO YOU also stirred exceptional interest among music critics because of a controversy that arose from the way the album was produced. The album was a unique production, assembled by several producers in different recording studios. Among the producers were long-time colleague David Foster and Jim Steinman but the legendary Phil Spector came on board to oversee the project. Controversy soon developed between Spector and the others.

As Jeff Gordanier interpreted the story in Entertainment Weekly, "Spector, 55, the mythic, reclusive, and notoriously eccentric producer whose Wall of Sound wizardry turned pop nuggets by the Righteous Brothers, the Ronettes and Ike and Tina Turner into Wagnerian epics, hasn't overseen a full album since the Ramones' END OF THE CENTURY in 1980. But in October, 1994, after watching Dion tear through his opus River Deep - Mountain High on Late Show With David Letterman, the master felt compelled to seek her out. Over the course of one month in Los Angeles, he and Dion crafted tracks that would never find their way onto FALLING INTO YOU. 'We all had our fingers crossed to the point of cutting off our circulation, because it could've been so magnificent,' Sony's Anthony says of the Spector / Dion dream team. 'It was a great idea, but it didn't work out.'"

Before the album could be completed, Dion had to depart on a previously planned European tour, aborting a finish to the recording sessions which, according to Dion, teemed with hundreds of people, including a 60-piece orchestra. As Jim Steinman recalls, these sessions were "turbulent" and soon became a "pretty hilarious nightmarish experience. They just had problems. I'll leave it at that. They ended up with nothing they could use." And as David Foster tells it, Spector "comes out saying that this is the project he's chosen for his comeback, as if the rest of us have nothing to do with it. That's a little pompous."

As Gordanier reports, "clashes over how the record should sound may have put the session on ice. After a protracted effort to reach Spector for comment, Entertainment Weekly received a three-page fax from him — one of only a handful of public statements he has issued in 16 years as a recluse. Spector — a man famous for obsessing over every facet of the studio process — offers lavish praise for the 'extraordinary talent of Ms. Celine Dion' but says he backed out when he got the sense that her handlers 'simply wanted to record hits even if they were contrived and repugnant — or nothing more than Whitney Houston — and Mariah Carey — rejected, soundalike songs and records.' Spector says he didn't want to remake River Deep nor did he yearn to rub elbows with other producers — people he calls 'amateurs, students and bad clones of yours truly.' (Jim Steinman, who finally remade River Deep, responded, 'I'm thrilled to be insulted by Phil Spector. He's my god, my idol. To be insulted by Phil Spector is a big honor. If he spits on me, I consider myself purified.') 'It became apparent,' Spector goes on, 'that the people around Ms. Dion were more interested in controlling the project, and the people who recorded her, than making history.'

"As for the session tapes — tapes the mysterious producer predicts 'should put her on the covers of both *Time* and *Newsweek* magazines' — Spector vows to release them. 'Should you wish to

hear the amazing and historic recordings I made with Ms. Dion,' he writes, 'have no fear, because you will. I am presently finishing them up, and since I paid for them, and own them, I am planning to release them on my label, for the entire world to hear, and compare to her current recordings, or whatever you call those things they've released.'"

Spector's parting shot points out the extent to which he had become a victim of his own belief that genius knows no deadlines. "One thing they should have learned long ago," he complained, "you don't tell Shakespeare what plays to write. You don't tell Mozart what operas to write, nor how to write them. And you certainly don't tell Phil Spector what songs to write, or how to write them, or what records to produce, or how to produce them." Back in 1966 when he was at his prime, Spector had told Canadian journalist Pierre Berton that it took him from "four to six weeks" to make a hit single. "Most of the time," he explained, "is spent *after* the artist leaves the studio — in putting it together, editing it, creating the right sound."

"He would have loved to take a year or two to do an album," Celine has commented. "For me, an album has to come out. We had a plan, we have to follow it. He knew about it and he didn't follow it. I cannot wait a year for him." Nor was Celine interested in coping with Spector's antagonistic attitude. "I can thrive very well in a hostile world and function much better in an antagonistic interview than in a friendly one," he told Pierre Berton at the height of his career. Phil Spector's "place in pop history is assured," Mark LePage wrote in the Montreal Gazette. "He remains, for all his reclusiveness, a throwback to the robber-baron days of rock 'n' roll. In 1980, Spector's legendary sessions with the Ramones ended when he allegedly held 'Da Brudders Four' at gunpoint in the studio. Apparently, the boys weren't concentrating. Efforts to reach Spector were unsuccessful. Next week, we'll try Amelia Earhart. In any case, there aren't enough Ouija boards in Salem to contact his like, nor would it profit us any. Dion's people and their arguments will come across as more stable and

reasoned than those of a man loonier than the Royal Canadian Mint, but Spector's Dion album would have been . . . interesting. Obviously, nobody running this industry, none of the 'people' wanted that."

When FALLING INTO YOU was released in March 1996, several months delayed from the optimum release date in November 1995, Phil Spector's absence was lamented only by critics and industry insiders. What was tangible was the sale of 25 million copies of this 'over produced' album that some critics said 'nobody' wanted. "Another area Dion addresses head on is criticism that she is over-produced and that her music is calculated and cold," Betsy Powell noted in her interview with Celine. "Being over-produced to me is not a bad thing," Celine responded. "It's a big thing, it's big time, it's *Gone with the Wind*."

Celine Don's confidence in all of the musical styles she has embraced, coupled with her no nonsense approach to show business, has provided her with the necessary resolve to ignore critics who would have her sound differently than she does. Her connection with the number one pop producer of the 1990s had come about quite naturally — through good fortune in the late 1980s — when Canadian-born David Foster heard Celine's first Juno Awards performance, at a time when Dion was only beginning to perform in English. Foster shared with Celine the same driving ambition to succeed. "I'm really frustrated," he told Vancouver Lifestyles, "when people don't have my work ethic. It really frustrates me when an artist doesn't show it, because there are no shortcuts. There's only the hard work." Foster had wanted to become the house piano player at Isy's nightclub in Vancouver, settled for playing in Chuck Berry's band, and one thing had led to another. By the early 1990s, David Foster had become the number one producer of hit singles in the United States. Time magazine described him as "The True King" of Pop: a producer of inescapable songs, especially those ultra romantic ballads that seem to blare out of every boom box on the beach." His production of Whitney Houston's I Will Always Love

You hit the top of the pop charts during the holiday season in late 1991 and stuck at the top of the charts for a record-setting 14 weeks. Year after year, his number one productions ate up at least 25 percent or 13 of the 52 weekly designations. He was producing Celine's all-time idol, Barbra Streisand, producing Michael Jackson, Michael Bolton, and boy bands like All 4 One who were burning up the pop charts. In February 1993, when he accepted his third Producer of the Year Grammy for I Will Always Love You, Foster pointed out that making hit records was a team sport. "This is a song," he told the awards show audience, "that Kevin Costner found, that Dolly Parton wrote, that Whitney Houston recorded. What did I really do?"

David Foster has co-written songs with the best in the business, including Paul Anka, Peter Cetera, and Madonna. His breakthrough soundtrack production, St Elmo's Fire in 1985, established him as a go-to guy for movie themes. Foster's first soundtrack production for Celine Dion was Listen To Me, a duet with Warren Wiebe, which appeared on the soundtrack for director Douglas Day Shepherd's feature film Listen To Me, starring Kirk Cameron, Jami Gertz, and Roy Scheider. Having her song in the movie houses was a thrill, but there was no soundtrack album produced. In fact, this is one of the most difficult Dion tracks to find, released in a limited edition mini-cassette by Sony Musique and only distributed in Quebec through Eaton's department stores. A second film contribution came when Tonight We Dance and Ziggy were included on the soundtrack of Tycoon, the English language version of the Parisian production of Luc Plamandon's Starmania.

Celine Dion's duet with Foster's ace-in-the-hole demo singer, Warren Wiebe, led to duets with Dan Hill and Billy Newton-Davis, duets that were released on their albums during the time that Sony was preparing Celine Dion's first English language album, UNISON. Can't Live With You, Can't Live Without You won Dion and Newton-Davis a Canadian MuchMusic award for Best MOR Video in 1991. Then Foster paired Celine Dion with Clive Griffin on another Grammy Award winning duet for the romantic comedy, Sleepless in Seattle. Dion and Griffin's rendition of When I Fall In Love (a Top 20 hit in 1952 for Doris Day) contributed glamor to the film in the much same way that Doris Day's rich vocals on her number 2 Billboard hit Whatever Will Be Will Be (Que Sera, Sera) had contributed to the production values of The Man Who Knew Too Much in 1956.

David Foster and Celine Dion have combined for many more hits. In 1996, Foster and his wife Linda Thompson wrote Celine a song to sing for a global audience at the Olympic Games in Atlanta. Foster co-wrote the title track to Dion's third album, COLOUR OF MY LOVE, but it was his production of Jennifer Rush's The Power Of Love that became Celine's first number one. When The Power Of Love stuck at the top of the charts for four consecutive weeks, it was heard everywhere that music critic Charles P. Alexander went, including those "boom boxes" on those beaches he mentioned in Time magazine. "The power behind the song," he wrote "is her bring-down-the-house voice, which turns an old, schmaltzy ballad into a soaring pop aria. That voice glides effortlessly from deep whispers to dead-on high notes." Celine was proud to be 'over-produced' in this way.

Being over-produced was one thing, but being over-managed was another, a charge Celine faced when her rendition of Jim Steinman's song *It's All Coming Back To Me Now* (number one for 10 weeks) on the FALLING INTO YOU album was not submitted by Sony to the Grammy award judges in the Song of the Year category. Diane Warren's *Because You Loved Me* (number one for six weeks), another hit from the FALLING INTO YOU album, was submitted instead. Steinman's manager David Sonenberg claimed that Sony executives did not want the two songs to split the vote. "It's wrong," Sonenberg said, "to put this in the hands of a record company and let politics take over." The other alleged manipulation to cause controversy was of note mainly in Quebec, but of interest elsewhere in Canada when it was suggested in the media that freedom of expression might have been compromised.

In late 1996, the *Montreal Gazette* reported that René Angélil had paid an author *not to* complete an unauthorized biography of Celne Dion. "There won't be an unauthorized biography of Celine Dion — at least not next year as planned," Alan Hustak reported. "The singer's husband, René Angélil, has paid author Nathalie Jean an undisclosed amount of money to stop work on her manuscript about Dion. According to *La Presse*, Jean will receive the equivalent of four month's salary for her trouble, but Jean said the details have not yet been worked out. 'Under the terms of the agreement I can't say anything,' Jean told *The Gazette* yesterday. 'But I haven't been bought out. I will still be able to publish the manuscript, but not before three years."

The book was to have come out in the spring of 1997. "Speculation," Hustak wrote, "ranges from an attempted coverup to the fact that Angélil has simply paid Jean to defer publication of her book so as not to cut into sales of an authorized biography by Georges Herbert Germain coming next year." Martin Knelman, author of a best-selling biography of John Candy, told The Gazette that he had never heard of anything similar in Canadian publishing history. "What are they trying to hide?" he asked. "And what's to say someone else won't do their own unauthorized biography? What's to stop them?" History would soon prove Knelman's statement to be right on the money. Angélil's blocking of a single book on Celine Dion would do little to discourage other writers or to dissuade publishers. During 1997, four biographies in French and two in English were published with Celine Dion as the subject. "There's a large difference in seriousness and quality among these books," one reviewer noted. "Half of those books are barely worth the paper they are printed on, the rest are good but not extraordinary, not even the authorized one."

While there might have been some confusion in the Canadian press and Canadian publishing industry, the news that Angélil had gone that far in blocking an unauthorized biography, particularly because it might interfere with sales of their own authorized version, there should be no confusion over the tactic. Throughout their long career together, Dion and Angélil have been artful in the strategies they have employed to control their own destinies. If this seems to be the pattern in the world of pop music, it is only coincidentally so, as it applies to Dion and Angélil. The tremendous worldwide sales of FALLING INTO YOU reflected the inevitable conclusion to a pact they had sealed when Dion first entered Angélil's office. To apply any suggestion of artistic compromise to her because she is a pop singer is to blame her for the genre. Better to blame the genre for Dion, than Dion for the genre. Especially in view of its long tradition of expediency.

While some critics continued to complain about the contrived nature of pop music generally and its pop divas specifically, using FALLING INTO YOU as a prime example, there was no ambivalence about the power of Celine Dion's voice and the success the album achieved. As noted in a *Canadian Press* article, "while some of the reviews for FALLING INTO YOU have been tepid — Dion's very commercial sound doesn't exactly make her a critic's darling — the 15-track CD has a hefty array of talent behind it, including credits from production giants David Foster and Jim Steinman, best known for Meatloaf's BAT OUT OF HELL." *RPM* magazine gave up on any real criticism: "The point here is, there's really not much need for criticism, because it would be fruitless. This album will sell a ton, and with a voice like that, she deserves every penny." *Billboard* described FALLING INTO YOU as "a deep album that will solidify Dion's reputation as one of the world's true pop divas."

Ironically, even *Eye Weekly's* Mark Weisblott, he of the poison Dion wedding pen, endorsed FALLING INTO YOU, once he got beyond the obligatory asides many journalists made regarding Phil Spector. "The final product," he wrote, "couldn't kick off with anything less idiosyncratic than *It's All Coming Back To Me Now*—seven minutes and 37 seconds written by Jim Steinman, whose fatal absence from the last Meatloaf album is finally justified here. Now it's Celine Dion who's been anointed most suitable to bring

such splendiferous bombast to the masses — and when she finally runs out of breath, whatever 'it' is *still* hasn't finished coming back. Tragically, some of Celine's strides in becoming more human than human are diminished by a sprinkling of hack producer dance tracks. However, the Dan Hill song *Seduces Me* succeeds in reaching its priapic peak, and the baroque handiwork of Aldo Nova (yes, *that* Aldo Nova) is a might consistent. Of course, it all pales in comparison with the three Steinman tracks. Given the chance to tackle Spector's most ambitious opus, *River Deep*, *Mountain High*, it all comes off like a jungle-techno ditty with the pitch-control on the fritz, at once optimistic and apocalyptic. This is the sound of the 'Wall of Sound' being chipped away once and for all, and Celine Dion is devilishly shaking the spray can."

Reducing Celine Dion's vocal rendition of Spector's classic to mischievous "graffiti" may not have been this reviewer's intention. Perhaps he couldn't resist the clever image. Or perhaps in an even more obscure reference he was suggesting or even admitting that Celine Dion was becoming a little less careful, a little more carefree in her English-language productions. One thing was for sure, reviewers had begun to dig a little deeper when reviewing Celine Dion's albums. They were no longer merely dismissing her tracks as "schmaltz." In fact, FALLING INTO YOU demonstrated the truth of Larry LeBlanc's observation that Celine Dion would continue to bring more maturity to her English-language albums as she became as comfortable with English as she is with French.

The success of Dion's fourth album was undeniable. She was rewarded with two Grammys (for Album of the Year and Best Pop Album), an American Music Award (for Favorite Female Artist Pop/Rock), four Junos, including Best Female Vocalist, Best Selling Album, and the newly created International Achievement Award, which she shared with Alanis Morissette and Shania Twain. She also won for Best Selling Francophone Album for LIVE À PARIS.

Celine Dion had accomplished what she set out to do. As a child she had expressed a clear, even single-minded ambition, to become an international music star before she was 30. She had released an album that was well on its way to selling 25 million copies. She had won several of the most coveted awards at the most prestigious Canadian and American awards shows, and she had done it before her 29th birthday.

Celine and René had worked very hard for these victories and they were not about to ease up yet. There were new goals to achieve and at least one more album to record before they would take time out to settle down and raise a family. The tenacity of their resolve to "take it to the limit, one more time" would become another topic that journalists focused on. With the release of FALLING INTO YOU, the pair had drawn on their energy reserves and spent a harrowing year and a half doing what they had always done — performing, promoting, cooperating, and traveling, traveling, traveling. If there ever was a point in her career when all the contributing traits of Dion's personality combined to push her onwards — the drive, the vision, even the humility — it was on the heels of recording this album. She had not stopped. From her performance at the opening ceremonies of the 1996 Olympics to appearances on Oprah and The Tonight Show with 7ay Leno, to tours of Asia and Europe, with all those awards shows wedged in between, she simply kept going. She also found time to record new material, this time in Spanish. She was no longer simply going for the gold, as they say. She was going for the diamond!

"Celine Dion must be the hardest working woman in show business — or at least the one with the most frequent-flyer miles," Charles P. Alexander observed in *Time*. "In the first half of 1996, the French-Canadian songbird chirped her way through concert tours of Australia, France and Canada; went on a press junket to London, picked up a World Music Award in Monaco, dropped into New York City three times for tv appearances and a recording session, and jetted to Prague to film the video for her new single

It's All Coming Back To Me Now. She owns two houses in Montreal, but until she breezed through town in April for three sold-out concerts, she had not set foot on either of her doorsteps for six months. And all this activity was merely a warm-up act for her big moment of the year — performing for the planet at the opening ceremonies of the Olympic Games in Atlanta. As soon as the world-class athletes hit the pool and the track, the world-class singer hit the road again for a 30-concert tour of the U.S., from Boston to Seattle. In September she lands in Monaco to begin a 47-concert conquest of 12 European nations, and in 1997 it's on to Asia. Her travel agent can soon retire in luxury . . . In an era in which rock stars are increasingly irritable about interviews and tours, Dion will crisscross continents, perform every night, answer stupid questions, cut ribbons, or do whatever else it takes to get songs up the charts."

In response to this exhaustive catalog of events, Dion remarked, "It's show business. I'm not necessarily happy about doing it, but if I do a record, I can't just sit down and tell somebody else to do the work." She also made it a point that working so hard was her choice, not a compulsion that may have left her anorexic, as some tabloids rumored. As she explained to Larry King on his show, "I have been thin all my life. My dad is as skinny as a toothpick. I am lucky, I can wear different clothing and I feel in top shape, and it's all right. . . . I eat anything I want and I am just lucky like that." If not driven to illness by her ambition, she was driven to succeed, as she declared in *Q Magazine*: "there is no limit for me, and there never will be."

Just how intense René and Celine's schedule was can be illustrated by a glance at the weeks that led up to her appearance at the Grammys and the Academy Awards that winter. The year kicked off with the announcement that Celine had been selected as the Artist of the Year by VH1. In Quebec, she received her fourth Radio Rock Detente award. Sony released a compilation of her early French recordings, C'EST POUR VIVRE. In February, Celine

was in Japan to begin a ten-concert tour of the Orient. On February 23rd, she was in the Middle East, where she gave a private concert for the Sultan of Brunei, a single-night performance for which it was rumored that she had received the same \$10 million dollar fee that Michael Jackson had received when he had entertained the Sultan. Three days later on February 26th, she appeared on the Grammy Awards show in New York. On March 21st, she was surprised on *Oprah* when her family showed up, invited by Winfrey, *all* of her family except her sister Claudette. On March 24th, at the Academy Awards, Celine sang Barbra Streisand's nominated song, *I Finally Found Someone*, from the film *The Mirror Has Two Faces*, filling in for an ailing Natalie Cole, *and* her own nominated song, *Because You Loved Me*.

Although the tabloids spread one rumor that Barbra was annoyed with Celine and another that Streisand had "not heard Dion" because she was "in the washroom" at the time Celine performed, neither was the case, as Celine explained to Larry King on his show while discussing her performance. "I said to them, I cannot learn the song by heart, because I don't have the words, but if I have a music stand for the lyrics of the song — no problem, I'll do it. I was very thrilled. I did my best and I had a wonderful time . . . with a beautiful orchestra . . . So, what happened is that I met her that night. . . . I saw her and we talked and she was very, very sweet to me, and she sent me flowers the next day, and she wrote me a wonderful note." According to various postings on the internet, the words to that note read: "I watched the tape afterwards. You sang my song beautifully and I regret I wasn't in the room to hear you. Next time let's make another one together."

Dion took Streisand at her word and she and René commissioned David Foster and Walter Afanisieff to write an appropriate duet. It would be included on both Streisand's HIGHER GROUND and Dion's LET'S TALK ABOUT LOVE album releases. Another piece of the dream that Celine and René had been piecing together for 18 years was fitted into place. As Celine told Larry King, singing

with Barbra Streisand was "a dream come true. Another one, another dream come true."

Celine confided she had not recorded the duet with Barbra at the same time, but later they had sung their song together, just for the heck of it. "I sang with her," she told King. "I took pictures with her. She invited me to her home. We had dinner — the best chicken I ever had in my life." During a later interview with King, Celine put to rest the question of Streisand's illness the night of the Academy Awards show. "That's the tabloids again," Celine said. "They can say whatever they want. I talked to her, and I know it's true. She had no voice. She had big flu, fever, sore throat. She sounded not so good on the phone." As Larry King noted, "A top professional never worries about a top professional." "The thing with Barbra," Celine replied, "is, like, she knows exactly how a camera works, and how the lighting is good for her, or what's her best side, or she's going to look the best if she does this or that. And she's not shy to let the people around her know 'this is what I need' . . . And she's not afraid to spend hours and hours rehearing until it's perfect. And I agree with that. It's great!"

Before month's end, it was announced that Celine Dion had signed a new \$100 million contract with Sony Music Canada, the largest to be awarded a Canadian artist. She was booked as the headlining act at the World Music Awards in April 1997, where she performed *Call The Man* with 30 members of a gospel choir as her backup singers. That night, she received three awards, including Best Selling Artist in the World. In May, she made her first appearance acting on network tv in the United States on the season finale of Fran Drescher's popular sitcom, *The Nanny*. Later that month, René's mother, 82, died, but Celine (and René) went on to fulfil her concert obligations in June before taking time off to recuperate — and, of course, record material for her next album. At this stage, Celine had been touring almost non-stop for 16 months, performing more than 150 concerts on four continents.

Celine's love of performing was noted by several journalists

during this period. In *Entertainment Weekly*, Jeff Gordanier reported on events backstage with René Angélil and Sony executive Vito Luprano during Celine's performance on *The Tonight Show*. "Back from a commercial break," Gordanier wrote, "Jay Leno flashes the cover of Dion's new CD, FALLING INTO YOU. 'Beautiful, beautiful, beautiful,' utters Luprano. Then Leno introduces his guest. Luprano and Angélil spend the next four minutes frozen, barely breathing. Dion stares down the camera, delivers her newest epic ballad, *Because You Loved Me*, and wields her five-octave soprano like a light sabre. When she finally kicks into the song's gooey crescendo, her husband releases an audible sigh. 'That was good,' says Angélil. 'That was good,' says Luprano."

Two days later, Gordanier witnessed another remarkable Dion performance. "Backstage at the Pantages Theatre in Los Angeles," he wrote, "she runs through a handful of high notes, rubs her throat, frowns. Seconds ago, Because You Loved Me brought the house down at the Blockbuster Awards. The applause keeps coming, the stage director keeps mouthing the word 'beautiful', but the singer looks glum. 'I'm a little tired,' she says. 'I'm afraid I did not have my full capacity.' No time to brood. Unfettered by doubt, Dion exits the Pantages and makes a beeline for a fence where about 50 fans are lined up for autographs. 'She always does this,' laughs tour manager Suzanne Gingue. All day, movie stars have rushed by with nary a glance at these fans, but Dion stops. She signs books, records, pads, hands, the sleeve of someone's red silk shirt. After being thwarted and ignored all afternoon, the crowd isn't sure how to respond, but Dion presses forward, leaving her mark on everything in sight. Then she does something that divas — even burgeoning ones — aren't supposed to do. She searches the crowd for more."

Gordanier's last image was a poignant one. More than anything, it reflects in capsule form the entire shape of Celine Dion's professional life so far. She has wanted to be a musical star for so

long that even reaching the top of the summit provides only an opportunity to gaze ambitiously at other summits. It's difficult to say whether it's a question of searching for adulation, or simply the byproduct of a young woman who cannot quite forget her humble beginnings and a related distant affinity she might feel for those who never reach the heights. Perhaps it was a bit of both — a glimpse into the nature of entertainment business that renders over-achieving pop music stars vulnerable to moments that appear to be nothing more than indulgent vanity. Or perhaps there is a fear that the runaway train of success is about to derail, with no warning to allow the star to steel herself against the impact of the wreck that must come once the wheels have left the tracks. As Dion herself intimates, "I always thought I was meant to be a singer. When I met René for the first time, we didn't know how far I could go. He believed in me and I believed in him and we both kept pursuing the career and our dreams and it's unbelievable. I'm not the kind of person who is wondering why it has happened . . . I just take every moment of it, just taste it and right now it's hot and good and I enjoy it because in show business you never know what's going to happen." Or perhaps, when one realizes the "dream" and passes through the gates in Disneyland, there is no return, no escape, no exit. "You can check out," as the lyrics to the Eagles' Hotel California suggest, "but you can never leave."

Whatever the "deep" reasons were for Celine Dion's need to perform in those days, she lived to do so. She loved singing so much that she simply did not want to stop. "I never had the exact picture in my mind," she told one interviewer, "of how it was going to be, but I always knew I wanted to be a singer. I hope to sing for the rest of my life, because I really am sincerely happy to be able to do it. But I don't wake up in the morning thinking, 'How many records have I sold today? Am I number 17 with a bullet? Am I number 4? I know that all these things are important, because it proves that it's all working. But I'm not a number. Deep in my heart, I don't want a hit. I want a career!" Statements that

her husband made to the press confirmed that this was their mutual goal. "Slowly, slowly, I think we did all the right things," he explained. "The only thing Celine asked me when she started was that she wants to sing all her life."

Despite our speculations about the internal motives and the external pressures shaping her character and driving her career, we did become fascinated with Celine Dion, after all, because of her exceptional recorded music and because of her exceptional live performances. "Probably on stage is the best way to get to know me," she has said. "It's who I am, really. This is where I feel good. I feel strong. I feel happy. Nobody can come on stage and tell me what to do. So, I can be myself and have a good time. In person, maybe I can be frightened a bit, or shy . . . on stage is the place to meet me." This is exactly how Celine Dion would like us to get to know her — as a performer. "When I get up on stage," she has confessed "I'm happy to stand in front of my audience to talk to them and tell them my secrets."

Celine Dion's audience revels in this sense of intimacy wherever she performs, as one of her fans, Louise Marris, describes in a review of Dion's show in England during the Falling Into You World Tour. Marris attended concerts at Sheffield Arena, Manchester NYTEX, Birmingham N.E.C., and Wembley Arena, all in November 1996. Her review was posted on the internet where it was read by her fellow Dion fans.

"Having seen her in concert last year in Britain," Marris commented at the beginning of her review, "I couldn't wait for La petite quebecoise to return to our stage. There was one thing I did ask myself and that was how could she improve on such an awe inspiring and impeccable performance? There was no doubt in my mind that she would find a way, as she has proved to her audiences at every one of her sellout concerts. Celine makes it clear that she

is in town to sing with all her heart, to act out each song as though it were a little movie, and to have her audience in stitches with her amazing sense of humour. Celine Dion, Superdiva of the '90s, has come a long way since *Ce n'etait qu'un reve*. She may well still be realising her dream, but we've felt the flame burn, we've learnt all we need to know, and one thing we can be sure of is — we've all realized the power of CELINE! You go girl!

"The lights went out, a whirlwind was heard from backstage, the suspense mounted, people screamed, clapped and cheered. The curtains lifted, the lights flashed on, and standing at the top of a ramp, dressed in a crisp, white leather, halter-neck trouser suit, and white leather jacket, her hair full of body and 'tres quebecoif', was Celine! Even her microphone was white.

"After taking a bow, and soaking up the huge applause that was ringing around the arena," Louise Marris continued, "Celine, still flabbergasted by the crowd's reaction, took a moment to talk to them as only Celine can. Obviously, Celine's speeches varied from concert to concert, but I'll do my best to include all she had to say:

"'Wow! Thankyou so much! That's the way we like it. So how you doin'? You're lookin' good, yeah, you are! You know we're really glad to be here with you tonight. We were here about a year ago . . . about this time, right? I don't know if you remember, but there are some rules when we go on tour . . . This isn't just my stage . . . Oh non, non, non, this isn't just the band's show here on stage, this is ALL OF OUR SHOW tonight! So, if at any point . . . 'Cause I've been to shows before and you sit for one and a half, two hours, doing like this . . . (Claps hands on microphone), so I know what it's like! And your legs . . . (Pulls exasperated face). So, if at any point you feel an urge to get up and dance, to sing along, especially you in the front rows 'cause you influence a lot of people, you know! You just do whatever you feel like tonight. Hey! You go girl!'

"Celine skipped round to pick up her microphone and placed it on the stand, centre stage. She then performed the title track to the album and tour FALLING INTO YOU. Celine wondered the crowd with her mesmerizing dance moves," Marris continued, "flailing her arms and swinging her hips to the tribal drumbeat of the song. At one point, she moved over to the stage set's lamp post. The stage is complicated with tv screens littered across the back, a ramp in the middle, and stairs at either side. The lighting was magnificent, changing from the soft and sensual deep blues and purples to bright yellows, greens and reds, depending on the mood and tempo of the song. The next song was more upbeat, Celine's version of River Deep, Mountain High, a definite improvement over the original. She sang the song with such tremendous strength, showing off the versatility of her voice. Inside that petite, angelic figure there is a rock star bursting to come out! This song was an obvious crowd favorite and one that Celine clearly enjoyed performing. She then introduced Seduce Me as one of her favorites from the FALLING INTO YOU album. She sat down on the stairs, by the lamppost, for much of the song. The interpretation of the song was very heartfelt, as Celine put herself in the role of the person in the lyrics, acting it out from the start to the finish. One felt that she was trying to 'seduce' the crowd with the song and the sensual atmosphere that she created.

"While the crowd launched into applause, Celine launched straight into *All By Myself*, a song that requires a superior vocal stamina that only Celine can pull off. Swirling white lights against purple background helped to animate the song to its maximum. Celine's live performance of the song is truly special, as she glides her voice with power and ease up to the high notes, which she sustains at pitch. But Celine was to pull out all the stops when she stunned her audience by taking the final chorus up a key and singing it completely a cappella. The band joined in with her for the end of the song, which she returned to centre stage to sing, changing the finale, and modelling her voice gracefully on the final sustain. The crowd went wild and Celine received yet another standing ovation. There was a look of sheer joy on her face as she commented, 'I'm glad I recorded the song!'

"Celine then picked up numerous bouquets of flowers and teddy bears and walked over to place them on the piano. There, she chatted with Claude Lemay, a.k.a. Mego, her pianist.

"'Now Mego,' she said. 'I know you wanna play your music and everything, but I just wanna have a chat with my audience. Go on, just give me a few seconds . . . please, please . . . you're the best!' (Turns to the audience.) 'You already know how I love to sing, well I love to talk, too.' (Cheeky grin.) 'You all know that I come from a French-Canadian upbringing, right? (Yeah!) Do you also know that I grew up the youngest in a family of 14? (Yeah!) God, you know everything about me, right? What am I doing here? Well, I'll tell you something that you don't know . . . When mum and dad married, dad didn't want kids . . . Yeah, that's right.' (Laughs and pulls a sarcastic face.) 'Isn't it amazing, poor dad. No, what am I saying? Poor mother! Can you imagine sixteen people around the dinner table, three times a day? I didn't get the chance to say much at that time, so now when I get the chance to talk!' (Turns back to Mego.) 'I'm sorry Mego, just a little longer.' (Turns to the audience.) 'Anyway when I was younger . . . Hey, I mean a lot younger, about five or six years old, my brothers and sisters used to put me on the kitchen table and hand me a pen to sing into . . . They thought that I thought it was a microphone! (Laughter all around as Celine pulls silly, confused look.) I knew it was a pen!'

"'You know what's funny? I did my first tour in the province of Quebec when I was just 14 years old. All my songs were in French at that time, except one that I'm sure you'll know . . .' (Launches into *Flashdance* . . . *What A Feeling!* The crowd applauded and cheers of 'Sing it!' could be heard.) 'Irene Cara, *Flashdance*, wow, what a song! And did you see the video? The shower scene?' (Starts to do the dance, captivating the audience with her frantic leg movements.) 'Well, the audience were dancing and singing along with me, we were having a great time, yeah, what a feeling! Don't get me wrong, I was not doing the shower thing on stage, but we were all dancing and singing and the crowd would cheer . . . But you know, I

did not understand a single word of what I was singing at that time! (Crowd roars with laughter and Celine laughs along with them). 'So I said to myself, "Celine, you're going to have to pack your bags and go to school and learn English," and so I did. 'Cause I don't write my songs and so you never know what you are gonna get! Well my English teacher, she wanted me to speak perfect English, and that's great, she was so cute. But can you imagine for two months, five days a week, ay after day, the same thing?! You know how the French have trouble with "H's?" (Stresses it) So for two months it was like ... "Well Hhhhhhello" and "Hhhhhow do you do?" and "Hhhhhhow do you do?" and Hhhhhhow are you?" Can you imagine every day the same? Well, I Hhhhhad a great time!" (Pulls cross-eyed expression)

"'Well, I'm glad I did learn English because it means that I can be here with you tonight, speaking to you, singing my songs on the stage, and I'm very proud of that. Do you want me to sing in French for you then?' (The crowd started to applaud and shrieked with joy)."

While music critics may have expressed some reserve over the achievement of the CD FALLING INTO YOU, they, too, were wildly enthusiastic about her live performances as she toured the world to support the record. In a review of Celine's performance at Wembley Arena in London, Nigel Williamson, for example, noted that "there is a certain anonymity to Dion's music that matches the non-image, at least on record, where her tonsil-baring soprano and emotional ballads can easily sound manufactured. No fewer than ten different producers worked on the most recent album and the result is polished, but lacking in soul. Live, however, she is a different proposition. This is her metier and she knows it, which is why the current world tour started last March and keeps her on the road into next year. Dion loves to perform and she never stops from the moment she appears, Fred Astaire-style, at the top of a flight of steps, until her Olympian finale. She runs up and down, talks ten to the dozen, and indulges in a series of unlikely grimaces and poses, many of which appear to have been borrowed from heavy metal.

Her particular favorite is to bend her knees and arch her back as if about to do the limbo, but she also performs a neat trick, throwing the mike stand around in a way we haven't seen since the heyday of Roger Daltrey and Rod Stewart. It is all slightly old-fashioned, yet Dion is so obviously enjoying herself that the exuberance, which is at first irritating, eventually becomes endearing. She is, too, a singer of so much more than syrupy ballads. Her big voice sounded least mannered when singing in her native French but Dion can handle anything, from the funk of *Declaration of Love*, through the gospel tinged *Love Can Move Mountains* and a soulful interpretation of *Natural Woman*, to the bluesy *Le Ballet*, in which she also displayed a talent for scat jazz. By the end of the evening the reason for her success is obvious. Celine Dion is a born entertainer who never met a microphone she didn't like."

Others agree that Dion's gift comes through during her concerts. "What makes Dion so unique is that she's not just a singer but a musician too," Hugh Fraser noted in a concert review in The Hamilton Spectator, "able to interpret color and mold music from the rock of River Deep, Mountain High to the gentlest ballad of If You Asked Me To, and she surrounds herself with musicians of equal excellence This is why, though I always wear earplugs for pop concerts, they come out for Dion." James Muretich of The Calgary Herald concurs in his review of her "Falling Into You" tour performance at the Saddledome in Calgary, built as a hockey arena. "To begin with, the size of the Saddledome was perfectly suited to Dion's voice. The 28-year-old singer possesses such range and raw power vocally that her voice filled the 'Dome' to the point of bursting, whether she was wringing every last melodramatic note out of her chart-topping ballads or doing her Tina Turner best with her rendition of River Deep, Mountain High. . . . Dion is equipped with a stupendous set of pipes and her carefully chosen repertoire shows off all that she is capable of vocally while also entertaining her fans with songs guaranteed to please at the 'adult' end of the radio dial. She delivered all that and more

during her Monday night show at the Saddledome, leaving one wondering where she can go from here. Perhaps next time through Calgary she'll sing atop the Calgary Tower, her voice booming across the entire city. Nothing, it seems, is beyond the reach of Celine Dion." Indeed, nothing seems beyond her reach.

The rigorous schedule of promotion and performance that Celine and René had maintained in order to promote FALLING INTO YOU was now interrupted by time spent playing golf. When René suggested that Celine take up golf as an activity that might help her deal with the stress she was often under, she took to the links with the same passion that she applied to her music, hitting up to 400 balls a day at driving ranges. It wasn't long before she was shaving points off her 24 handicap. "I'm completely hooked," she told Larry King. "I started eight months ago and I'm so glad I did, because I've been in studios, recording, fighting like an animal, wanting to beat my last performance, my last record, and I need a balance. If you want to keep your head on your shoulders, and your feet on the ground. My husband has been playing for 25 years. He wanted me to play, but I said to him, 'René, don't tell me to go try and hit a few balls. Give me some time off. Give me a month.' And he gave me one month off, and I took courses. The game is to me focus, and in show business you need to be very focused, so golf is the same thing, concentration, focus, and at the same time it's like you are in control. You are also like in show business, you are in competition with you. You want to beat your last performance. It's like you hit the ball, and every day, every hole, it's a new game." When King asked Dion if she thought she could join the ladies tour, someday, she replied, "Hey, why not? People come to me and say 'there is not a lot of people who can break 100.' It's not what I want to hear. I broke 100 three times already, and everybody says it's fantastic. I'm happy. Now I want to break 90,

and I want to break 80, too." As Celine told Ann Liguori, "When I go on stage and sing, it's very powerful to me because I love it. I feel in my element. In golf, this is my focus, and then my strength and concentration comes when I hit the ball and look at it."

Celine also looked to golf as a form of relaxation, as she explained to Liguori when the golf columnist asked her if she got "the same satisfaction hitting the perfect golf shot" as she got from "hitting a note perfectly." Celine replied, "You go on stage and you hit some good and some bad. But it's not a normal life traveling around the world, eating room service. It looks great, silver plates everywhere, the best hotels, jets, it's great. But it's not the real life. I need to be home, play golf and share something with my husband. It's a game you can play forever as long as you can walk, as long as your hips can turn." Golf had done a lot for her quality of life. In fact, it had improved her marriage. As she told Liguori, "It changed our relationship. We got closer. I want to spend as much time with René as possible. It changed my life in a big way, because I needed a balance to do something, a sport, go outside, take some air. . . . Hollywood, it's exciting, but it's not real. Real life is to walk on earth, see green, water, see flowers — meet people."

The media seemed to take as much pleasure in Celine's golf game as she did herself. "Celine Dion is a golf junkie with a 'Fore!' that could shatter glass," Edna Gundersen reported in USA Today. "The rolling fairways may not be the stomping grounds you'd expect for a gal with a passion for fashion, but Dion happily kicks off her Gucci stilettos to get in nine holes in her Ralph Lauren golf shoes." "I needed some balance in my life," Celine told Gundersen. "And I missed nature. I spend most of my life indoors — in recording studios, airports, airplanes and hotels. I can't play tennis because my life is too fast and I need something that calms me down. When you play tennis, you fight to beat somebody. It's not relaxing. Swimming is great, but if it's hairwaxing time, you don't feel like putting on your bathing suit and having everybody look at you." An often-mentioned item was the

36-hole Le Mirage golf club in Montreal that Celine and René had purchased. LPGA golf stars like Annika Sorenstam were frequent guests. Now that René and his wife were out on the golf links together, René was quoted more frequently in the press. "When we're playing," he told USA Today, "we can spend five hours outside in the fresh air, not thinking about anything but hitting that ball and wondering why it didn't go where you wanted it to." He also admitted that the fairways and greens had become a neutral ground where they could let their hair down and agree to disagree. "The one place where we fight," he confided, "is on the golf course . . . whenever I say something that's not exactly what her teaching pro told her, we disagree. Now, I've learned a little trick. Whenever Celine misses a shot and looks at me with eyes wondering 'What did I do wrong?' I tell her I don't know." By all accounts, the workaholic artist and her workaholic manager were having more fun, scheduling tee times into their hectic schedule.

As time passed by, Celine got even better at relaxing. She loved the spacious splendor of her Florida mansion, which she and René had designed, and was happy when her sister, Linda, and her brother-in-law, Alain, took up some of the tasks involved in managing the estate. Alain, it turned out, was a chef-quality cook. Her sister Manon often traveled with her now. She gave all her brothers and sisters one hundred thousand dollars as Christmas presents, and her mother and father had accepted the gift of a house, graciously, too.

With the release of her fifth English-language album scheduled for November 1997, Celine and René found themselves redesigning her stage show and stage set for stadiums instead of the arenas that she had mostly played in the past. The crowds were getting bigger and louder. Record sales had never been brisker.

Let's Talk About **L**ove

I don't want to hold on to a dream anymore. I want to hold on to my roots, my origins, my family, my friends . . . My soul and my heart need to talk, and I need to become a woman. I need simple things. I need to cook. I need to see . . . To walk in the rain and see nature and maybe have a kid. Be at home with René, travel the world maybe, but as a tourist. Play golf. Have no pressure. Because for 18 years I've been a very, very disciplined person. — Celine Dion

While journalists and fans speculated as to why Celine and René were not taking some well-deserved time off to start a family, as she had hinted at off and on since 1996, there was one very good reason, as Celine explained to Larry King. "Before *Titanic*, we were supposed to take a year off at least, and then *Titanic* happened, and we postponed everything." The momentum was there, and Dion and her record label seized the day, releasing her fifth English-language album in November 1997, a full month before the movie was to be begin its run in theaters. By February 1998, LET'S TALK ABOUT LOVE had already sold more than seven million albums in the United States alone. Celine was nominated for a Grammy for *Tell Him*, her duet with Barbra Streisand, and was about to realize a lifetime goal when she and her idol

performed their Grammy-nominated duet on February 25, 1998 at Radio City Music Hall in New York.

LET'S TALK ABOUT LOVE was not hampered by the controversy that had surrounded the release of her previous album. With no specter from the past to distract reviewers, the promotion of LET'S TALK ABOUT LOVE was propelled by the pre-release of Tell Him, mailed to radio several weeks before the album was made available in record stores. Once again, this was a song tailormade for Dion and Streisand by David Foster, Linda Thompson, and Walter Afanasieff. It hit the top of several easy listening charts during the Christmas season. Beatles producer, Sir George Martin, had come out of retirement to produce Carole King's The Reason for Dion, and King sat in on the piano for the session. There were also duets with the Bee Gees and Luciano Pavarotti, which led to concerts with these performers in the new year, but it was the blockbuster success of James Cameron's Titanic that pushed sales of LET'S TALK ABOUT LOVE past the already incredible numbers — 25 million — that Dion's previous album, FALLING INTO YOU, had racked up. George Martin invited Celine to sing Here, There and Everywhere on his Beatles retrospective IN MY LIFE, and reviewers would respond by picking her contribution, and Sean Connery's monologue version of the title song, as the most outstanding and unique tracks on one of the most listenable Beatle tributes ever made.

Celine Dion had first 'tested the waters' of soundtrack recording with her duet with Warren Wiebe on the 1989 movie Listen To Me then with Peabo Bryson on The Beauty and the Beast soundtrack. She succeeded with her contributions to the Tom Hanks and Meg Ryan film Sleepless In Seattle and the Robert Redford-Michelle Pfeiffer film Up Close And Personal. That she was approached to sing on the soundtrack to Titanic was not surprising, except that director James Cameron had told his soundtrack composer, James Horner, that he didn't want songs with vocals for his film. Horner had ignored this directive and gone ahead

and written a song, with lyrics by Will Jennings, and he had brought Celine into a studio to record her vocals. As Celine Dion told VH-1, "He said, 'James Cameron does not know about this, but would you sing that song just to give it a try as a demo?' So we did a demo, and the demo became the record. I never re-sang the song, they just built an orchestra around it. I'm glad that James Cameron changed his mind about having a song in the movie. A lot of people related to that song."

In order to meet enthusiastic demands projected for the November release, Sony Music shipped 10 million copies of LET'S TALK ABOUT LOVE, worldwide. Promotion was relentless. Celine and René were in Montreal at the end of October for a press conference that kicked off the pre-release promotion campaign. Streets outside the downtown Montreal TVA network studios were gridlocked by remote broadcast trucks from other networks and a crush of fans on hand to catch a glimpse of 'Queen Celine'. Simultaneous satellite feeds were also in place for overseas transmission to France, England, and Germany. On November 4th, fan club members were treated to a listening party and a virtual chat. The next day Dion's website offered preview video clips of her Tell Him video with Barbra Streisand. On the November 8th. VH1 kicked off a their special coverage of Celine Dion with three specials: the premiere of her Celine Dion Video Collection, a onehour documentary based on the LET'S TALK ABOUT LOVE album, and a live concert broadcast from the Falling Into You tour.

On November 9th, it was announced that Celine Dion's *Because You Loved Me* would be included on the DIANA PRINCESS OF WALES TRIBUTE CD. Diana's sister, Lady Sarah, thanked the artists who had donated their royalties. "So much time and energy," she said, "has been given by people in the music industry, to whom the Trustees also extend their thanks. I very much hope that this album will give as much pleasure to those who buy it, as comfort to the charitable causes which ultimately benefit." On the 13th, Celine participated in a virtual press conference on the web. On

the day of release, Tuesday, November 18, Celine was on *The Rosie O'Donnell Show*, where she chatted with the host about Barbra Streisand, who was scheduled to visit Rosie later in the week. The next day, Celine appeared on *Good Morning America* in New York before flying to Spain to accept an Amigo award for Best International Artist on the 20th. On the 21st, Celine was featured as part of the coverage of VH1's annual charity golf tournament. She was seen in a pre-taped segment taking a golf lesson from a pro. On the 23rd, the Lifetime channel debuted their *Intimate Portrait: Celine Dion* documentary.

After completing promotional commitments on the continent, Celine and René were in London on December 1st, where Celine Dion was a special guest of Queen Elizabeth II, during the British monarch's 50th wedding anniversary celebrations. She performed briefly during Queen Elizabeth and Prince Philip's gala festivities. On December 18th, My Heart Will Go On became the second single released from the new album. That same day it was announced that Celine had received two American Music Award nominations. On the December 19th, the day that Titanic opened in theaters throughout North America, Ladies Home Journal named Celine Dion as one of the "10 Most Influential Women of the Year." Celine and René spent the Christmas holiday season with family and friends, and at year's end Celine entertained her home province fans at the Molson Centre in Montreal.

In the early weeks of 1998, My Heart Will Go On lodged itself at the top of the charts, this time for 10 weeks on both the Bill-board adult contemporary chart and the Billboard Hot 100 Singles chart, propelling LET'S TALK ABOUT LOVE to the top of the Billboard Hot 200 albums chart, where the album ran neck and neck with the soundtrack album TITANIC for the duration of the year.

In February at the Grammy Awards in New York, fate intervened, as it had a year earlier at the Academy Awards when Natalie Cole had been unable to sing Barbra Streisand's nominated song. This time the sometimes performance shy Streisand

caught a cold and was unable to perform their duet *Tell Him* with Celine. Instead, Dion sang *My Heart Will Go On*, which just happened to be the number one single in the nation, and in 11 other countries, at that time. It would become her signature tune. Singing her duet with the recording, stage, and feature film star Barbra Streisand, who had gone on to a multi-faceted career as a producer and director — several steps further than Doris Day had managed in the late '50s and early '60s — would have been sweet. But fate was sweeping Dion ever closer to becoming the next in a long line of popular vocalists that stretched from Bing Crosby, Frank Sinatra, Doris Day, and Elvis to Barbra Streisand, Cher, and Whitney Houston, all the way from "New York to L.A."

"My next step," Dion admitted to Larry King a few weeks after the Oscar show, "is to play in a movie. To be a singer, you have to be an actress. I know I'm an actress, I know I can do it. I'm ready to work so hard and I do want to be a movie star actress. I don't want to do a movie as a singer — maybe I'll sing in my movies — but I don't want them to say 'she's a singer who's trying to be an actress."

On March 24th, Sony Music released three dance mixes of *My Heart Will Go On* — Tony Moran's Mix, the Soul Solution Mix, and Richie Jones' Mix, all of which extended the airplay of her single and drew in additional listeners who might have not been attracted by the big drama movie theme production of the sound-track version.

On April 14th, Celine shared the stage of the Beacon Theater in New York City with the Queen of Soul, Aretha Franklin, Mariah Carey, Gloria Estefan, and Shania Twain for the live VH1 broadcast of the first *Divas Live* special, a fund-raiser for the music channel's Save the Music Foundation. Celine began her short set with Diane Warren's *River Deep*, *Mountain High*. Carole King joined her on vocals and piano for *The Reason*. She also performed *My Heart Goes On*. But the highlights of the show for many in the audience came when Celine, Gloria, Shania, and

Carole sang King's You've Got A Friend, and when Aretha joined them for (You Make Me Feel Like) A Natural Woman, a rousing finale to a very entertaining tv special.

When asked what the *Divas Live* show had meant to her, personally, Celine responded to her VH1 interviewer, "Everything that I decide to do means something, otherwise I don't do them. That night I was going to be surrounded by amazing, talented people like Aretha Franklin, Mariah Carcy, Gloria Estefan, and Shania Twain. I was going to sing, which is one of the things I enjoy most in life. I remember when Carole King came on stage. We joined her and sang *You've Got A Friend*, which is one of my favorite songs. The audience sang along with us. It was fun, it was wild. Everybody wanted to be a diva!"

The recognition that these five women had sold more than 200 million albums led to a number of articles heralding a women's revolution in pop music. Women artists had begun to outsell men in 1995, but the media had been slow to recognize their accomplishments in print. The January 18, 1999 edition of People featured Celine, Whitney, Mariah, Shania, Madonna, and Jewel on the cover, and focused coverage on the wealth these divas had accumulated and what they spent their fortunes on. Madonna was touted as a savvy entrepreneur who headed up her own record label. Madonna had signed Alanis Morissette, the anti-diva, who had also sold more than 11 million copies of her U.S. debut JAGGED LITTLE PILL. Five contributing writers mentioned Celine's shoe collection, but they also pointed out that she was the top-selling artist in the world at that time. In response, Celine told People, "I don't drink, I don't smoke, I shop." She was said to have spent \$10 million on a 10-bedroom "turreted mansion in Jupiter, Florida, equipped with fountains, waterfalls, and 33 television sets."

Another extravagance was reported when Dion and Angélil purchased property in rural Quebec, their choice of a home on an island, and several houses and wood lots in the surrounding area. *Le Journal de Montreal* ran a story reporting that "Celine Dion and

husband-manager René Angélil are spending \$7.8 million to buy a fortress-like mansion in Laval." Access to this dwelling was said to be difficult. A large gate guarded the only road that led onto the island. The premises were said to be equipped with security cameras. All of these details would no doubt be of interest to any celebrity interested in purchasing a rural home. However, they proved to be a novelty for Canadians, especially journalists, who at least pretended to wonder at the luxuries included in the package: the indoor swimming pool with its domed roof, numerous living rooms, bathrooms, a game room, underground parking, and separate servants quarters. As *People* magazine noted, "When Dion told Letterman last November that she had a personal putting green, he howled, "Oh, stop! When I go bowling, I've got to rent shoes."

The VH1 *Divas Live* show also prompted a discussion of the politics of these performers. "No one is likely to mistake Shania and Celine for Women in Rock," Karen Schoemer wrote in *Newsweek*. "Their politics are all wrong." Schoemer's article was titled, "The Girl Problem: While critics slug it out over the meaning of 'Women in Rock', new albums from mainstream divas Shania Twain and Celine Dion soar above it all." As she continued, "They do womanhood the old-fashioned, un-ironic, hyper-feminine way. They comb their hair and flaunt their bellybuttons, and it's *not* a statement. Their music is unabashedly domestic, without complicated sub-texts; rock critics don't often write about them because there isn't a lot to explain. But out there in the real bedrooms of America, Twain and Dion have had real impact."

Celine's political colors appeared in another hue on April 30th when was awarded the title of Officer of the Order of Quebec. The next day, she was appointed an Officer of the Order of Canada, a tribute awarded Canadians who exemplify "the highest qualities of citizenship and whose contributions enrich the lives of their contemporaries." Since Canadian Confederation in 1967 some 3,000 recipients, including the members of the band Rush,

k.d. Lang, Anne Murray, and Bryan Adams, have been named to this prestigious Order.

Celine Dion's new stage set for the Let's Talk About Love Tour, designed for stadiums, provided Celine with even more territory to pace and even more spectacular lighting and video effects. Every aspect of this set was high tech. A hydraulic lift raised her up from within the bowels of the stage machinery, which also raised and lowered her band members on separate dais platforms. Even the stage floor was illuminated from within so that, as the star of the show rose into view, the heart-shaped stage throbbed.

The new show and stage set were introduced at the Fleet Center in Boston on August 21st. Dressed in a black blouse, a floorlength silver skirt open at the side to reveal black pants beneath, and a red cumberbund, Celine rose up into the midst of a bright, red, pulsing heart. As she broke into her opening number, Bryan Adams and David Foster's Let's Talk About Love, she was joined by a children's choir. At the end of the number, as the choir exited, Dion removed the skirt, revealing her tight black pants, and launched into the funky groove of Declaration Of Love. At the end of the third number in her program, the gorgeous ballad Because You Loved Me, fans delivered flowers to the front of the stage.

As internet reviewer Donna Rezsonya described the atmosphere of the new tour when it set down in Indianapolis, "We got to the arena and I felt myself getting nervous. I was so happy that someone who I look up to and has accomplished what she has done is in the same building. The concert started with a comedian and then there was a 15-minute intermission. While my friend and I were sitting there talking, we saw about three guys roll thus huge box underneath the stage, and then about five minutes later, roll it back out. We knew that Celine was in that box and the concert was going to start. The lights went out, the music starts, just as it starts on *Au couer du stade*, and then she rises up from center stage. I started to cry because of the emotion she had in her voice, and because she didn't let anyone down. She is just so great. She talked to us throughout the concert, about her and René wanting to have a baby, and her golf game . . ."

Celine's stage poses now ranged from the Tai chi "horse stance" during *The Reason* and flamenco struts during the special effects lightning flashes of *It's All Coming Back To Me Now* to the Michael Jackson-influenced dance routine during her heated up version of the Bee Gees' *Stayin' Alive*. Virtual duets with Barbra Streisand and with the Bee Gees on *Immortality*, with Dion's duet partners hyper-real there on the jumbo-size video displays, proved popular with her audiences. The gowns Celine donned for her encore delivery of *My Heart Will Go On* often drew special notice in reviews. An acoustic interlude, which had been added during the transition from the previous tour set list, proved so popular that it survived the entire tour. Concertgoers just loved to hear their Celine singing nostalgic covers of Roberta Flack's *The First Time I Ever Saw Your Face*, the Beatles' *Because*, Eric Clapton's *Heaven*, and Frank Sinatra's *All The Way*.

The success of FALLING INTO YOU had taken many people by surprise, but no one expected that the follow up album LET'S TALK ABOUT LOVE, even with its vigorous first four-month sales figures, could possibly eclipse Dion's previous album. Performing My Heart Will Go On on the Grammy show and a month later on the Academy Awards show lifted sales of her fifth album higher and higher. The box office success of Titanic helped. Sales of the soundtrack album, when added to sales of LET'S TALK ABOUT LOVE, would grow to more than 50 million record buyers who were listening to Celine Dion sing My Heart Will Go On in the privacy of their own homes, not to mention the people who rented or purchased VHS or DVD copies of the film. Celine Dion had not acted in a single Hollywood movie scene and she was already a movie star in her own right.

That summer, Celine hit the top of the Billboard Adult Contemporary chart for eight weeks with David Foster's To Love You More, which also became the first English-language record in 15 years to top the national charts in Japan. In September, Sony released SIL SUFFISAIT D'AIMER, Celine's second Jean-Jacques Goldman album. In October, Epic and VH1 released a CD version of DIVAS LIVE. In November, Celine hosted the Felix Awards in Montreal. She didn't win an award, but René picked up his 9th Impresario of the Year trophy. A few days later, Sony Music released Celine Dion's first English-language Christmas album, THESE ARE SPECIAL TIMES. Foster's previous recording of Celine's duet with Andrea Bocelli from the soundtrack of The Quest for Camelot was included, as well as his arrangements of standards such as O Holy Night, Blue Christmas, Ave Maria, and Adeste Fideles. Also included was her recording of Brahams' Lullabye, which was adapted from the track that he and Celine had included on the FOR OUR CHIL-DREN TOO tribute in 1996. I'm Your Angel by R. Kelly and Celine Dion hit the Top 40 when it was released as a CD single during the holiday season. Dion's first CBS Special, These Are Special Times, capped off a whirlwind year that had seen Celine rise from the number 12 ranked singles artist in 1997 to number 8 in '98.

The top-selling album of the year was TITANIC, followed closely by LET'S TALK ABOUT LOVE. Just in case consumers had any money left in their digital bank accounts to spend on Celine Dion product, Sony released a new video, *Live In Memphis*, which had been shot in 1997 during the Falling Into You Tour. The world had caught "Dion Fever," a condition as acute as "Shaniamania." In Canada, when Dion and Twain swept across the map during the Canadian legs of their world tours, the dailies published centerfold posters and six-page special sections on the day of their concerts. For Canadian reporters, it had become Beatlemania all over again, Canuck style. Canadians interviewed in the street were proud of their divas.

At year's end, the workaholic diva once again told interviewers that she would soon be taking time off to get a "normal life." "I'm only 30 years old," she said, "but I live with somebody who's 56. I don't feel like going on like this for another ten years, because René won't be there forever, unfortunately."

In April 1999, Celine Dion cancelled a number of shows. René had been diagnosed with Squamous Cell Carcinoma Metastasis, and she wanted to be by her ailing husband's side while her recovered from surgery and radiation treatments for his skin cancer. As she later told interviewers, the couple had both come down with winter colds, but René had been unable to shake his and kept coughing well into his second week of illness. On a plane flight into Dallas, where their tour management had them stationed for the next few days, Celine discovered a swelling on one side of his neck. The next morning, a doctor called at their hotel room. He referred Angélil to a specialist who booked René into a hospital for some tests. After the tests were done, Celine went around to the hospital, but the news was not good. René was scheduled for a biopsy the next day. As the doctor explained to Celine, "We have to open him to see what it is, but it doesn't look so good."

Angélil told Dion that he wanted her to go on with her show in Kansas City that night, but as she admitted later, she "wanted to be with him so bad." Celine kept thinking positive thoughts and performed her show that night. Immediately afterward, she flew back to Dallas and hurried to her husband's side. Angélil's right-hand man, Pierre Lacroix, had contacted a friend who had put them in touch with a top-notch surgeon in the area. The hospital had provided Lacroix with a room next to Angélil's. "After my concert," she later explained to Larry King, "when I joined him back at the hospital, we were with a couple of friends. And then at one point he said to me, 'Go to bed, you have shows to do. I want you to rest.' So, I stayed with him until I think three or four in the morning, and then Pierre Lacroix stayed at the hospital with René, and I went back to the hotel. Coko, his wife, she came to the

hotel with me and she said, 'Sleep, everything's OK. Don't worry about it.' And so I slept for a couple of hours and then she woke me. She took my face (like this) and she said, 'Your husband needs you. He just got the news.' When she said to me, my husband needs me, I knew it was not going to be good news. I have never got dressed so fast in my whole life."

Ironically, the doctors operated on René on March 30, 1999, Celine Dion's 31st birthday. She was a big girl now, she could handle this, but she was shaking just the same. When René's surgeon pronounced that the cancer had been fully removed, she was relieved. There would be a long period of recuperation, but the worst was behind them.

The tabloids were quick to exaggerate this event, alleging that Celine had rushed in as a priest was administering last rites. "I think I am starting to get a sense of show business a little bit," Celine told Larry King. "And I know what they're going to do with us. It's their work, but I don't need to follow this. I definitely don't want to follow this at all. I know what we went through — what *he* went through, especially. . . . No tabloid, no newspaper is going to tell us what is going to happen."

Hundreds of friends and well-wishers flooded their phone lines during the time that René Angélil was undergoing therapy. One of the calls that meant the most to the Montreal impresario had come from Tiger Woods. "You should have seen his face," Celine said, speaking of her husband's convalescence during an August press conference in Las Vegas at Woods' "Tiger Jam II," the golf star's annual fund-raising event for his Foundation for Underprivileged Young People. "You lifted his spirit up so much," Celine told Woods, who had not merely called once. During her 30-minute set that night, Celine paid Tiger an ultimate compliment when she said, "He's not only the number one golfer, he's the number one human being!" In addition to the set that Celine donated, an auction of items donated by other celebrities, including a round of golf with Tiger Woods in Orlando, Florida, and a guitar

autographed by the Eagles, brought in a total of \$242,500 for the charity. Money raised at the event would be donated to Tiger Wood's youth charities in California, Nevada, and Michigan. Woods told reporters that his foundation provides opportunities for underprivileged children to play golf, with him teaching many of the classes and pitching an important lesson "that they can make something of themselves. . . . We're not about golf, we're about humanitarianism."

The doctors had operated twice on René, just to make sure that they had caught all the malignant cells. René would still need to undergo radiation therapy, along with some chemotherapy. In a brave, desperate move, Celine and René arranged to have some of his sperm frozen and stored in a sperm bank before the radiation and chemo, just in case some collateral damage was done to his reproductive abilities. Their dream had shifted suddenly from the stage to the cradle. From this point onward, it was no problem for either manager or performer to set a definite date for the end of the Let's Talk About Love Tour. The time had come to get off the road and to begin to enjoy life.

"I just wanted to take a long break," Celine told Larry King in November 1999. "Take a break and have a normal life for a while. There's so many things I want to do. I have been realizing, you know, when you're 18 and 21 and 22, you hold on to your dream. Well, when you grow older, you have more experience, and I don't want to hold on to a dream anymore. I want to hold on to my roots, my origins, my family, my friends . . . My soul and my heart need to talk, and I need to become a woman. I need simple things. I need to cook. I need to see . . . To walk in the rain and see nature and maybe have a kid. Be at home with René, travel the world maybe, but as a tourist. Play golf. Have no pressure. Because for 18 years I've been a very, very disciplined person. Training my voice, only my voice. No dairy products and eating different types of food, because when you sing it's a different diet. And I'm a little tired to have this discipline,

now." As she noted, "I've been on Oprah's show, but I've never been to an opera."

Celine would retire, it was announced, on New Year's Eve 1999. There were a few loose ends to tie up before her farewell concert at the Molson Centre in Montreal as the new millennium dawned, but the Celine Dion that the world now saw appeared liberated from her workaholic past. When Celine and René attended the LPGA Nabisco Championship golf tournament in Rancho Mirage, California, she waded into the waist-deep water surrounding the 18th hole to congratulate Karrie Webb, who had taken to the water with her caddy to celebrate the victory.

In September 1999, CELINE AU COEUR DU STADE, her new French-language album, recorded on June 19th and 20th at the Stade de France in Paris, was released in North America. That same month, she embarked on the Canadian leg of her Let's Talk About Love Tour, with Corey Hart as the opening act. The Montreal rocker, best known for his 1985 hit Never Surrender, had contributed Miles To Go (Before I Sleep) and Where Is The Love to Celine's LET'S TALK ABOUT LOVE album. Then in November, Celine's first English-language compilation, ALL THE WAY: A DECADE OF SONG, was released. In addition to a ninesong selection of Dion's best tracks, the album featured seven new cuts, including a virtual duet with ol' blue eyes, Frank Sinatra. Also included were If Walls Could Talk, Celine's first collaboration with Mutt Lange (Shania's husband), a cover of Roberta Flack's The First Time I Ever Saw Your Face, and Diane Warren's I Want You To Need Me. The lead single was That's The Way It Is, produced by Backstreet Boys and Britney Spears producers Max Martin and Kristian Lundin. After a flurry of tv appearances on Oprah, The Today Show, The Tonight Show with Jay Leno, Rosie O'Donnell, and Larry King Live, Celine Dion appeared in her

second CBS special, Celine Dion: All The Way.

During René's convalescence, when Celine was on the road without him, the two were seldom more than a whisper away from each other. Connected to her via a satellite feed, René spoke to Celine on stage through her in-ear monitors. She couldn't speak to him while she was performing, but they had worked out little gestures that became a set of signals that her audience was unaware of at the time. René has said that he didn't overdo things. He merely provided occasional encouragement. At home, he was supposed to be recovering, resting, losing a few pounds, but he also managed to plan the logistics of Celine's Millennium Concert on New Year's Eve.

Celine let it be known that she had "declined every proposal and invitation" she had received from promoters in Vegas, New York, L.A. and Sidney, Australia, in order to share the arrival of the new millennium "surrounded by family and friends." She promised that her show would be "a magical evening, the most memorable in history." Celine's guests were Bryan Adams, Bruno Pelletier, Daniel Lavoie, Garou, and Luck Mervil of *Notre Dame de Paris*. Luc Plamondon directed solo and group performances by the cast of the famed Parisian musical.

"It was very emotional for me to be home and do one last farewell show," Celine later told VH1. "I was going on to a new life, which was very important to me. I was looking forward to seeing my husband and having a life, and maybe trying to have a little child. And I have no schedule, no training, no discipline. I knew I was going to come back, so it wasn't, like, 'Ciao, adios, I'm leaving forever.' It was, like, 'I'm going on vacation.'" Celine took the old year out in style. With all the hoopla associated with the Y2K problem, nobody on the planet could be 100 percent sure that the lights and sound system in Montreal would not fail at the midnight hour. "One emotional moment in the show for me and René and my family," she told VH1, "was when we did the countdown to the year 2000. That was special and scary, because a lot of things

210

had been said, like, 'Oh, it's going to be the end of the world." But as she came together with her loved ones on stage, Celine felt good energy as "everybody hugged, everybody kissed." As she looked out over the audience, she saw "no strangers." Celine had come home. Five days later Celine and René renewed their marriage vows at Caesars Palace in Las Vegas, the town she would make her home with her husband and son as she launched her comeback in 2002.

A New Day Has **C**ome

"Becoming a mother makes you a grown-up. You're all they have. They trust you, they need you. That's all they want. To be loved, protected and supported. Children know the secrets of life. They know everything. To be around children makes you discover the child that you are inside. I approach my whole life differently now. Nothing has the same meaning anymore." — Celine Dion

Following her farewell concert at the Molson Centre in Montreal, Celine Dion began a two-year vacation away from the stage and studio in Las Vegas. The vacation began in style, as she explained to Larry King. "Instead of doing a big party the first of January for the New Year, we're bringing everybody to Las Vegas. We're going to be, like, 250 people. It's kind of a private party, Larry, for friends. So they're going to be there with us for that show. And we're going to celebrate Christmas. We're going to share gifts and time and dance and music and love and hugs. And on the fifth, René and I are getting married again."

When the amiable talk show host asked "Why?" Celine replied, "Because I love him more than ever, and because 'five' is our lucky number. It's going to be five years we're going to be married."

Their January 5th restatement of wedding vows took place at Caesar's Palace, another imaginative production that was reported in the media as "lavish" and "indulgent." In order to pay homage to her husband's Lebanese and Syrian ancestry, Celine chose an Arabian theme that evoked the tales of Aladdin, Ali Baba, and Sinbad. The Casino chapel was transformed into a mosque, the ballroom into a fantasy garden where six "Berber tents" were erected. Robes were provided for the gucsts. According to a media release, "Each of the tents represented a scene from A Thousand and One Nights. The magic and mystery were enhanced by jugglers, musicians, and singers. Men were dressed in black, women wore gowns in the colors of precious gems."

Celine wore a golden Givenchy gown, René, a white, gold-laced djellaba, also designed by Givenchy. The cuisine was Mediterranean, prepared by Lebanese, Syrian, and Moroccan cooks. Celine was now listed as one of the "Worst Dressed Women," her wardrobe described on this infamous list as a "profusion of confusion."

During these days in Las Vegas, Celine and René attended a show by Cirque du Soleil, an event that changed their lives, as Celine enthused that she wanted to model her stage show on this production by director Franco Dragone. When René protested, citing costs and other production difficulties involved in putting such a show on the road, Celine suggested they mount the show in Las Vegas. Negotiations began with Dragone and Caesar's Palace.

Celine and René had learned that celebrity comes with a price that often includes defending their good name from opportunists who file spurious lawsuits and aim to settle out of court. Celine and René have shown a determination not to be blackmailed by claimants. For example, during this period, a five-year-long battle with a disgruntled ex-drummer surfaced now and then in the media. Peter Barbeau's wrongful termination allegations, including a charge that Celine lip-synched during her concerts, came with a \$5 million price tag. "The way it was said," she told

reporters at a press conference, "makes it sound like I'm not singing live at my shows. In the past, we've used instrumentation and voice samples on the uptempo numbers. This just gives the dance tracks a bit more punch to enhance the live performances, but I think that's normal."

Another lawsuit filed in Nevada alleged that René had raped a woman in a Las Vegas hotel room. The woman who filed the charges was on the run for casino bills amounting to more than half a million dollars and looking to settle out of court with Angélil. In another less scandalous case, Celine, René and Sony Music Canada collectively wrestled the rights to her domain name, www.celinedion.com, away from cybersquatter Jeff Burgar—a notorious domain name hoarder. They appealed to the United Nations' WIPO and eventually won their case in February 2001, a feat that several other celebrities whose domain names had been registered by Burgar, including Bruce Springsteen, were not able to accomplish.

When a tabloid erroneously reported that Celine was pregnant with twins, Celine and René filed their own lawsuit against the tab. In a statement issued to the press, Celine said, "I am deeply affected by this story. This thing has really upset me. Since that story came out, everyone has been congratulating me, and I have to keep telling them that it's not true. I only wish it was true, and I hope and pray that some day it will be." The tabloid eventually apologized, and Celine's wish came true, in part.

Celine had arranged for a "twin" embryo to be stored in a New York fertility center, and on May 31st, it was announced that she had responded well to fertility treatments and minor surgery, though it would be two weeks before she and her husband would know if she were pregnant. This announcement came on the heels of the death of Montreal Canadiens hockey legend Maurice

"Rocket" Richard and explained Celine's absence at Richard's funeral. "Only reasons of health," Celine declared in a prepared statement, "could keep me away from this Basilica, where the hearts of Quebeckers will beat as one in memory of their hero. I will therefore be with you only in spirit, but knowing that you will understand my absence." In early June 2000, another statement told the world what everybody wanted to hear: "There's no hiding happiness. We can't keep something so big, so wonderful a secret for us. This time it's real — I'm pregnant! We are completely, totally happy. And we thank God for the great joy we've been given. Over this past year, we went through a terrible test together, but we made it through stronger, closer, more loving than ever." She was expected to give birth in February 2001, perhaps on Valentine's Day. The child had been conceived through in vitro insemination, and a second fully fertilized frozen egg awaited Celine, whenever she chose to bear another child.

Celine may have been officially retired and planning a family, but her presence was still felt in the music world during 2000. She was VH1's artist of the month for January 2000, and two specials, Celine Dion: Behind the Music, and All the Way — A Decade In Song: The Concert from Radio City, were aired several times that month. Also in January, the Canadian Recording Industry Association declared Celine Dion the "best-selling Canadian recording artist of the century." Her Canadian sales were more than nine million, her worldwide sales approaching 120 million. On March 22, Celine sang a short set at a reception for the Nabisco Championships, a PGA golf tournament held in Rancho Mirage, California. Celine and René both played in the celebrity portion of the tournament on Tuesday, along with Alice Cooper, Tommy Smothers, Johnny Unitas, and other celebs. After the celebrity dinner, Celine and three backup singers sang along with backing tracks for the 1000 guests. In December 2001, Sony Music released CELINE DION VOLUME 1 — THE COLLECTOR'S SERIES, the first in a projected series of compilation albums. Within a month this album was certified gold in the U.S. In January 2001, Celine Dion was named Favorite Adult Contemporary Singer at the American Music Awards.

On Thursday, January 25, 2001, René-Charles Angélil, named after his father and grandfather, was born at 1:00 p.m. EST. Dion spokesperson Francine Chaloult reported that the baby "weighed six pounds, eight ounces, and was born in Florida." Mother and child were "doing marvelously well and are in perfect health." As media outlets scrambled to get quotes from those close to the happy parents, Quebec's Radio One aired an interview with Celine's band leader, Claude LeMay, aka "Mego," who had spoken with René Angélil. "You could hear the joy in his voice," LeMay reported.

Six months later, on July 25, 2001, the baptism of René-Charles was broadcast in both official languages on Canadian news channels. Once again, this ceremony, at the same Montreal church in which Celine and René had wed, bore all the trappings of a royal event in Quebec. As Canadian Press writer Michelle McAfee reported, "For all Celine Dion's desire to keep her son's baptism a private affair, Wednesday's event had the look of a Hollywood movie premiere or a celebrity wedding. Roads were closed, security was tight, and shuttle buses and limousines chauffeured the roughly 250 family members and friends to the long, blue carpeted runway leading to the small chapel inside Montreal's ornate Notre Dame Basilica."

Celebrity guests included René Angélil's new management client, Garou, Luc Plamandon, and Montreal Canadiens' assistant coach Guy Carbonneau. Celine was serene, dressed simply in a gray pantsuit. The only flaw in the program came when the baby began to fuss before the ceremony was completed. Quebec tv show host Michel Jasmin, a friend of the family, noted that "that little René Charles wasn't cut out for a big ceremony like that, because he cried quite a bit." Jasmin further speculated that being "fully immersed" in the baptismal font had set the baby off.

Another church witness, one of the priests, confided that "when she took him in her arms ... he became quiet."

Many of the more than one thousand fans gathered outside the church followed the official party as they left for a private gathering at Celine Dion's mansion in Laval. As the entourage moved toward the suburbs, the vehicles carrying Celine's official guests were surrounded by police vehicles and followed by a swarm of helicopters.

The reality of life as a day-to-day mother was somewhat less regal, however, as Celine confessed during an interview published in *Redbook*. "For me," Celine noted, "poop says it all. When you want to know the truth, look to the poop. You know if he digests well, if he's constipated, if he's not getting enough water . . . if the milk is doing fine."

At the Grammy Awards show in February 2002, Celine Dion returned to the stage after a two-year hiatus, joining Stevie Wonder and Bonnie Raitt to present the Record of the Year Award to U2. A month later, on March 26th, Sony Music released A NEW DAY HAS COME, Celine Dion's first studio album in five years. Although Celine had not performed on the concert circuit for 26 months, she was still listed as the top-selling female vocalist of all-time, with a reported 140 million albums sold, worldwide, and still referred to in the media as the planet's supreme pop diva. "It's a truly remarkable record," said Denise Donlon, President of Sony Music Canada. "Celine's number one debut, both internationally and at home, is a testament to her undeniable talent and the enduring loyalty of her legions of fans." Polly Anthony, President of Epic Records, declared A NEW DAY HAS COME to be "the album that Celine's fans have been waiting for. This number one debut is a testament to their devotion, to the exceptional quality of the music, and to Celine's stature as the world's premiere female recording artist."

In the long wake of the "9/11" tragedy and the escalating "war against terrorism," people throughout the free world looked forward to the day that the dark cloud of uncertainty would be lifted from their day to day lives. They were ready to embrace the yearning, the perseverance, and the resolve expressed in Aldo Nova and Stephan Moccio's song *A New Day Has Come*.

I was waiting for so long
For a miracle to come
Everyone told me to be strong
Hold on and don't shed a tear

So through darkness and good times
I knew I'd make it through
And the world thought I had it all
But I was waiting for you
—A New Day Has Come (ALDO NOVA, STEPHAN MOCCIO)

The world was waiting for a miracle, and when people realized that Celine was singing these lyrics to her son, René-Charles, they realized how much this highly-publicized and difficult fertilization and birth had meant to her. They could also relate to her feeling of solidarity in the workplace. As Celine Dion writes in the liner notes to A NEW DAY HAS COME, "I'm not the first one to say that life has changed, but I feel it just as strongly as everyone else does. While we were recording this album, there was a much different feeling from times before. With a renewed feeling of family and commitment, it felt as if the producers, writers, and musicians, and all of those who were involved, were putting even more of their own special love and tenderness into everything they were doing."

"It is a songwriter's dream to have Celine Dion sing your song," Stephan Moccio told JAM! Showbiz reporter Paul Cantin. A New Day Has Come had been one of four songs Toronto songwriter, Moccio, and former heavy metal star, Aldo Nova, had come up

with during a weekend songwriting session in Montreal, "an ethereal Enya-meets-Annie Lennox number." Moccio supplied the melody and the arrangement, Nova the lyrics. "The one thing that he brought," Moccio told Cantin, "is that he is such good friends with Celine. He wrote that song about her boy. Aldo knows her well enough to get inside her head and her heart. I was confident. The song was fresh and cool. It had a new enough sound but tying in elements of Celine. It has the big drama moment. It has all that stuff, which is what Celine does so well."

During interviews and media appearances in March 2002, La Belle Diva, now a proud mom, appeared well-rested, vibrant, confident. Staging her comeback had been challenging, but the challenge had not come from being out of practice. "Pretty much everybody said," Dion confided to *Toronto Sun* feature write Jane Stevenson, "that the record industry had changed so much. 'Love songs?' they said, 'you're going to have to do some rap music!' Which I was not prepared to do."

When A NEW DAY HAS COME was made available to critics, and reviews began appearing in newspapers and magazines, Celine was encouraged by critical acknowledgment that she had "adapted myself to more modern things." She also noted that "the record industry is afraid because what I do is more soft, ballads, and they were afraid coming out with an album like this was going to be very, very hard to sell. I'm knocking on wood, but so far, so good. It's the most incredible sales so far for us, ever!" With album sales of more than 550,000 in its first week of release in the United States, A NEW DAY HAS COME debuted at the top of the *Billboard* Hot 200 albums chart. Sales in Canada were 151,000, a whopping 138,000 more than Shakira's LAUNDRY SERVICE, and well ahead of the rest of the pack.

In *Billboard*, Chuck Taylor wrote that A NEW DAY HAS COME "marks the dawning of a new musical chapter for the 33-year old chanteuse, who returns after a two-year sabbatical with a new baby and a new attitude." He also praised her new release for its

easygoing natural feel. "This first all-new collection since 1997," he continued, "adds fresh colors to Dion's musical canvas, as she explores a broader, more adventurous range of pop music. The common thread here is immeasurable ease and confidence, adding up to Dion's most versatile and thus gratifying recording vet." British journalist David Sinclair, writing in The Times, declared that "Celine Dion is so much more than an MOR Muppet." As proof of this assertion, Sinclair related the story of the time he had been seated next to the singer in a small, noisy, 15-seat airplane. "For some reason," he says, "we got to talking about heavy metal music and she professed a secret passion for AC/DC. The next minute, amid the roar of the engines, she launched into an impromptu rendition of Thunderstruck, transforming her bell-like voice into a convincingly raucous approximation of Brian Johnson's screech. The point is that Dion has the voice, the ear, and the personality to have been any sort of singer she wanted to be. There is a song on her latest album, A NEW DAY HAS COME, which illustrates this perfectly. It is called *Ten Days*, and was written by Aldo Nova, a Canadian heavy rocker from the 1980s. 'Ten days have come and gone / Ten days and I'm all alone / And all that I can do is pray and pray,' Dion sings in a low, bluesy drawl against a dry backbeat and a rising swell of guitars. If you added a middleeight rap and stuck this number on an album by Eagle-Eye Cherry or Crazytown, you would have a pop-rock track as cool as they come."

Celine herself admitted that the track represented a new direction. She admitted to listening to "Gerald De Palmas' music a lot recently. I loved this song in particular, so I asked Aldo Nova to do the English translation and it became *Ten Days*. It's more of a rock song, which is a little different for me and very refreshing. I love my ballads, but at the same time, why not try something different? Music is always changing and I don't want to limit myself to only one style."

Through viewing music videos such as *Celine Dion: Live à Paris*, Dion's North American fans have become familiar with her

concerts in France where she belts out throbbing Euro-pop that drives Parisian audiences into a frenzy. *En anglais*, however, she has been marketed as a balladeer. As Sinclair notes, "the rest of the songs are a more familiar mix of power ballads, dance-floor throw-downs and traditional pop anthems. On *I Surrender* she hauls a typically glutinous lyric to the top of a mountainous chorus, whence she hurls it to the four winds — a performance that makes other merchants of bombast, from Meat Loaf to Shirley Bassey, seem timid." To her credit, Dion had stuck by her principles. There were no rap overlays or overdubs. Instead, there was both the ballad version of *A New Day Has Come* and the radio remix version, which took a page from Jann Arden's book of production tricks with breathy airbrushed vocals and cool, syncopated rhythms.

Listening to the tracks on A NEW DAY HAS COME, Celine Dion's fans discovered a fresh approach, as if motherhood had miraculously transformed their angel Celine into an even more divine diva. She sounded so relaxed, so natural. "I don't like to spend too much time in the studio," Celine told interviewers. "I don't like to work my songs, to sing them over and over — you've got to find your emotions the first time. It's got to come naturally."

"We went into the studio in Montreal," Dion explained to *Toronto Star* critic Jim Holt, "and we recorded during the day. Just next door to the studio was a playroom that I had stocked with a crib, a tv, and toys. René-Charles was there everyday. It was an incredible experience just singing and knowing he was so nearby."

"The last two years have been among the best of my life, as my husband and I have started a family and enjoyed our time together," Celine told CBS *Early Show's* Mark McEwen. "This has made going back into the studio a vehicle to express my growth both personally and artistically." Apparently, she and René had figured out how they could combine a career and a family. "I understand," she said, "I have a career, but I didn't put a child on this earth to say 'I wanted you but now I have to sing, so wait for

mommy'. He's going to be with me everywhere. But instead of spending two days in LA doing 12 interviews a day, we'll spend four days doing six a day."

In a moving statement made during the taping of a program for VH1, Mama Angélil said, "becoming a mother makes you a grown-up. You're all they have. They trust you, they need you. That's all they want. To be loved, protected and supported. Children know the secrets of life. They know everything. To be around children makes you discover the child that you are inside. I approach my whole life differently now. Nothing has the same meaning anymore."

Although she had no plans to tour in support of her new album, Celine did appear on her third CBS Special in early April and on a French game show at the Molson Centre in Montreal. Toronto Sun music critic Jane Stevenson witnessed the taping of the CBS Special in Los Angeles. "Apparently," Stevenson wrote, "even a performer who has sold 130 million albums worldwide can still get insecure. Celine admitted off the top that she was feeling pressure, even with a teleprompter feeding her intros and song lyrics. 'Well, where do I begin?' Dion said, after launching the night with the title track from her new record, A NEW DAY HAS COME. 'I'm a little bit nervous. I've got butterflies right now and my heart is pounding. I'm so excited to be back on stage.' The start-stop quality of the concert didn't help her. There were three wardrobe changes and other technical requirements that had her singing one song over entirely and redoing another intro no fewer than four times. Her voice was in good shape, even if her goofy banter — she covered everything from her wacky Grammy dress that had a seat belt hanging off it to her habit of pounding her chest while singing — had some eyes rolling, while others proclaimed her eternally cute."

Jim Holt at the *Toronto* Star also reported on Celine's candid banter. "'First of all, I'm a little nervous. I got some butterflies. I'm so very much excited to be back on stage,' she said. 'I've

wanted to do this for so long.' But Dion, 34, quickly turned an elaborate and highly technical production into a family reunion. It was as if tv crews had invaded her living room and she kept darting into the kitchen to sing and tell stories to her friends seated at the table. With her trademark brashness and humility, Dion made everyone feel as though she had taken them backstage."

While CBS producers were editing this footage, Celine and René traveled to Toronto, where MuchMoreMusic rolled out the red carpet for her March 28th appearance at its Queen Street West studios, and then to Montreal, where she appeared on SRC TV's wacky game show La Fureur, a show that has been described as being "insanely popular," perhaps as in vogue with Quebec viewers as Dion herself. As Ottawa Sun music critic Denis Armstrong reported, "This was no ordinary television taping. Part Electric Circus, part WWF RAW, sharing the stage with host Veronique Cloutier, gave Dion the chance to find her feet again." Performing before an audience of 14,000 in the Molson Centre arena where Les Canadiens play their NHL games, Celine said she had returned to Montreal in order to fulfil a promise she had made in 1999 at her farewell concert. "I do what I say," she told the game show audience, "and I said that I would be back in two years. Here I am!"

"The high energy disco inferno," Armstrong continued, "performed entirely in French with local celebrities and a bevy of dancers. Dressed in black chiffon with leather pants (size zero) and backed by a live band and singers, she plugged six songs, beginning with her first single off A NEW DAY HAS COME and followed that with I'm Alive, At Last, Have You Ever Been In Love and Ten Days. 'Do you want to hear more?' Dion joked. Her between song kibitzing with host Cloutier seemed to drive time-sensitive producers to distraction. Regardless of the constraints of producing television, the free-for-all atmosphere was infectious. She closed the show with The Greatest Reward and Right In Front Of You."

On Sunday evening, April 7th, 13.6 million North American

viewers invited Celine Dion into their living rooms as they watched the spit and polish edited version of the Kodak Theater show broadcast on CBS and CBC. As Celine Dion performed new songs from A NEW DAY HAS COME and familiar hits like My Heart Will Go On and The Power Of Love, she spiced the show with her familiar banter, inviting her audience into her home. "I have a new boss," she commented. "He's a very young boss. He can't even tie his shoes. No matter how hard I work, he still shits on me." She also made a dig at well-fed husband René Angélil, pointing to him and saying, "He got pregnant with me. He's still pregnant!" And as this third Celine Dion Special moved to its finale, with la petite fille de Charlemagne delivering an exquisite rendition of the Nat King Cole standard Nature Boy, Celine hauled out her baby pictures, projected on a big screen. When the Nielsen Ratings for this CBS special were released, "the network won Sunday night," Mark Armstrong reported, "thanks to Celine Dion: A New Day Has Come. The French-Canadian diva's comeback special — replete with baby pictures — topped the competition with 13.6 million viewers."

International sales of A NEW DAY HAS COME had Celine's "comeback" album at number one on the charts in 17 countries. A promotional jaunt through France, Germany, Holland, and Sweden was a working vacation with stopovers as a guest on Michael Drucker's *Vivement Dimanche* tv show, where she was reunited with friends Luc Plamondon and Eddy Marnay, and a surprise walk-on during French pop star Garou's concert at the Omnisport de Paris-Bercy, where she and Garou performed their duet, *Sous le Vent* and *Ten Days*, the English-language version of Gerald de Palmas' *Tomber*.

When she returned to North America, Celine headlined VH1's *Divas Live Vegas*, along with Cher, Mary J. Blige, Dixie Chicks, Shakira, Anastacia, Stevie Nicks, and special guest Whitney Houston. Celine surprised the MGM Grand audience by singing with international dance music star Anastacia on a duet version of

AC/DC's classic headbanger, You Shook Me All Night Long, before returning to sing the title song from her new album and the second single, I'm Alive. All of the divas joined in on a playful tribute to the King, performing outrageous Elvis impersonations. Celine's a cappella delivery of I Can't Help Falling In Love With You was breathtaking, but cross-dressing Elvis impersonator, Cher—who sported a pompadour and sideburns for the occasion—stole the show at the finale by planting a big old 'hunk of love' kiss on the lips of the show's host, Ellen DeGeneres. It was just Cher's way of saying, "Thank you, thank you very much."

A busy schedule during March and April saw Celine Dion appearing on most of the network shows, chatting with Larry King, embracing Oprah, and sitting down with Barbara Walters for an in-depth interview. As a full picture of Dion's future plans emerged, her fans came to accept the fact that they would have to trek to the Entertainment Capital of the World, Las Vegas, to see their angel Celine.

She had no plans to begin another international tour. Instead, she had signed a three-year deal to perform in a new showroom at Caesar's Palace, starting in March 2003. In Nevada, where she and René were building a new home, a half-hour commute from the casino, she could be both a mother and an entertainer. "I can play with my child all day at home," she told Barbara Walters. "Mommy's going to leave home at about 6 p.m. The shows will be at 8:30."

Hockey arenas and football stadiums would remain a thing of the past. She had toured relentlessly for 15 years, sold more records than any woman before her, and she was not prepared to look back. "I have no regrets," she told Walters. "I had such a great time. When you don't have any responsibilities other than to give the best possible show, it's fine. But once you become a mother, it's a different deal. I didn't train my voice at all for two years, so, going back into the studio and doing my vocal exercise, 'meeting' my voice again — yes, I was a little nervous. But the first

session went so well. I felt my singing was looser and more relaxed. Still powerful, but more controlled, and I think that comes from happiness!" She could have been speaking for Faith Hill, who attributes much of her success on her breakthrough 1998 album FAITH and her crossover hit *This Kiss* to the happiness she felt recording during the late stages of her pregnancy.

At Caesar's Palace, Celine hoped to raise her theatrical approach to entertaining to a new threshold. She planned to work with Cirque du Soleil director Franco Dragone to choreograph a show for the 4,000 seat venue built specifically for her engagement. "When I saw Cirque du Soleil in Las Vegas in 2000," Celine explained to interviewers, "it changed my vision. I said, 'I want to perform like that. I want a visual show like that — for every song to be a visual experience.' And there was no way that I could have done that on the road." René described the show as being "like something you have never seen before, a mix between a live show and a movie or a video."

Celine was quick to point out that Las Vegas had changed from the days when Frank Sinatra and his "Rat Pack" had put it on the entertainment map. Changed even from the days when Elvis and Wayne Newton had kept it on the map. The desert had filled in around the original hotels and casinos with more hotels, casinos, golf courses, and mile upon mile of suburban sprawl. When you approach Vegas from the south, from Phoenix or Los Angeles, it first appears as a glittering line of light etched onto the flat night horizon, a sparkling landmark that has been described as looking like the fattest, longest line of cocaine ever laid out to entice, dazzle, and hook customers. In days past, gangsters had filled the desert with unmarked graves. Martin Scorsese's 1996 film Casino documented this "bloody golden era of Vegas, when wiseguys ran the place with iron fists," Mark LePage has noted, but "those days are gone, their echo left in the complaint department of Robert DeNiro's character, bemoaning the Walt Disneyification of a good, dirty gangster business like gambling."

Today's Las Vegas is being transformed into a family entertainment complex, a destination resort, that has become "more family oriented," Celine has commented. "Like Disney World, it has everything, water, mountains, and golf!" There is something going on for people of all ages in the new Las Vegas. Nannies have become as important as showgirls once were. When questioned about raising her son in Vegas, Celine defended her decision: her son was "not going to be raised between a craps table and a slot machine." Her fellow Canadian Anne Murray had likewise taken up residence with her family in Vegas when she was booked there for long-standing engagements in the 1980s.

During an appearance on the Larry King show, Celine was asked by a caller if she had ever considered performing in a Broadway musical. King suggested Oklahoma, then Annie Get You Gun. "I'd love to do some musicals," she responded enthusiastically. But she qualified her response by saying, "One thing is for sure. I'd love to do some movies. Maybe a little more than Broadway, but you never know." The show Celine had planned with Franco Dragone would no doubt be "a little more than Broadway" and perhaps suitable for cinematographers as a basis for a feature film. Contemplation of what other projects Celine Dion might become involved in during those additional 165 days, when she was not working the luxuriously appointed Caesar's Palace showroom, encouraged people to believe that she would also appear in stock and trade Hollywood films, as Elvis had done, even before he became a Vegas fixture, and as Doris Day had done in the 1950s and Barbra Streisand in the '60s and '70s.

Caesar's Palace had extended a \$100 million dollar long-term contract and a generous production budget. "The sets," Celine remarked, "the special effects — aside from the costs — Caesars was capable of giving us everything we wanted: building the theater, working with Franco Dragone, having 50 to 60 performers on stage with me — there's no limit!" Tom Gallagher, president and chief executive officer of Park Place Entertainment, which

owns Caesar's Palace, told the media that "to open with Celine is about the best you could ever imagine." No doubt, Gallagher looked back to the success of Elvis and Anne Murray in Vegas and put his chips down on Celine. "We are delighted," Gallagher continued, "to join them in this all-star coalition to create an extraordinary show that will combine the best in music and the best in theater." He also revealed that the \$65 million amphitheatre, to be named Caesar's Palace Coliseum, was being built to replace the hotel-casino's famed 1,000-seat Circus Maximus showroom, which had been demolished in September 2000.

Celine Dion the performer is now indeed admired in the same mature way fans and critics respect Dolly Parton and Reba McEntire. We might be put off by Dolly's wigs, her frequent plastic surgery, or by Reba's entourage, but how could you not like someone as down to earth as Reba and Dolly who, like Celine, have risen from rags to riches? Such familiar celebrities are frequently lampooned, but few of them have responded with the same embracing sense of humor that Celine displayed when she became a target of Saturday Night Live cast member Anna Gasteyer. "I'm flattered when they take the time to impersonate you," Celine told VH1. "I think it's a good sign. Anna Gasteyer exaggerates my character and personality, but it's funny. I asked her to come and be part of my show. When it was time for me to change for the *Titanic* thing, I used to come up in the middle of the stage changing my wardrobe, putting on my big dress for the finale. Instead, she came on stage in my dress and started to exaggerate — 'Nearrrr, farrrrr . . .' the whole thing. Everybody thought it was me. People in the audience thought I was going to go crazy. Finally, I came on stage behind her and I'm, like, 'Hello?' Everybody cracked up." Her audience had also responded to Dion's parting shot as Gasteyer made her exit and Celine cracked, "I thought she was Anne Murray . . . " Celine has always been quick to acknowledge the trails Anne Murray blazed for her and to celebrate the achievement of her fellow

Canadian snowbirds — Joni Mitchell, Alanis Morissette, Shania Twain, Sarah McLachlan, Diana Krall, Nelly Furtado, and Avril Lavigne.

As Celine and René made their way down the fairways in the summer of 2002, she could relax and concentrate on keeping her head down and her eyes on her golf ball. She had done it! Her career was alive and well despite her maternity leave. Her future looked very bright indeed. She and René and René-Charles would spend the fall in La Louviere, Belgium, where she would begin rehearsals with Franco Dragone for the opening of her new show at Caesar's Palace in March 2003.

The opening night of Celine's three-year show "A New Day in the Colosseum at Caesar's Palace" was a grand success. Oprah Winfrey called the performance "the most amazing show I have ever seen!" The press followed suit. Revered Los Angeles Times critic Robert Hilburn wrote, "Dion is the kind of powerhouse presence that makes your pulse quicken." San Francisco Chronicle critic Cynthia Robins declared that "Dion's voice is a miracle." Bruce Weber of the New York Times wrote, "the show goes out of its way not to defy expectations but to exceed them." Time magazine's Josh Tyrangiel proclaimed, "the dancers are electric. The LED screen provides crisp and dynamic scenery. Dion's voice sounds fantastic." New York Daily Times critic Gary Dretzka noted that "A New Day blends surrealism, fantasy and pageantry with the athleticism of its dancers." And Chris Jones, writing in the Chicago Tribune, called the new show a "singular feast for the eyes."

Oprah was not the only fellow show business personality to herald Celine's "New Day." "Celine is one of the greatest singers," Barry Manilow quipped, "now she is one of the great flying singers!" Siegfried of Siegfried and Roy paid Celine a Las Vegas tribute: "Her show is bigger than life and that's what Las Vegas is all about." Fellow Canadian Alan Thicke gushed, "the show was phenomenal!" Celine Dion, that small French Canadien girl, had sung her way out of the Canadian cultural dilemma to become the most popular performer in Las Vegas and the best-loved singer in the world.

You only have to see the look on René Angélil's face, his son René-Charles cradled in his arms, both looking up at Celine standing by their side, to know how much love this family shares. Celine's affection for René is beyond question. She was the force behind their elaborate wedding ceremonies and the architectural design of their Florida mansion, where she placed those 33 tv sets in their Admiral's Cove house because she knows her husband is a tv addict. The hundreds of candles that burn in the evening are for Celine. She is an incurable romantic.

The story of Celine Dion's "new day" is colored by this family love, which extends to the entire Angélil family and the Dion family, her mother and father, and her brothers and sisters who gather around Celine and René, as they did during the Vegas celebration of their fifth wedding anniversary to sing the old, familiar Quebec folk songs they had serenaded Celine with even before she was old enough to sing along. It is this very old-fashioned, provincial, European-style family solidarity that has been the strength Celine has been able to draw upon to summon her energies when she has stepped into global spotlights on stages in Montreal, New York, Los Angeles, Paris, Tokyo, and London.

Celine Dion's affection goes even further. Her art has bridged divergent cultures and leant a hand in bringing people from many nations closer to a common ground. Her songs have had this healing effect because Celine Dion — forget about her occasional extravagances — truly is a kind person. In the face of a world crisis, as armies converge on the cradle of civilization and suicide terrorists claim the lives of innocent bystanders, the hope

that burns brightest shines in the eyes of proud parents like René and Celine. Forget about their wealth, their success, their personal idiosyncrasies. If Celine has her way, she will bring laughter and joy back to as many people's lives as she can.

Don't be surprised if René-Charles Angélil has some surprises up his sleeve, as well. Celine began performing at age five, at her brother's wedding. The year after his mother has fulfilled her contract at Caesar's Palace René-Charles will be five years old. Whether or not he will follow his parents into the world of entertainment cannot be determined, but it's a sure bet that he will turn out to be kind to others, as his parents have proven to be. To paraphrase Tiger Woods, "they're not about the money, they're about the music," and the music heals everybody, at least some of the time.

Bibliography

Aizlewood, John. "Why The Long Face?" Q Magazine, June, 1995.

Alexander, Charles P. "Celine's Power." Time, February 28, 1994.

"The True King of Pop." *Time*, August 29, 1994.

"Tuned In Everywhere." Time, August 12, 1996.

Anonymous. "A Star in Quebec, Dion starts Anew in English." *The Province*, 1990.

Anonymous. "Dion Buys \$7.8 mil Quebec Mansion." *The Province*, April 11 2000.

Anonymous. "Celine Dion Speaks Out." The New York Post, February 16, 2002.

Anonymous. "Celine Dion Timeline." Rock on the Net.com.

Anonymous. "Las Vegas Doesn't Frighten Dion." Associated Press, March 21, 2002.

Anonymous. "Oprah Stages Celine Dion Love-in." Jam! Showbiz, March 21, 1997.

Anonymous. "The New Pop Divas." People, January 18, 1999.

Anonymous. "Mariah Carey In Street Fight With Producer." Mr Show-Biz, April 30, 1997.

Anonymous. "Album Pick." RPM, March 11, 1996.

Anonymous. "Celine Dion: Music To Industry Ears." *Canadian Press*, March 15, 1996.

Anonymous. "Did Hubby Slap Whitney In Hawaii?" *The Whig-Standard*, June 4, 1997.

Anonymous. "Kid With Vampire Fangs Finds Success As Singer." *Canadian Press*, March 1, 1984.

Anonymous. "Je Suis Une Pop Star." Sunday Mirror, April 16, 1995.

Anonymous. "Dion To Marry Her Manager." Canadian Press, November 5, 1993.

Anonymous. "Dion Marries Manager In Almost-Regal Show." *Canadian Press*, December 19, 1994.

Anonymous. "Annulment Rulings Are Totally Impartial, Tribunal Head Says." *The Gazette*, January 21, 1995.

Anonymous. "Dion's Love Life Gets U.S. Tabloid Treatment." *The Gazette*, May 12, 1994.

Anonymous. "Avoiding Questions." *Maclean's Magazine*, October 16, 1995.

Anonymous. "Untitled." Daily Mirror, October 13, 1995.

Aubry, Jack. "Many Believe First Nations Funding Loose." *The Whig-Standard*, June 26, 1997.

Armstrong, Denis. "Diva's Bright New Day." *Ottawa Sun*, April 4, 2002.

Armstrong, Mark. "Celine Dion Has a Baby René." *Eonline*, January 25, 2001.

"Somber TV Telethon Makes History." *Eonline*, September 21, 2001.

——— "NBC, CBS Trounce Ratings Competition." *Eonline*, April 9, 2002.

Bateman, Jeff. "Sony Execs Brainstorm on New Celine Album." *The Record*, September 15, 1997.

Baker, Geoff. "Celine Dion Sues Crime Tabloid, Denies Living With Manager As Teen." *The Gazette*, July 21, 1994.

Beaulieu, Pierre. La Presse, June 1, 1977.

Berton, Pierre. *The Cool Crazy Committed World of the Sixties*. Toronto, ON: McClelland & Stewart Limited, 1966.

Blain, François. "Star Potential." Music Scene, January-February, 1989.

Cantin, Paul. "Canadian Songwriter Lands Celine Dion Title Track." *Jam! Showbiz*, February 8, 2002.

"Celine interview draws huge numbers." *Jam! Showbiz*, December 19, 2000.

Clark, Pete. "Housewife Superstar." *Evening Standard*, February 22, 1996.

Clarke, Norm. "Singer Takes Exotic Path for Wedding Vows." Las Vegas Review Journal, January 7, 2000.

Conlon, Patrick. Maclean's, Nov. 3, 1975.

Contenta, Sandro. "Quebec's Queen Of Pop Weds In Royal Fashion", *Toronto Star*, December 18, 1994.

Corr, Alan. "The Colour of Their Love." *RTE Guide Magazine* May 26, 1995.

Corliss, Richard. "Viva The Divas!" Time, August 12, 1996.

de Billy, Hélene. "L'angélil Gardien." L'actualité, June 15, 1993.

Dolbec, Michel. "Celine et les Français." Châtelaine, January 1997.

Errico, Marcus. "Celine Pulls an Elvis." Eonline, February 4, 2002.

"Stork Time for Celine." Eonline, June 9, 2000.

Farache, Emily. "Celine's Frozen 'Twin' Boy." *Eonline*, December 18, 2000.

"Celine Dion, Karaoke Star?" Eonline, Oct 13, 1999.

"Celine Dion Renews Wedding Vows." *Eonline*, January 6, 2000.

Farley, Christopher John & Serrill, Michael S. "From a Cuban Heart." *Time*, August 12, 1996.

Flynn, Andrew. "Nelly Furtado Bags First Grammy." Canadian Press, February 27, 2002.

234

Flynn, Andrew. "Northern Lights Shine: Twain, Dion, Morissette Come Out Winners in Grammy Awards Ladies' Night Out." *The Province*, February 25, 1999.

Fraser, Hugh. "Dion Has Tremendous Range And Depth In Stunning Show." *Hamilton Spectator*, May 29, 1996.

Fulton, E. Kaye. "Queen Celine." Maclean's, June 1, 1992.

Ceraldi, Anna. "Foster's Fantasy on Hitting the High Notes of fame and Fortune." *Vancouver Lifestyles*, March 1998.

Gordanier, Jeff. "Naked Ambition." Entertainment Weekly, March 29, 1996.

Gunderson, Edna. "Dion Bitten by Golf Bug." *The Calgary Sun*, September 18, 1998.

Holt, Jim. "Celine Dion at the Kodak Theater." *Eonline*, March 8, 2002.

Howell, Peter. "(Rankin) Family Affair At Juno Awards." *The Whig Standard*, March 21, 1994.

Hustak, Alan. "Angélil Pays Author to Stop Work on Dion Book." *The Gazette*, November 21, 1996.

Jackson, Rick. "Robert Charlebois." *The Canadian Encyclopedia of Rock, Pop & Folk Music,* Kingston: Quarry Press Inc., 1994.

——— "Celine Dion." The Canadian Encyclopedia of Rock, Pop & Folk Music .

——— "Roch Voisine." The Canadian Encyclopedia of Rock, Pop & Folk Music.

Jenison, David. "Celine Dion's 'Day' on Charts." *Eonline*, April 3, 2002.

Jennings, Nicolas. "High Notes." TV Times Magazine, December 4, 1993.

Kaplan, James. "The Gospel According To Whitney." *Premiere*, January, 1997.

Kelly, Brendan. "Celine Dion Willingly Pays Price of Success." *Financial Post*, March 27, 1993.

——— "It Took Two: Dion and Voisine Successes Spur More Euro-Quebec Linkage." *Billboard*, January 25, 1992.

"That's Ms. Dion To You." Chatelaine, September, 1996.

Kennedy, Shauna. "The Celine Dion Band: The Force Behind The Voice." *Canadian Musician*, August, 1994.

Lacey. Liam. "Dion Sings At Home." The Globe & Mail, December 4, 1993.

LePage, Mark. "Celine Dion's New Album Tackles Hometown Dilemma." *The Gazette*, April 1, 1995.

"Play-it-safe Dion 'People' Scared Off By Spector." *The Gazette*, April 6, 1996.

Liguori, Ann. "Playing Is High Note for Celine Dion." *USA Today*, April 8, 1999.

Macy, Robert. "Singer Celine Dion Is Golfer's Biggest Fan at Charity Benefit." *Associated Press*, August 9, 1999.

Marris, Louise. "We've Realised the Power of Celine!" www.netrover.com/~eyevet/uk.html

Meere, David. "Celine Dion: Let's Talk About Success." VH1 Artist's News, April 4, 2002.

Mollins, Carl. "Songs For All The People." *Maclean's Magazine*, December 28, 1992.

Monahan, Iona. "Gown Made Canada Gasp." Calgary Herald, December 27, 1994.

Montgomery, Sue. "Celine Dion's Wedding Album Reveals Unusual Family Traits." *The Chronicle-Herald*, December 22, 1994.

"Celine Dion: Climb To Fame Amazes Her." Calgary Herald, May 19, 1996.

Muretich, James. "Celine Is the Queen." Calgary Herald, October 3, 1998.

"Celine Dion: Singer Filled The 'Dome With Incredible Range And Raw Power." *Calgary Herald*, May 20, 1996.

Nantel, Linda. Photo-Journal, December, 1977.

Niester, Alan. "La Petite Fille De Charlemagne." *The Globe & Mail*, April 25, 1996.

236

Pappas, Ben. "The Richest Women in Tinseltown & How They Spend, Spend, Spend." US Weekly, April 29 2002.

Powell, Betsy. "Celine Answers Her Critics." Canadian Press, April 19, 1996.

Powell, Betsy. "Down-Home Dion." Canadian Press, April 21, 1996.

Rezsonya, Donna. "Celine Dion In Indianapolis, March 31, 1999." Posted at www.studiozone.com/celine.

Riese, Randall. Her Name Is Barbra: An Intimate Portrait of The Real Barbra Streisand. New York, NY: St. Martins Press, 1984.

Roberts, Roxanne. "His Heart Will Go On: Larry King, Celine Dion Team Up for Benefit Gala." *Washington Post*, November 21, 1998.

Sargeant, Winthrop. "Fifty Years Of American Women." *Life*, January 2, 1950.

Sheldrick, Frances. "Review: Celine Dion, Sunday July 11, 1999, Wembley Stadium." Posted at www.studiozone.com/celine.

Sinclair, David. "She's the Cream of the Cheese." *The Times*, March 21, 2002.

Schoemer, Karen. "The Girl Problem." Newsweek, November 17, 1997.

Schumacker-Rasmussen, Eric. "Celine Does AC/DC." MTV News, May 24, 2002.

Slack, Lyle. "Will Celine Dion Set The World On Fire?" *Chatelaine*, August, 1991.

Stevenson, Jane. "Dion Will Go On." *The Toronto Sun*, March 5, 2002.

——— "Celine Here for Live Appearance on Much." *The Toronto Sun*, March 22, 2002.

"Dion of a New Day." The Toronto Sun, March 29, 2002.

Stoter, Neil, "The Best Concert I Have Ever Seen." Internet reviews 1996, 1999.

Taylor, Chuck. "550's Celine Takes Stardom To Next Level." *Billboard Magazine*, November 9, 1996.

Taylor, Chuck. "Review: A New Day Has Come." *Billboard*, March 24, 2002.

Weatherford, Mike. "Celine Dion Lives Up To Superstar Label." Las Vegas Review Journal, October 18, 1998.

Weisblott, Marc. "She Did: A Quick Flip Through The Celine Dion Wedding Album." *Eye Weekly*, January 26, 1995.

"Celine Dion: Falling Into You." Eye Weekly, April 11, 1996.

Williamson, Nigel. "Love That Microphone." *The Times Newspaper*, November 18, 1996.

"Dion Loves Her Mike." The Times, July 18, 1999.

Yakabuski, Konrad. "A Tin Flute Goes Platinum." *The Globe & Mail*, May 24, 1997.

Additional Selected Bibliography

Anonymous. "Quebec Star Sings For Car Campaign." *Marketing*, October 10, 1988.

"Dion, Murray Sing The Bay's Praises." *Marketing*, March 27, 1995.

"The Marketing Power Of Celine." *Marketing*, April 25, 1994.

Chiasson, Gail. "Bay Drops Dion, Murray In Ad Strategy Revamp." *Marketing*, May 20, 1996.

"Celine Sings For Coke In Quebec." *Marketing*, May 13, 1991.

Dagenais, Nicole. "Celine Dion: Conquests Past, Present and Future Light Up Her Career." *Music Scene*, March-April, 1984.

Demers, Dominique. "L'ogresse Reno." L'Actualité, June 15, 1992.

------ "Big." L'Actualité, August, 1989.

Ducharme, André, "La conquete du monde." L'Actualité, January 1996.

Germain, Georges-Hébert. "Ma sorciere bien aimée." *Chatelaine*, February, 1991.

"Une chanteuse sur mesure." L'Actualité, November, 1983.

Grills, Barry. Ironic: Alanis Morissette, The Story. Kingston: Quarry Press, 1997.

———— Snowbird: The Story Of Anne Murray. Kingston: Quarry Press, 1996.

Henman, David. "Born To Sing." Canadian Musician, October, 1990.

Howell, Peter. "Singers Wage Cancer Battle-With A CD." *Toronto Star*, September 7, 1995.

"Dion Wants A Rest And A Baby." Toronto Star, April 19, 1996.

Labreche-Larouche, Michelle. "Ginette Reno: Derriere la star une femme fragile." *Chatelaine*, February, 1992.

LeBlanc, Larry & Nunziata, Susan. "Dion's Language Is Universal." *Billboard*, May 16, 1992.

Lahey, Anita. "P&G Uses Promo Power Of Dion To Push Brands." *Marketing*, April 8, 1996.

Melhuish, Martin. *Oh What A Feeling: A Vital History of Canadian Music.* Kingston: Quarry Press, 1996.

Ostick, Stephen. "The Language Of Music: Dion, Voisine Break Out Of Francophone Isolation." *Winnipeg Free Press*, May 20, 1994.

Simard, Mireille. "Le Bonheur D'Etre Celine Dion." *Chatelaine*, September, 1987.

NOTE: Additional information on release dates, tour dates, press releases, news archives, FAQs, sales figures, chart numbers, and statements by label representatives was found at: www.sonymusic.ca, www.celineonline.com and www.celinedion.com.

Acknowledgements

Photo Credits

Cover:	Reuters/Corbis/Ethan Miller
p. 2	Columbia Records/Sony Music
p. 6	Columbia Records/Sony Music
p. 81	CanaPress/Paul Chiasson
p. 82	Corbis/Magma/Neal Preston
p. 83	CanaPress/Frank Micelotta Ho
p. 84	Courtesy of Olive Allen
p. 85	Reuters/Corbis/Magma/Jim Young
p. 85	Reuters/Corbis/Magma/Daniel Auclair/Trustar
p. 86	Corbis/Magma/Ethan Miller
p. 87	Reuters/Corbis/Magma/Peter Morgan
p. 88	Advertisement in Gotham Magazine

Lyrics

A New Day Has Come. Written by Aldo Nova, Stephan Moccio. Copyright Aldo Nova Inc. (SOCAN) / Sony ATV Music Publishing Canada and Sing Little Penguin.